Jasper Johns Drawings 1954-1984

JASPER JOHNS DRAWINGS 1954-1984

Text by
David Shapiro

Project Director
David Whitney

Editor
Christopher Sweet

Harry N. Abrams, Inc.
Publishers, New York

FRONTISPIECE:

Ventriloquist. 1984.
Ink on plastic, 33½ × 22¾".
Collection the artist

NOTE: The dimensions given here indicate sight-measures of the drawings. The titles and mediums given here, which in some instances differ from those given in previous publications, are considered definitive by the artist.

Project Manager: Margaret L. Kaplan
Project Editor: Anne Yarowsky
Designer: Judith Michael

LIBRARY OF CONGRESS CATALOGING IN PUBLICATION DATA
Shapiro, David, 1947–
Jasper Johns drawings.

Bibliography: p. 207
Includes index.
1. Johns, Jasper, 1930– . I. Johns, Jasper,
1930– . II. Title.
NC139.J58S5 1985 741′.092′4 83-25775
ISBN 0-8109-1156-6

Line from "In Memory of My Feelings" by Frank O'Hara, Copyright © 1958 by Maureen Granville-Smith, Administratrix of the Estate of Frank O'Hara. Reprinted from THE COLLECTED POEMS OF FRANK O'HARA, Edited by Donald Allen, by permission of Alfred A. Knopf, Inc. Lines from "A Step Away From Them" by Frank O'Hara reprinted from LUNCH POEMS, Copyright © 1964 by Frank O'Hara. Reprinted by permission of City Lights Books. Lines from "The Man on the Dump" and "The Idea of Order at Key West" by Wallace Stevens, Copyright 1936, 1942 by Wallace Stevens and renewed 1964, 1970 by Holly Stevens. Reprinted from THE COLLECTED POEMS OF WALLACE STEVENS, by permission of Alfred A. Knopf, Inc. Excerpt from LETTER TO HIS FATHER by Franz Kafka, Copyright © 1953, 1954, 1966 by Schocken Books, Inc. The lines from "Cape Hatteras" by Hart Crane are reprinted from THE COMPLETE POEMS AND SELECTED LETTERS AND PROSE OF HART CRANE, edited by Brom Weber, with the permission of Liveright Publishing Corporation. Copyright 1933, © 1958, 1966 by Liveright Publishing Corporation. Lines from "The Hollow Men" in COLLECTED POEMS 1909–1962 by T. S. Eliot, Copyright 1936 by Harcourt Brace Jovanovich, Inc.; Copyright © 1963, 1964 by T. S. Eliot. Reprinted by permission of the publisher.

Published in 1984 by Harry N. Abrams, Incorporated, New York

Printed and bound in Japan

Contents

Acknowledgments

We wish to thank Mark Lancaster for his work on every aspect of this book.

We would also like to express our gratitude to the following people whose efforts and generosity helped to make this book possible: Susan Brundage; John Cage; Leo and Toiny Castelli; Riva Castleman; Robert McDaniel; Rosa Esman; Richard Field; Sally and Victor Ganz; Elyse and Stanley Grinstein; Fiona Irving; Margaret Kaplan; Hiroshi Kawanishi; Mame Kennedy; Margo Leavin; Lois Long; Susan Lorence; Joseph Masheck; Jane and Robert Meyerhoff; Judith Michael; Robert Nickas; Ann Reynolds; Bernice Rose; Lindsay Stamm Shapiro; Glenn Steigelman; Christopher Sweet; David Sweet; Debbie Taylor; David White; Anne Yarowsky. Above all, we are deeply indebted to Jasper Johns, whose drawings were a source of constant inspiration for us.

David Shapiro
David Whitney

I am not more certain of the meaning of words than I am of certain judgments. Can I doubt that this colour is called 'blue'?

[My] doubts form a system.

—Ludwig Wittgenstein[1]

Jasper Johns Drawings 1954-1984

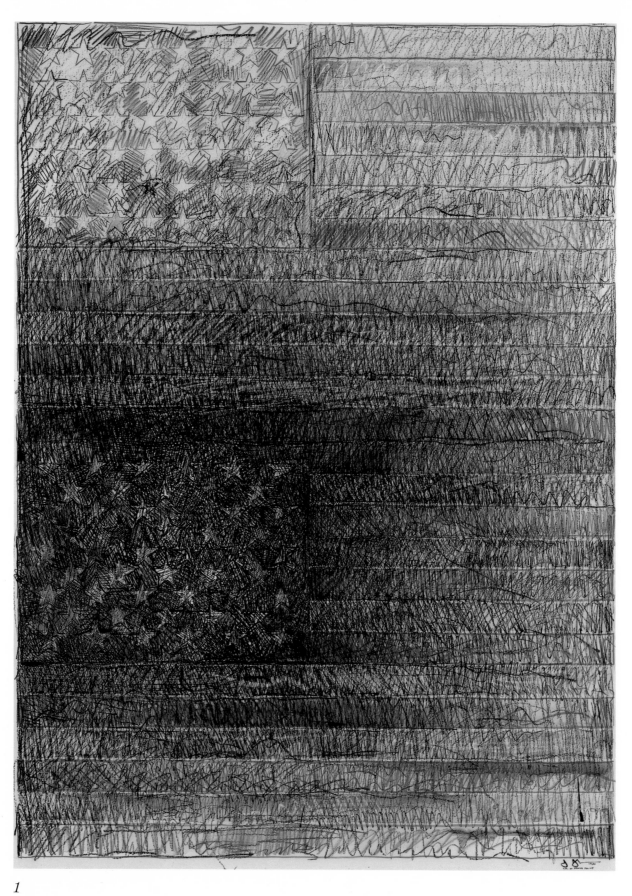

1

Two Flags. *1980.*
Ink and crayon on plastic,
40½ × 30".
Museum Moderner Kunst,
Sammlung Ludwig, Vienna

Introduction: The Hand As Voice

In Jasper Johns, the hand is a kind of voice. Where others draw persons, things, and objects, he draws intrinsicality. Each mark of Johns is a disagreement, a contradistinction, a modification of the mood. Johns' drawings are not preparations; they are perturbations. They do not so much study and organize as dislocate and unhinge.

Others think of drawing as a preface; Johns uses drawing as a turning point. His drawings are not epilogues to his paintings and sculptures and prints, nor do they innocently begin. Drawing for him is a visionary negative.

Johns has had a lover's quarrel with the real. He loves to differ and discover; therefore he draws. Where De Kooning is instantaneous, Johns is constant. Where Rauschenberg assembles and includes, Johns dismembers. In him, drawing is a suffix, an alternative, a prolongation of thinking by other means. Others think of drawing as an approach. Each drawing of Johns is a retrospection; spontaneously he draws in the past perfect.

Jasper Johns is a practitioner of the art of memory. The Romans memorized by associating ordinary things with the most vivid imagery. Johns' drawings use the imagery of a garbage can lid, a hinge, a hook, a thermometer, and place it in such a puzzling and poignant space that it cannot be overlooked. He makes the ordinary unfamiliar and somehow metaphorical. Thus the transition in a *Cicada* drawing, for example, from primary colors to secondaries, has been compared to the insect as it sheds its skin.[2] In Johns' watercolors, each aqueous pool is both a fact and an ambiguity of suggestive depth. He haunts us by his mastery of surfaces.

One of the problems for the criticism of Johns' drawings is the nature of his development. The quality of the artist's draftsmanship was assured from the 1950s in such works as *Flag Above White* (1957; plate 20) and *Flag on Orange Field* (1957; plate 22). The intensity of his marks and the certitude with which he juxtaposes washes, as in *Tennyson* (1958; plate 27), do not precisely develop from these amazing early works. What does occur, in a parallel to the maturation and evolution in his painting style, is an increasing experimentation with subject matter, some drastic experiments with skin tracings, a complication of subject matter with collage elements, and, in recent works, an efflorescence of the idea of color and its materializations.

The sense of early work is transgressed in Johns by the intransigent insistence of his early flags and targets. Of course, the artist's destruction of much early work contributes to the sense of sudden independence of these images. A work of enormous scale like *Diver* (1963; plate 67) seems to appear *ex nihilo*, and yet its concerns are linked to previous work. What is remarkable about Johns is the freedom with which he changes motifs, for all his well-known obduracy in repeating and remembering. The final effect is variety and not obsession.

Perhaps one formal way to approach Johns' development is to say that his early drawings

concern the analysis of monochrome and that his later work involves a constant synthesis of all color and line. It is true of his earliest paintings that they seemed to "solve" a color–line opposition by yielding to the public givens of color—red, white, and blue, in the case of the flag—and by the blankness of the schemata of the target and flag. But the early drawings are filled with a conflict and even a fury of line. In *Flag* (1958; plate 33) the lines inside the stripes seem ready to burst their confines and erupt into the field of stars. The later watercolors (*Cicada*, 1979; plate 132) indicate a fusion in which each line is a line of color.

Some of these solutions seem to tame Johns' expressionism, and yet some critics have noted an increased expressionism in such works as *Between the Clock and the Bed* (1981; plate 143). There is, indeed, this paradox in Johns' recent work. The advent of color dominance permits Johns another element of expression: the powerful use of secondaries and color dissonances. The use of a plastic drawing film as a ground, begun early, permits him disquieting effects of randomness. Linear qualities are no longer dominantly used as oppositional sequences, but the design is not one of false serenity. Johns makes his investigation of watercolor so analytic that it becomes an agitation of mind and eye.

One of the most useful ways to see Johns' drawings is as a dark affirmation of the palpable and the theoretical in an age that divorces the two. Claude Lévi-Strauss has remarked that in our epoch only food and writing remain expressions of undivided sensibility and mind. Technology divides us from the consequences of our perception: what we see outside the airplane window, for example, has no real bearing on our passage to a continent whose language we may not comprehend. In Johns' insistence on the act of drawing, and particularly in his putting individual marks upon public signs, we have a subversive conspiracy on behalf of wholeness.

Some critics have remarked on the blankness of his separate marks, as if they were intended merely as signs of the taking of space. But, actually, the early drawings are temperate compared to Abstract Expressionism. There are, however, violent indications of the personal as caught against the impersonality of the public design. In *Target* (1958; plate 25) in Conté crayon, we have an explicit symbolist rupture as if the target were only the premise of a personal dream. It is not that the personal is a good in itself—but that the artist affirms it in the context of public signs, where subjectivity might be so easily deleted, that is of interest. Johns' drawings are not fashionably part of the disappearance of man.

Johns may be thought of alongside his great precursor Albert Pinkham Ryder. Lloyd Goodrich speaks of Ryder as sweeping away "the dead wood of the older romantic school,"[3] and this is precisely the program of elimination conducted by Johns in relation to the romanticism of the older Abstract Expressionists. Even the thematic of the sea in Ryder is paralleled in Johns' *Diver* drawing and his watery pooled inks. Neither Johns nor Ryder troubled with long academic training. Ryder's obsessional working and reworking of the same canvas are recalled in the layered look of Johns' drawings and paintings and in his obsessional return to the motif.

Goodrich speaks of "the intimate poetry" of Ryder's early landscapes and farm scenes and their

relation to William Blake and Samuel Palmer.[4] Their strangeness in relation to colloquial subject matter is an analogue for the visionary way that Johns tonally traduces and transforms public icons. While public attention came late to Ryder and early to Johns, both are essentially hermetic in attitude and art. As Johns has drawn on literature and philosophy for an art that is not entirely retinal, Ryder was inspired by Wagner, scripture, and Romantic poetry. Above all, the fascination with monochrome effects relates the two artists, as Goodrich avers: "His [Ryder's] color was prevailingly dark, but with great depth and quiet richness. It was not remarkable for wide range; some of his finest effects were achieved in works that were almost monochromes, by the masterly use of closely related tones."[5] Ryder, like Johns, ruminated over "strange mediums" and turned to "wax, candlegrease" in attempts to achieve luminosity. Both Johns and Ryder represent extreme attacks on the degraded naturalism of their day.

The "Americanness" of Johns does not seem to be in question, since he is the man associated with the flag and beer can and the transition to a national "Pop" art of American clichés. His link with American still-life painters such as John F. Peto and William Harnett is continuous from the earliest drawing of *Coat Hanger* (1958; plate 31) or *Thermometer* (1960; plate 45) to the recent use of John Cage's music in *Perilous Night* (1982; plate 147). Johns is also linked to Ryder's darkness in what may be called a tradition of American darkness, an introspective heritage opposed to the Hudson River School of American light.

But too much can be made of the American theme. Johns is perhaps to be distinguished in his drawings and other work by an analytic that is not circumscribed by the national. He has been at pains to remove the sense of his early iconography from the political and has, after all, returned to a particularly abstract set of concerns, though he has not tabooed a new, concrete imagery.

To many, Johns' drawings come as the ultimate refutation of his relation with the affirmative painters of the Pop Art movement. The worst aspect of that movement was perhaps its relationship with the world of fashion, with its comfortable conventions and lies. Johns does not try to make danger glamorous, nor is he involved with the trivial novelties of fashion.

A drawing such as *Device Circle* (1960; plate 46) is at the furthest remove from any easy sense of populist or popular art. While such drawings are refreshed by a notion of factuality that comes out of American and European realism, out of Peto and Harnett as it were, and out of the demotic tendencies of Dadaism, it is also part of the drawing's goal to avoid seduction, to avoid the fashionable garment. The differences in his series of *Usuyuki*, with its complicated cylindrical structure, and of the *Cicada* series, are those that involve the viewer in an elaborate hunt exactly the opposite of the comforts and spectacles of fashion and the concealments of political cliché.

Max Kozloff speaks of Johns' conservatism, and not simply to underline his relationship with nineteenth-century techniques in Conté crayon and shadowing.[6] Johns' drawings, in their rigor and systematic antisystemics, refuse the sordid melodramas and expressionisms of the age. The flag may not affirm America; the target does not begin to trace a contest; the numbers defy quantity; the coat hanger is more superb than any peignoir; the map distinguishes no true country

from the dark ocean; the hand is attached to no obvious hero; the word is bent, shattered, cut, torn, scraped, and erased.

Johns has gone far along the road to a de-Platonized art. He has not taken art as subordinate to some kind of truth, but has thrown into doubt the very notion of truth and fact. He has then doubted the doubts. Johns' art is neither about absence nor a demonstration of inhumanism, as has been said. In his drawings he seems to meditate skeptically on the loss of these two distinctions. As the philosopher Richard Rorty has said of philosophy, such an art grows by emphasizing a whole new set of problems rather than by being plagued by the old, but it keeps its ironic force by assailing the old terms as no longer a privileged terrain.[7] Johns' art demands both enough allegiance to an older sense of reference to make for the feeling of a fight, and enough detachment from such a belief to make his pragmatic labyrinths useful. His art is, particularly in the late crosshatchings, profoundly disturbing if one is searching for illusionism and profoundly satisfying if one is satisfied with the blankly real. For those who need an art of sufficient skepticism, his drawings seem subtler and more consequential than any of his generation.

The aesthetician Arthur Danto writes: "Some interesting attempts in contemporary art have been made, pre-eminently, I think, by Jasper Johns, to collapse the distance between vehicle and content, making the properties of the thing shown coincident with the properties of the vehicle, and hence destroying the semantical space between reality and art. Needless to say, I regard all such attempts as logically foredoomed. . . . When *philosophy's* paintings grey in grey, are part of the artworld, the artworld has shaded into its own philosophy, and by definition grown old."[8] Johns' drawings reveal that he has always been fully conscious of the semantic "space" between reality and art. His work has always betrayed through touch the difference between vehicle and content. The very scale of the smallest flags betrays that they are "mental" images in intimate reductions of public monuments. His flags were never meant to be saluted. His tormented numbers with their smears and swipes are attacks on any logical utopianism about conflating art and reality.

The work of Johns comes not out of a formal desire to play and make cohesive, but out of the desire to entangle and disrupt. He teases the viewer in his meanings and in his sense of meanings; he ruptures space and line because he wants to underline the notion that unity is merely notional. The most unified of public icons is sought, only to be put under the doubt of chiaroscuro. Johns' forms of self-laceration are always precise and vivid and tough. Drawing is both the caressing of the icon and its deletion under a cloud of doubts, as in his 1980 *Two Flags* (plate 1). Johns opens and closes boundaries with ruptures.

Johns' work is an allegory of skepticism. After the pure immediacies of the Abstract Expressionists, both Rauschenberg and Johns restored a disjunct ironist mode to art. Rauschenberg worked on Dante's *Inferno* and transformed it into a melting pot of epic American images. Johns restored the commonplace to the enigmatic tradition of riddling allegory to create a didactic art of prudence. In this regard Johns' work may be interpreted through Angus Fletcher's early

researches on allegory as a universal mode.[9] From the beginning, Johns' work has been about the crisis of the *doubled vision*. If Fletcher is correct—that all allegory finally revels in the concealed, in the hidden god—then Johns may be thought of as the allegorist of the immanent, of the revealed world. The Cubists presented the shattered world—paraphrasing Robert Delaunay —broken, as the fruit dish of Cézanne. The target, as Arthur Danto has put it, is logically broken, foredoomed not to be itself.[10] The world of forks and spoons, the so-called real world of common sense, is revealed to be a balloon drifting as in the broken but real world of dreams. Johns' allegory is one of massive distrust, but a distrust so persistent it has become the opposite of contempt: an investigation.

It is possible to compare the unity of Johns to Marcel Proust in the coherence of plural signs. In Johns, as in Proust, there is an apprenticeship and a revelation by way of signs. According to Gilles Deleuze, in his analysis of Proust, "To learn is first of all to consider a substance, an object, a being as if they emitted signs to be deciphered, interpreted. There is no apprentice who is not 'the Egyptologist' of something."[11] Just as worldliness itself is found by Deleuze to be one of the first significant Proustian signs, we may say that Johns begins his own examination by means of signs of worldliness: the target, flag, and numeral.

Johns, like Proust, has forced us to think about lost time, as in his "devices" that present us with process as just another sign. Johns goes over and over the object, say the light bulb, to rid himself of objectivism and subjectivism and to search for truth. Deleuze has said that Proust's must be a violent truth, a truth that is forced upon us.[12] In Johns this is always so: even the wax casts of body parts have lost their sense of passivity and are scrutinized as by a jealous lover.

Much has been said of repetition in Johns, but perhaps Deleuze's sense of the need for the series and group in Proust will help toward a definition of Johns' profound employment of difference. The lover in Proust is driven again and again in a search for the "law" and the "essence" of his love. Yet he is always profoundly unconscious of this law and lives out the painful separation from it. Johns' difficult style, like Proust's, is to force an analogous apprenticeship upon the viewer, to make him into a reader of sensual signs. We are forced to look at the crosshatchings for the tiniest differences that are already the law of a single, pluralist work. Thus, repetition begins to be built into the structure of any single work as if to explode its unity. As Proust writes: "We shall need, with the next woman, the same morning walks, or we shall need to take her home in the same way each night, or to give her a hundred times too much money."[13]

Johns is always an embodying, material master. He has said that darkness reminds one of a sense of work: the hand has been there.[14] He reminds us of drawings as symptoms, as signs of the body without a reductive gestural expressionism. The emotions produced by these signs are ambiguous symptoms. They are not the emotions of a scrutiny of mechanical reproductions alone; they are the emotions violently produced by encountered signs in a search for lost time: double and triple losses of meaning. Because of Johns' skepticism, we are made to produce our sense of meaning violently and slowly, paradoxically, like the apprenticeship of a diver.

Edmund Bergler has commented in his psychological works about the fear of objects. One of the pertinent infantile confusions is that between inanimate and animate objects. We know that it is impossible for children to make this distinction, and much of Surrealistic charm and its theme of the uncanny is a play upon this confusion.

Johns' drawings are constantly confusing the realm of the animate and inanimate. The uncanny sense is that his light bulbs and ale cans are alive. Even his sense of the melancholy or dying object is a vivid way to play upon the archaic notion of the life in all things. The Romantics protested a mechanical universe by noting the pulsing value of the landscape. The late Romantic in Johns yields the uncanny spectacle of pulsing signs and symbols. Romanticism was a protest on behalf of value; Johns is directly attacking valuelessness, and with the very signs of value in flag and numeral.

James J. Gibson has evoked a beautiful image of two fliers. One is a novice who looks out into the visual field with nondiscriminating eyes. His lack of focus may be fatal. The other flier is experienced and knows exactly what gradients to make in gliding to a halt. His world is the same as the novice's so far as the retina is concerned, but he discriminates and divides that visual world more finely.

Many of our aesthetic difficulties with Johns may be resolved with this image. His distinctions have been called "hair-fine." He has created paintings whose very divisions may be overlooked by the inattentive viewer.

Johns' interest in Gibson's theories of perception has been underlined by Barbara Rose.[15] Gibson's idea of "masking" is one way of understanding the crosshatching in Johns' pictures. The pictures mask when they evoke a perceptual hunt because the structures are peculiarly camouflaged or contradictory or deficient in their information. The concept of masking is useful in dealing with the whole array of techniques in Johns for producing a perceptual hunt: *whiteout* in the early flags and *blackout*, too, being fine techniques for producing an effect on the perceptual system comparable to being lost in the Arctic or deprived of sensations by fog. Chiaroscuro reproduces those effects that men have come to love in the disorientations of atmosphere. The question remains of the *meaning* of an artist who tends to mask his structures.

Johns has spoken of the kind of completion he looks for in a painting that finally exhibits itself as autonomous. We might say that in almost all of Johns' drawings there is the blissful sense that much has been "worked out" but not into the state of completeness that Johns might look for in another medium. The fluid inks, for example *Disappearance II* (1962; plate 57), are filled with "aristocratic nuances," as Ellen Johnson has noted,[16] and these nuances are never labored. While many of Johns' drawings are extremely thorough and autonomous, they retain the sense of freshness traditionally asserted by the medium.

We may also see Johns' work in another framework, along lines suggested by David Rosand's sense of the tension between ideal and real in Leonardo.[17] Leonardo's obsession with transience, old age, and tumult in a storm is contrasted with his love of ideal beauty and form. Leonardo's

studies of floods and the apocalypse have influenced and intrigued Johns. Johns' work has made explicit the sign of death in his 1980 *Tantric Detail* (plate 138). There the skull is juxtaposed most shockingly with symbols of sexuality. His 1983 *Untitled* drawings (plates 149, 151) also disturb in this vein.

The tension between the real and the ideal in Johns may be evidenced throughout his work. The numerals, flags, and maps are not simply public signs but are peculiarly exempt from the pathos of change, although the artist himself has noted that even the flag has changed its stars.[18] Those signs have not always been seen as symbols exempt from transience. But we may say that it is part of the peculiar power of Johns' work to juxtapose body parts from the very beginning with an imagery, like that of the target, as eternalized, in a sense, as any mythological figure or ideal landscape. The target is part of Johns' play of the real and illusion, but the targets are complex objects because they can also stand in for what Rudolf Arnheim has referred to as "the power of the center."[19] The pathos of *Souvenir* (1964; plate 72), a drawing with reference to the artist's trip to Japan, is in its time-bound imagery. In general, a perilous balance is maintained in Johns' work between the real and the ideal. In some of his most recent work, for example, Grünewald's imagery of the Isenheim altarpiece contrasts with the Peto-like reality of a musical manuscript (see *Perilous Night*).

It is Cézanne who must be underlined as the central aspiration and inspiration of the artist. Johns visited a Metropolitan Museum of Art show of Cézanne in 1952 in New York and later made the following reference in his sketchbook notes concerning the painting *Watchman:* "Looking is and is not eating and being eaten. (Cézanne?—each object reflecting the other.)"[20] The emphasis here is on a kind of alliteration of the objects in a work. Further evidence of his interest in Cézanne lies in the fact that he once responded to a question of Roberta Bernstein and said he would have liked to have been Cézanne or Ludwig Wittgenstein.[21] She emphasizes both Cézanne's and Johns' obsession with familiar motifs, "objectivity and self-detachment" as values to both, and also what has been called the conflict between Cézanne's "sensuality and restraint."[22]

It is important to note that Cézanne, as William Rubin has put it, should not be deprived of his "conceptual" bias. Rubin mentions that Cézanne's *Bathers* was rendered not before nature but in the cerebrations of the studio. In his essay "Cézannisme and the Beginnings of Cubism,"[23] Rubin attributes the monochromy of the bathers to this studio origin. Their blueness he refers to as "anti-naturalist," and compares this with the *symbolistes* and early Picasso. It is fitting, then, that Johns should also choose to render Cézanne, but from a postcard (plate 129). Moreover, Rubin insists that Cézanne worked from photographs and conceptualized his very distortions, distortions that he argues should not be read as merely perceptual. Johns' 1969 drawing *According to What* (plate 98) is very much a part of this line of Cézannisme: antinaturalist, conceptual, with distortion for the sake of structure.

Johns and Cézanne: both meditators on the problematic of part and whole; both observers of observation itself and resentful of the excesses of decoration. Johns' imagery of skulls and

testicles disrupts decorative crosshatchings and has a pressure of ambiguity that constantly vexes an explicitly lyrical abstraction.

In both Cézanne and Johns we find what Meyer Schapiro has called the minimal will to power.[24] The watercolors of both have a rare tension of delicacy and determination. In the last decade, Johns' use of primaries and secondaries on translucent plastic must be compared with that supreme achievement of Cézanne's late pastorals. The crosshatchings are always regulated, never intuitive. Both artists were wisely passive to nature, in Johns' case the shadow of nature in body traces and symbols made liquid by the hand. In both, Poussin's homage to the geometric and an elegy to all sense of experience as primary regulate their art. Both mastered an early expressionism and won a largely autonomous abstract art that is paradoxically public, realistic, and revolutionary.

In both Cézanne and Johns there is an unresolvable tension between depth and flatness. It is impossible to view Cézanne's work as merely a matter of dogmatic flatness. Yet it is part of the curious history of Cubism's dogmas to link Cézanne with the history of the increasing flatness and literalism of the picture plane. However, Cézanne and Johns render depth ambiguous by what Bernstein refers to as "broken outlines,"[25] in Johns a technique observed in his *Figure* drawings (plate 65). Bernstein also adduces Leo Steinberg's sense of the relation between Johns' brushstrokes and those of the French master: "Johns' brushstrokes don't blend; each makes its short shape distinct in tone from its neighbor. That is the way Cézanne used to paint, in broken planes composed of adjacent values imparting pictorial flatness to things the mind knows to be atmospheric and spatial. Johns . . . does the reverse, allowing an atmospheric suggestion to things the mind knows to be flat."[26]

Now we see the importance of the dark aqueous inks in Johns' looser works of the 1970s. They are the mature monochromatic opposition to Cézanne, something Bernstein analogizes on the order of Cézanne-blue, Johns-gray. This equation has to be partly changed in order to understand the explosion of primaries in Johns' recent *Usuyuki*, *Cicada*, and *Corpse and Mirror* crosshatchings. Bernstein is perceptive in speaking of both artists as masters of discontinuous, de-Platonized time. In them, "imperfection is the summit," as the poet Yves Bonnefoy put it in a marvelous paradox.[27]

One of the subtlest analyses of Cézanne by Meyer Schapiro uses the insights of a demystified Freudian approach to find in Cézanne's apples an erotic imagery filled with a characteristic emotional physiognomy.[28] We may say that Johns' drawings make the same claims on our sense of the eroticized object, as in *Thermometer*, long before *Tantric Detail* made the sexual metaphor so explicit.

We choose to link the wide-awake draftsmanship and cerebrations of Johns and Cézanne. In this direction, the artist furnishes some intriguing proofs. He spent much time at the exhibition "Cézanne: The Late Work" at The Museum of Modern Art in 1980 and before that traced—a rare homage for Johns—a postcard of the great *Bathers* (1900–1906) painting that hangs in the

National Gallery in London. On plastic in his most seductive inks, this tracing is a full quotation. Johns has paid homage to many givens, and among his gigantic precursors he has literally taken and parodied or alluded to a few: Duchamp, in *According to What* and elsewhere; Picasso, in the lithograph *Cup 2 Picasso* (1973); Grünewald, in *Perilous Night;* and Edvard Munch, in *Between the Clock and the Bed.* But to Cézanne he gives constant homage.

Cézanne's desire to make Impressionism into something durable as the museums is something we repeat all too formulaically. Johns' desire has been the transformation of Abstract Expressionism into something solid and monastic and menacingly flat while retaining the broken space and discontinuous draftsmanship of expressionism.

As for other precursors and peers, Johns has been very generous in his representation of the value of Rauschenberg as a fecund influence. If one looks at Johns' drawings as the region of the personal, the graphological, one might miss the dynamic of the collective or shared or conspiratorial sense of style. Here let it suffice to bring out what is sometimes missed in studying Johns' drawing merely as intimist refrain or symbolist nuance. It is not that themes and treatments derive from one or the other artist, but that by observing them in a system one notices otherwise invisible aspects.

Rauschenberg's blueprints of the human figure made with Susan Weil in 1949 remind us that both Johns and Rauschenberg have had a representational rage, always, and both have emerged with images, however spectral, skeletal, and estranged. Rauschenberg's *Automobile Tire Print* (1951) is a gesture toward the real that is analogous to Johns but much more theatrical. One senses comparatively how Johns has reduced the grandiosity of the events that might precede painting, and the physical event is usually sublimated in favor of the cerebral. Rauschenberg's early black-and-white paintings are important analogues to Johns' work in eclipsing forms. However, in most of the work of the 1950s, Rauschenberg's urge seems willfully inclusive, antisystematic, and affirmative. His quotations from the imagery of the past, present, and commercial art make these seem the apotheosis of what certain critics call Post-Modernism. Johns makes use of quotation, too, in his use of clichés and conventions, in drawing and painting, but the tension of system is more evident. The delicate transfer drawings of Rauschenberg in ink, pencil, watercolor, gouache, crayon, and other mediums suggest the play in Johns of montaged textures. Rauschenberg is a master of dissociated skeins and abrupt images as Johns is the master of concentration and a clear darkness. Rauschenberg's early collages with found material are echoed in Johns' use of newsprint and the collaged drawings with objects (plate 103). In Rauschenberg the attempt seems to be to make a Whitman-like catalogue of resources. In Johns, each part of a reasonable catalogue is scanned and doubted, weighed and measured in antimetaphorical draftsmanship.

Johns' drawing may be usefully compared with Redon and Ryder, and also with the neglected artist Walter Murch, whose slow Romantic renderings of machinery parts are an interesting analogue to Johns' works. In Murch and Johns, it is as if Dadaist machines had been rendered with

less preciosity and impersonality. In Redon, Ryder, and Murch, as in Johns, we are given that luminous opacity that Barbara Novak speaks of as a layering of thought.[29] This emphasis on layered traces that are never fully erased is part of the theme of *Night Driver* (1960; plate 49) and the early targets of the 1950s. It is part of current French philosophy to insist that such painting breaks with a tradition that sees significance only in the object, not in the traces toward and away from the object. In a sense, all of Johns' drawings are most concerned with tracing, tracing from an object hermetic as *The Bride* of Duchamp, tracing from Grünewald, tracing from Cézanne, and from the artist's own hand. It is not that an object is merely affirmed or echoed. The theme of the drawing is the impossibility of a complete presence or erasure. Rauschenberg erased De Kooning, but Johns, as it were, underlined the imprints that remained and framed those traces. It is the complexity of Johns' sense of the trace that divides him from his influences.

There is a kind of precedent for Johns' use of lettering found in Willem de Kooning's work. De Kooning once told the artist that the difference between them was that De Kooning was a house painter and Johns a sign painter. De Kooning had also worked as a sign painter. Thomas Hess notes that De Kooning "studied lettering at the Rotterdam Academy" and that many of the 1930s abstractions began with simple words that were slowly eroded or slashed out. "Letters are part of the landscape-still-life-drawing details strewn over the picture as clues. . . ."[30] While some of these words were emotionally connotative—"RAPT" and "ART"—Hess comments on the nonutilitarian bias of De Kooning: "The letter, freed from any duties, is a shape that is perfectly familiar and perfectly new." But De Kooning was "unalphabetic" and used the antisystematic to refer to the integrities of experience. Johns resists a too fluid formlessness by returning to the alphabet (see *Alphabets*, 1957; plate 19) as an object fit for drawing and fit, too, for humorous elegiac collage. But it is a mistake to think of De Kooning and Johns in oppositional anxiety; they are both masters of drawing as thinking. Johns uses the alphabet to meditate on completeness. He has said that he does not prefer centering as a compositional device, but prefers the image to occupy the whole space.[31] His collage alphabet desolates by the way it isolates each part of this difficult whole.

There is a play of illusion and disillusion in Johns' work that is perhaps best explained by the work of the child psychologist Donald Winnicott. Winnicott hypothesized that the child receives one of its far-reaching models of experience when it longs for the mother's breast and receives it, through no action of its own but the simultaneous goodness of the mother. The child is forever tensely concerned with the differences between inner and outer realities, and it will find in the world of dolls and other "transitional objects" ways to mediate these tensions.[32] In Johns we even have the sense of a mother's face and breast in the motif of a target with four faces, but this is a crude analogy compared to the constant play in Johns as to whether an artist can truly construct reality. One of the reasons for the power of his drawings is the way Johns seems to mesmerize the observer into the belief that the Other may be summoned by an act of will; and yet the maturity of such art is that it confesses simultaneously to a factual separation. In Johns' art we find the most

strenuous maintenance of the contradiction of illusion and disillusion. Each motif—ale can, Savarin can, target, alphabet— is part of a process by which the artist explores the space of this contradiction. Some drawings emphasize the hallucination; others the desolate facts; a precarious balance is found in the best.

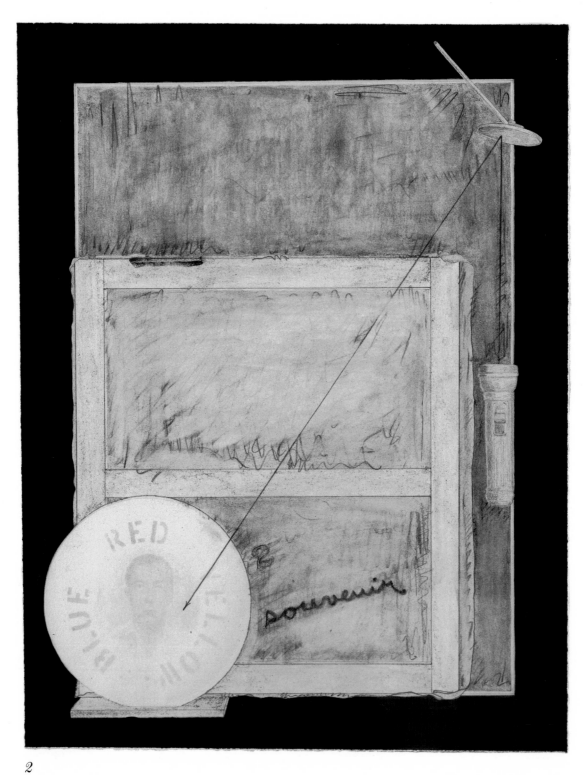

2

Souvenir 2. *1969.*
Graphite, ink, and watercolor
on paper, 17¼ × 13⅝".
Collection the artist

The Drawings: Encountered Signs

Jasper Johns distinguishes himself from other artists by almost exclusively drawing *after* the motif has been rendered in painting or sculpture. Very rarely has he made studies, and his sketchbook is filled to a great extent with written notes. Some studies exist, for example *Study for "Painting With a Ball"* (plate 29), and these often have the finish of complete works. In most cases the drawing is a meditation on a detail of a work in another medium, as in *Perilous Night*, or a kind of quotation of the whole, as in *Between the Clock and the Bed* (plate 146), *Target with Four Faces* (plate 142), or *Three Flags* (1959; plate 39).

Thus Johns' drawing is a kind of complete memorial, or a memory with a new perspective. In graphite, ink, and watercolor, *Souvenir 2* (1969; plate 2) softens the sense of reminiscence from its original presentation in 1964. *Ale Cans* of 1978 (plate 3) in ink is a tribute to his sculpture and a tribute also to the plastic surface he has often used. In some cases there is no source for the motif, as in the earliest, almost illegible *Untitled* pencil drawing from 1954 (plate 11). Color has been important to the artist from the beginning, and not simply tonally, but in the strange greens of the 1956 *Green Flag* (plate 17). His mastery of collage is evidenced in the broken field of letters in the 1957 *Alphabets* (plate 19) and in the use of different "levels," as in the 1960 *Three Flags* (plate 48). But we may think of an *essential collage* in his changes of textures within one work, as in the differentials of chalk, Paintstik, watercolor, and oil in the 1975–76 *Corpse and Mirror* (plate 4). One motif will be sought again and again, as in *Land's End* (1977; plate 122) or *Periscope* (1977; plate 121), in different mediums. In some cases, like his 1962 studies for *Skin* (plates 59–62), the drawing is most supremely autonomous and becomes the subject itself. But even in a humorous sport like *Scott Fagan Record* (1969; plate 88), there is sufficiency and grace.

A chronological survey might begin in 1954, when there are drawings with only the barest hints of indeterminate circular objects limned. The artist told Lois Long that some of his earlier destroyed works contained still lifes of potatoes and such objects.[33] By the time of his early *Flag* drawings (see plate 14), one large symbol prevails, but is nearly eclipsed by darkness.

Johns has always questioned the notion of unity, and his work is ironically unified by this investigation. His drawing from 1956, *Figure 1* (plate 15), is a delicate presentation of this question. Like *Target* (1958; plate 25) in Conté crayon, this pencil drawing is Redon-like in its reticent contours. The number lies on a whitened maze of strokes, and it casts a shadow to the left. It looks like a miniature obelisk on a very precarious base, but all of the shadowing cannot disturb the irony of its flatness. Shaded by such ambiguity, it is an integer that lacks all integrity or, at the very least, questions all integrity.

Like his earliest drawings of 1954, *Tango* from 1956 (plate 18) seems an avoidance of all stability. In the painting *Tango*, Johns joins music to painting. This synaesthesia, or the linkage of

the senses, is alluded to in the drawing by the cornered title itself. The floating world of a popular dance of intimacy is rudely juxtaposed by a very impersonal tangle of lines. In some artists synaesthesia is a way of distorting or throwing off balance; in Johns, here as in *Perilous Night*, where a musical score is represented, the appeal to different senses is a pointer to desire and its fulfillments. As Frank O'Hara wrote, "Grace to be born and live as variously as possible."[34]

Each drawing by Johns is an homage to variety. He manages to wrest this variety even from the stern singularity of an alphabet, as when, in his collage of 1957 (plate 19), each letter is given a distinct facture as part of a keyboard of "tones," reminding one of the Rimbaud poem linking letters and colors. The delicacy of this collage fabric and its variety link the early Johns to Joseph Cornell and his toylike constructions. Johns is capable of making the flattest topic into something as penetrable and hermetic as a box.

In *Flag Above White* (1957; plate 20), the pencil emits sparks. In the closest monochrome, the artist is capable of an almost Islamic precision in the creation of color. The flag itself and its territory of white are mounted with the physicality of collage. Literal marks go beyond this flag. The *Target with Four Faces* (1955; plate 13) has this sense also of charcoal moving beyond frames, a probabilistic extension in color. Marks go beyond the boundaries. In *Flag Above White*, tiny marks glisten and make the flag an all-over darkness, but the stars are evident. The whiteness is exaggerated as an erasure (perhaps) of another flag. This raises the possibility of a double erasure. The white is like an experiment in sensory deprivation. We have a contrast that is not usually evident in a tonalist: dramatic drawing because the darkness is so evidently opposed to its white partner. And the grain of the paper is extraordinary in its intimacy. Marks in the white region lead us to suspect erasure. The main topic throughout both drawings is the opening and closing of boundaries through erasure.

Johns has a sense that his images of common objects are regulated by an idea, if not an ideal, as in his comments on a search for the true, universal flashlight: "I had this image of a flashlight in my head and I wanted to go and buy one as a model. I looked for a week for what I thought looked like an ordinary flashlight . . . and I finally found one that I wanted. And it made me very suspect of my idea, because it was so difficult to find this thing I had thought was so common."[35]

This sense of the ideal in Johns illuminates many of the drawings afresh. *Flag on Orange Field* (1957; plate 22) no longer appears to be a formal maneuver in situating the flag in a space not entirely congruent with its self. The flag now floats as a detached form in a landscape of changing marks. (Is the ambiguity here that the drawing reads as a portrait of a fluctuating flag in a large and idealized field? It is not for nothing that Johns loves the famous Gestalt examples of double readings.) One way to mark the skepticism toward the ideal is to see the *Green Flag* (1956; plate 17) as an attack through color on the public icon. In this sense, Leonardo's description of a public space inundated by the deluge may not be such a far-fetched analogue, because here as elsewhere Johns is eclipsing form with a turbulent overlay.

An extraordinary *Flag* of 1957 (plate 21) presents one with a *via negativa* in drawing. It

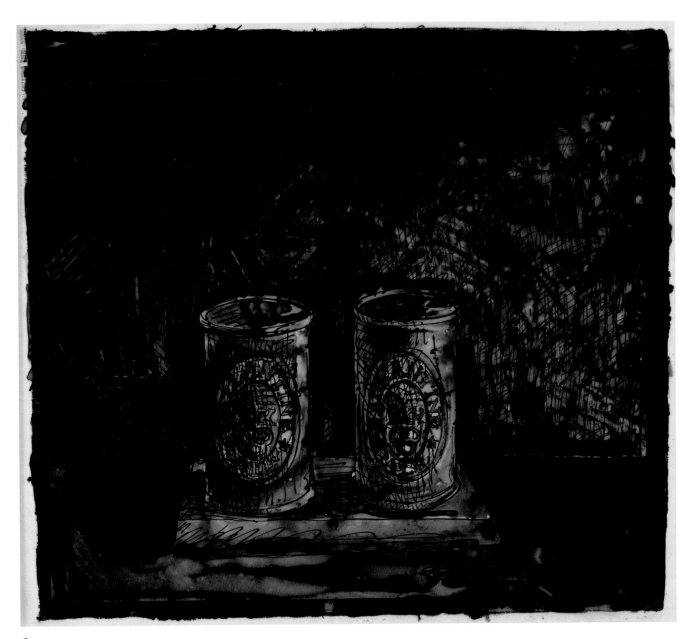

3

Ale Cans. *1978.*
Ink on plastic, 14⅛ × 16".
Collection the artist

reminds one of Ad Reinhardt, almost, and his list of *caveats*: Not this, not that. Johns has erased the flag with this overload of darkness. The emblem has been divorced from its significance. And what is palpable is that this negative way is not directed for mystical purity.

The highly metaphorical *Target* of 1958 (plate 25) in Conté crayon has been compared by Max Kozloff to Redon's mystical portraits of eyes.[36] The target yields evidence that Johns is distinguishing between the conventional sign and its deautomatization through art. Art incarnates. Johns does not so much mask or eclipse the target as remodel it to become an animate eye. Where elsewhere he has made an electric and white target through overlaying an incessant tangle of bright "negative" marks, here the target becomes a Romantic spiraling into an interior. One could say that this miniature is the intimate precursor for the *Spiral Jetty* by Robert Smithson. There is a beautiful stabilizing effect of the arc at the bottom of the outer rim of the target.

One of the rare studies, or preparatory drawings, of Johns is the *Study for "Painting with a Ball"* (1958; plate 29), which shows the possibility of a vertical arrangement of the central slit. The single ball then becomes closer to Johns' imagery of circular object and target. One does not approach this drawing for the mere pleasure of watching an initial decision. It is not a witticism concerning canvases pried open; it is already a sexual *Tantric* detail and a kind of carpet of contingent crosshatchings.

The melancholy of *Tennyson* (plates 27, 36, and 83) in its various states (1958, 1959, and 1967) has been much remarked upon, as has the sense of disjunction in the floating name. It should come as no surprise that the Victorian poet is of little help here, unless it is for the anecdote in which he goes into a trance by simply reciting his own name. The recital of any name, any Tantric detail, as it were, becomes a kind of linguistic mandala. But in Johns this leads to no pantheistic bliss, only to the difficult knowledge that we are essentially cut adrift. Just as in his early painting *The*, an abstract field with the title word below, reminding one of Wallace Stevens' conclusion to "The Man on the Dump" ("Where was it one first heard of the truth? The the."),[37] here again we must deal with the word as it floats in comical divorce. It is the central act of modern poetry to make that divorce, between signifier and signified, most palpable. And in Johns the bachelorhood of the word is inviolable.

What moves us so in the drawing *Coat Hanger* (1958; plate 31), and why is this not simply a *trompe l'oeil*, a repetition of the still lifes we know in Peto and Harnett? In Johns we may recall the philosophical doctrine that meaning is use, that the meaning of a word is its employment. What happens to the word that is unemployed or useless, what happens to the unemployed object? The word for its own sake is analogous to the tool for its own sake—it sets up vibrations of a kind of non-sense. The coat hanger has become a sign of all the isolated and superfluous individualizations of the world; and it floats on its field of dark, labored strokes that make a mockery of its clean uselessness. Here we have a kind of agoraphobia of the common object. Johns is like a man who has stayed in the dark long enough to make out a glimmering piece of stability. *Coat Hanger* has the dignity of ordinary language but the hanger's odd lack of employment makes

it and its context an extraordinary new language form. This picture of unhappiness is not a game; it is more like the sustained cry of the particular.

How subtly Johns breaks or ruptures space is shown by the way in which his marks betray perspective. Bernice Rose notes that the *Three Flags* of 1959 (plate 39) reverses classic perspective by using the longest strokes on the third, largest, and seemingly most distant flag.[38] The most melancholy aspect of this drawing is its all-over neutrality and conventionality, as if even the private gesture had been reduced to the zero degree. Something aberrant remains but is imprisoned by signs.

Out the Window (1960; plate 41) is a dynamic work in charcoal and chalk and shows a new confidence on the part of Johns. We sense this confidence in *Reconstruction* (1960; plate 40) of the same period and in *Jubilee* (1960; plate 42) in the vigor of the marks and the lack of philosophical detachment of subject matter. Meyer Schapiro has commented on that moment in Picasso when the self-enclosed figures of the Blue Period give way to the lifted arms and exteriorizations of the more mature artist.[39] We might say that the zones of color-words, with their short bursts of high contrasts, are already a maneuver out of the more "symbolist" and emotive early objects. While the color-words are in a sense also unemployed and meaningless in their divorce from appropriate color, the whole investigation is carried on in a state of confident turbulence. While Johns is always capable of expressing the most vulnerable and melancholy of modes, as in his 1960 *Thermometer* (plate 45), with its reference to the difficulty of all true measurement, his drawings of this period are capable of showing most directly one of his central concerns: the rage for the real and the true as it is distorted in everyday oblivion. The dark color-words and their divorce from their meanings are drawn by a man who despises loose invention and is suspicious of all gossip.

Measure and measurement are a kind of obsession with Johns as they were with Wittgenstein, who dreamt of the ideal ruler or measuring implement. The *Thermometer* drawing is a dark representation concerning the difficulty of representing and dividing. It is a comedy on the feverishness of expressionism. It is also a symbolist and synaesthetic homage to artistic ardor, unmeasurable, as the numbers on both sides of the thermometer are eclipsed. It posits the dream of a universal thermometer that has proved as elusive as any other particular in an art that puts all inside quotation marks. Ezra Pound asked for a squirrel that would be nothing but "that goddam squirrel."

Johns' *Device Circle* drawing (1960; plate 46) is extraordinary in its combination of factuality and what Max Kozloff referred to as the "obfuscating" tendencies of the artist.[40] Nothing could be more direct than the image of the stick and its swath through a circular field; and nothing is more affirmative, perhaps, than the device of the title itself in dark free-hand lettering: "Device Circle."

The Russian formalist Viktor Shklovsky is known for his dictum that art consists in the laying bare of devices, the sudden revelation of the art-making process itself.[41] In *Device Circle*, one might say that there is a paradox of such revelation and concealment. In an action painting, the device might indeed have been a demonstration of the reality of process. In this drawing, in no

27

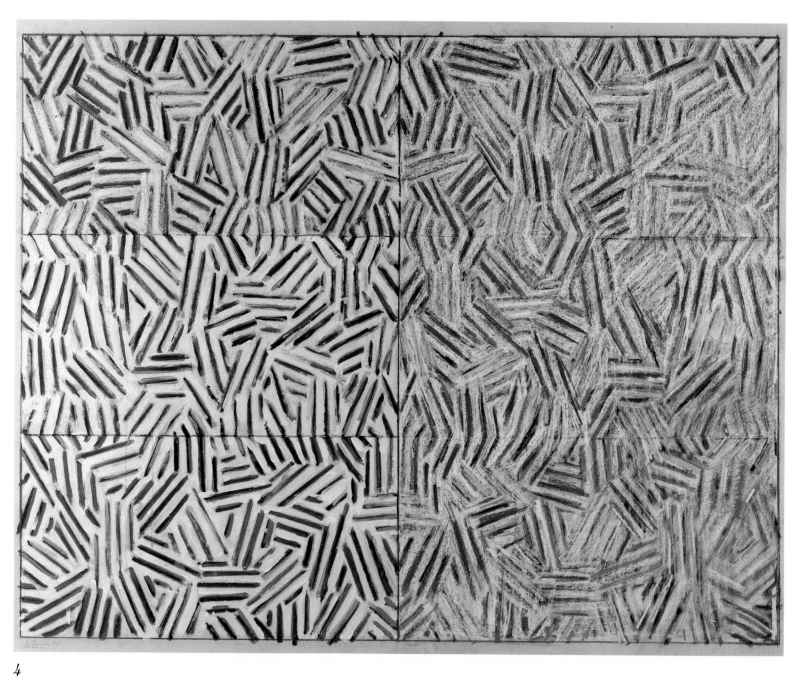

4

Corpse and Mirror. *1975–76.*
Chalk, Paintstik, watercolor,
and oil on paper, 37³⁄₄ × 48".
Collection Donald B. Marron

way preparatory, we have the bizarre trope of showing the devices naked and in such shadows that our sense of modernist freshness is both satisfied and appalled. These circles are broken, even when most whole; the *Device Circle* title is shattered like the fruit dish of Cézanne. If Sidney Tillim was once dismayed that Johns was painting metaphorical apples in his numbers rather than the real, here once again there is an uncanny confusing of boundaries. If Giotto announced himself by the drawing of the perfect circle, Johns advertises the defeat of all such circles of containment.

The critic Nina Sundell has likened the draftsmanship of Johns' paintings and drawings to each other and found the drawing of *Night Driver* (1960; plate 49) as "amply developed" as any painting.[42] Interestingly, she speaks of *Night Driver* as "all surface," whereas one might paradoxically say that the constant superimpositions make it a work of depth exerted against surface. She also notes that it is the torn papers of the large rectangle and smaller rectangles that create a palpability that is not merely atmospheric. She notes the predella-like aspect of the squares, tinged with yellow and red, though they are also the colloquial images of a taillight. For Johns, then, it is the way of making the profane into something as sacred as an altarpiece, as later he will make the Grünewald tracing into something as illegible as mere patterning. With the extraordinary richness of sudden lines at contingent angles, this drawing summons for Sundell what "one experiences looking into darkness through glass."[43]

There are more than two ways of interpreting a drawing such as *Night Driver*. One might say that *Night Driver* offers nothing but a formal series of lines, horizontals, the small squared compartments, and in more than one sense, a field of free play in which there is no referent.

The "Night Driver" in Johns' drawing is a truly nomadic decentered visionary without a vision. The phrase "Night Driver" is seen by Sundell as lending "resonance to the image . . . [but] not a part of it."[44] Why should the words be any less arbitrarily juxtaposed than any of the glints of gray chalk? This 1960 work, like the black works of Rauschenberg and the graphologies of Cy Twombly, is our most patient analysis of multiplicity. The conventional signals are traduced or veiled, and as Sundell notes, the artist does not so much furnish an image as cover paper, anti-hierarchically, contingently. Horizontal lines imply a rudimentary grid, but the idea of the whole and such geometry is scratched and torn.

Look at the figure eight and the zero from *Ten Numbers* (1960; plate 52). On the one hand, this eight is a mark of infinity, with a spiraling sense. But here we have the depth, or abyss, of color. The eight is bounded by neutral marks. There is a cut at a sculptural unit, cut out of the ground; there is the tear that one feels in the marks that abrade the surface; scraping and erasure effected throughout while achieving a boundlessness to the lower loop of the eight. The eight merges with the ground through erasure and scraping. This is an explosive eight, now a symbol of finitude.

Johns has made his zero most alive, most tumultuous. Here we are reminded of the lesson from Hegel: there is no such thing as a nullity. The zero is framed and becomes a colorful picture of sensuous eruption past stenciled devices. There is no simple framing. The zero that explodes, a zero corroded by the cutting, tearing, scraping, and erasure of the artist. What could be more colorful than the grays and whites of this zero?

The use of the handprint in Johns' *Study for "Skin II"* (1962; plate 60) is an example of the ambiguity of the sign. It is an impression and a proposition about doubt. If there were ever an easy armchair of a serene Matisse-like draftsmanship, it is not here. Here all is agitation and smudge and correction, and not correction toward a final serenity, but correction toward the next species of corrigibility. From the earliest drawing (1954) of an almost entire tohu-bohu, to the early black flags, and through to the configuration in *Perilous Night* (1982), one constant in Johns' identity is a suspicion of rest. *Study for "Skin II"* is also a conscious attempt to think about the act of imprinting, printing. The most outrageously fastidious and conscious drawing is engaged in fastening to "ordinariness" some extraordinary notions, tones, nuances of doubt.

The four *Studies for Skin* (plates 59–62) are, in effect, preparatory studies for a flat rendering of an entire head in bronze. Johns smeared his own body in oil and applied "himself" to the paper. Then charcoal was applied and it took only to the oiled impression. In these shockingly real traces of the body, we find the pathos of the drowned figure in *Diver*. The doubled pair of hands in *Study for "Skin I"* seems to be an attempt to escape the picture plane. In *Study for "Skin II,"* the hands are placed in rotation, as if they are en route to becoming a mere device. In the 1973 *Skin I* (plate 109) and *Skin II* (plate 110) the drawing is almost completely darkened by the body and something genital and smoldering has been created by the simplest of means. Sometimes compared to Yves Klein's canvases in which a nude model smeared with paint was dragged across the surface, Johns' works are more rigorous and self-lacerating analyses.

The polarities of Johns' drawings are extraordinarily tensed and as often as not glimpsed within a single work, for example the tracings and impressions of a shoe and shell in *Edisto* (1962; plate 56). These two images, the darkly outlined and shadowed sole and the ghostly shell, are as far apart in technique and tone as a Surrealist juxtaposition. They are also souvenirs of the locale summoned in the title. All of this local factuality and tracing contrasts with *Disappearance II* (1962; plate 57), in which ink on nylon film gives the Mondrian-like refusal of all objects. And yet *Disappearance II*, which seems to mark the absence of subject matter, is still based on the self-reflexion and the broken space of composition, and it would be absurd to deny that this is as "realistic" as the shoes and shells of memory. This is particularly true for an artist who uses his own skin as a device and who employs simultaneous numbers as a metaphor for mental contradictions and confusions. *Folly Beach* (1962; plate 64) is a confident conclusion of such investigations, where zones of the color-words Red, Yellow, and Blue are based upon a simultaneous beach of all such color-words superimposed. Johns contributes a neologism to drawing by the Cubo-Futurist device of layering language like a color. To call such a neologism "abstract" or "real" points to the artist's rupturing of such false boundaries.

The small drawing for *The Critic Sees* of 1962 (plate 63) is a reprimand and an homage to all mediators. The usual response to art is mere chatter, false gossip, distortion without knowledge. A person looks intently at a picture for a long time, gets up, and, discovering its maker, looks no more: the lazy connoisseur. Johns is an artist discouraged by such trivializations of perception.

What makes this drawing so acute is that the mouths are presented as languorously precise as possible. Thus the sarcasm becomes softened and the whole becomes more like a monument to the similarity between looking and any oral possession: a metaphor explicitly examined by the artist in his sketchbook notes on *Watchman*.

Wilderness II (1963; plate 66) is a true replica of states of mental contradiction. A cast of a hand holds a rag inside its own small rectangle; a brush dangles in a field marked by the imprint of an ear and a hand. Below, a ruler lies as if to measure the whole space of this difficult fiction of a studio. Johns practices a form one might call "critical drawing," since it entails a presentation and analysis of every form of smudge, mark, and relic that one can use to shatter the usual perspective. There is a desire to make this slovenly wilderness precise and conventional as a ruler.

The drawing *Diver* (1963; plate 67) succeeds in being a masterwork that is greater than the painting of the same name. Though the painting is an explosive and furious work with other images, no one, I think, would argue that the condensation of the drawing is not the most provocative expression of Johns' great motif. A figure, cut into the schemata of his hands and feet, is seen either drowning, reaching, or diving across the picture plane. The hands and feet in *Diver* describe both an action and a memory in foreboding, dislocating space: two feet at the top of the tremendous page and four hands connected to each other by a smeared corridor where arms might be and two directional arrows. The proposition here might be like Wittgenstein's "If you do know that *here is one hand*, we'll grant you all the rest."[45]

Diver in its sense of scale is perhaps even more monumental than the painting, which is the largest, as Bernstein suggests, of the group of personal works of struggle and pessimism in which it is located.[46] There is no need for cast objects in the drawing, since Johns' shadows are so ferociously ambiguous. The range of painted hues is also not necessary in the drawing since he can make of darkness such a complete kingdom. Instead of the many panels of the painting, the essential split in the drawing is suggestive enough of the shattering of personal unity. Instead of shattered and fluctuating color-words, we are given something more cruel, the over-all blackness of this sea-bottom of a picture frame with no title but the name of its form of suffering: "DIVER."

Bernstein has indicated that *Diver* is the tracing of a swan dive, and that Johns is in a sense performing an Eadweard Muybridge on the successive stages of this physical act. On the painting she writes: "The upper handprints could correspond to the initial stage of the dive, where the feet are together and the arms are resting by the diver's side . . . and the lower, to stages where the hands are together. . . ."[47] Bernstein also delimits the arc as the stage of the leap and the spreading of the diver's arms. She compares it with the anxious isolation of Cézanne's *Bather with Outstretched Arms* and with Hart Crane's suicidal jump into the sea.

With stains of red dripping next to and on the fingers of a hand, *Diver* is a work of immense agitation and horror. Body parts split open suggest the most intent paranoia and dissociation. One is not exaggerating to see this work as a furious lament. Johns is quoted elsewhere by Bernstein: "Art is either a complaint or appeasement."[48] Here there is no peace. C. G. Jung told James

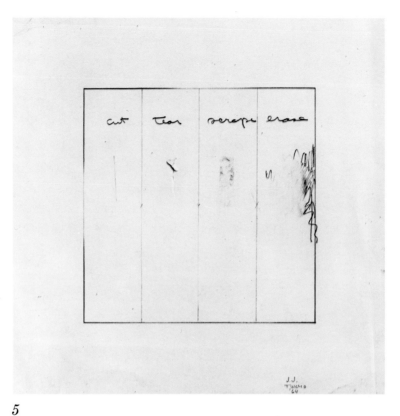

5

Untitled. *1964. (cut, tear, scrape, erase).*
Pencil on paper, 11¼ × 11¼".
Collection the artist

Joyce that the artist was diving whereas his schizophrenic daughter was drowning. The acts are thus differentiated, and one must note the careful control of Johns in expressing such a leap into the eclipse of forms. If the sense of all-pervading unity in mysticism comes from an echo of the paradise of the mother's breast, this picture is a nightmare of the split-off, the bad object, the body torn apart.

Diver is a drawing that in its scale and its physical warm luminosity is as grave as sculpture. Nothing is more theatrical than the suicidal gymnastics implied, and yet nothing is more contemplative than such an act; nothing in drawing seems to be more profoundly in scale addressed to the beholder and yet needing no sentimentality or evasion to be seen as a literal object. It is palpable form, filled with all the possibilities of art.

A little piece of physicality is the drawing *Untitled*, 1964 (cut, tear, scrape, erase) (plate 5). A savage cut; a tremulous tear; a scrape and an erasure of Johns' neutral marks. This gives a sense of all the Johnsian motifs. For instance, the arrows in the drawing *Voice 2* (1982; plate 10) are themselves a kind of cutting; the erasure is a constant of the overlapping inks; scraping is part of

32

the sense of *Device* (1962; plate 55); and erasure is both a rubbing, an illegibility, and physical labor of overlay. Even in the *Usuyuki* drawings, thin lines are cuts or cutting; one can see the tear as another way of creating a biomorphic line. A scrape is another way to think of the physically abraded and abrading line, and erasure is another form of physicality.

In the drawing *Untitled*, the four processes—cutting, tearing, scraping, and erasing—are all negative, lacerating movements. The acceptance of the given, the flag, the target, or numeral, which might seem passive, now might seem the beginning of a strategy to lacerate, humiliate, or desecrate. Johns' attitude, however, seems mostly to find an Olympian multiplicity that would not contain an easy emotional attitude toward aesthetic procedures.

To my knowledge no one has compared the iconography of *Watchman* (1964; plate 74) to Kafka's parable of the watchman, *At Night*, which is a revelatory analogue of this drawing. Kafka's story reveals the nightmare concealed in ordinary life. Where others see conventional sleepers, Kafka sees a vision of primitive fury and watchmen with burning sticks. There is no explicit lyrical "I," but the evidence points to Kafka's identification of the artist as one who pierces through ordinary codes to underlying terror. Johns' drawing also seems to have two codes: neutral shapes and terrifying darkness.

In Johns, as in Kafka, there is the turning over of the ordinary in patient and despairing reflection. In Johns, an inverted chair speaks of this vertigo and crisis. The plain speech and legalism of Kafka is reflected in the hatchings of Johns and his division of his drawing into a dark red, yellow, and blue set of straightforward zones. In both, the usual world is torn apart and is presented as conflict. In Kafka's letter to his father he speaks of a shooting arcade, and his description is enormously redolent of Johns' early uncanny targets: ". . . when the Ark of the Covenant was opened, [it] always reminded me of the shooting galleries where a cupboard door would open in the same way whenever one hit a bull's eye; except that there something interesting always came out and here it was always just the same old dolls without heads."[49] Johns' world is that of the mutilated body, mutilated color, the wide swath of darkness that the watchman must reflect in a hypervigilance. Both creators treat a shooting arcade like the Ark of the Covenant; finding in the everyday both darkness and a kind of revelation.

Kafka invented a prose style that reminds one of Johns' use of stencils. On the one hand, Kafka takes something from the legal profession's flat jargon; on the other, he learns from Hebraic rabbinical commentary and parables. But this patient legal prose presents stories of the most excruciating pathos and privacy. We might say that Johns' stenciled lettering presents, through paradoxical absence, the anguish of the personal uprooted in a world of convention, as the thwarted figures of Kafka twisting in a legal maze, but slowly, yielding ever more clues to a veiled interiority. Thus it is too easy to speak of the stencils of Johns as avoiding expressionist draftsmanship. We could say instead that they are part of a strategy that releases that much more expression. Johns has appropriated these stencils and given them his own peculiar stamp. Anyone who uses them is quoting, as it were, so personal has his selection of the stencils been.

Jasper Johns' contribution to the 1967 volume of homages to his friend Frank O'Hara (a work not classified literally as a drawing by the artist) is extraordinary: a place setting of fork, spoon, and knife (plate 6). The plate is absent. Judith Goldman relates this work to the themes of self-consumption and to the link between eating and looking underlined by the artist in his sketchbook notes and in the earlier painting itself, *In Memory of My Feelings*.[50] This elegy with its effaced plate is a fitting homage to absence. O'Hara was a master of what he called his *Lunch Poems* of empirical observation. As in his "A Step Away from Them," O'Hara is both a celebrator of urban detail and an elegiac poet in the Roman mode: "First/Bunny died, then John Latouche,/ then Jackson Pollock. But is the/earth as full as life was full, of them?"[51] All the liquidity of Johns' drawing is around the margins and the placid utensils, and the dry space between is indicated with a thousand crosshatches and wavery, wiry lines. The viewer is made to fill in the vital and missing element. It is a scene reminiscent of O'Hara's poem of the same title about the ruses of our many selves, of self-deception, and the problem of making an art that is not whimsical but one of necessity. Here a necessary homage and elegy does not delete the possibility of humor. It is like an invitation to an immortal party, as in the Tang poets to whom O'Hara appealed when in a letter to Johns he said he wished their conversation could be eternal like the Chinese poets' on mountainsides. This mundane sketch seems endless.

Zone (1969; plate 101) is an extraordinary cadenza in textures and gleaming glints: graphite, chalk, and tempera on paper. The artist has commented that the painting on which it is based was about the interaction of two mediums, oil and encaustic.[52] Here the dark upper rectangle has all the palpabilities of *Night Driver*, and nuances of blue-green fleck the darkness with its obsessive neutral marks. Architectonic dryness regulates the drawing of a letter "A," inverted and representing the neon "A" in the painting. An outlined cup breaks through the two zones. There is an extraordinary care in the framing through pencil and chalk of this deliberate enigma. A pool of white rests at the lower edge of the top zone, and the lower zone is divided itself by a dark square and tilted lesser rectangle. Here we are at the furthest remove from the sense of positivity in still-life objects. The cup, the dangling implement, the hinged letters "A" and "T" are all parts of a disjunct style that can never be connected. Johns the tonalist presents a very dramatic contrast of dark and light. But even the dark zone is shot through with whites, and the lower region is troubled by a constant agitation of shadows. If for Apollinaire the poem "Zone" was a way of dealing with a positive tour of the great city of business streets and advertisements, in Johns the tour has become internal, strange, and hermetic. Even more elegiac is the sense that this drawing is a portrait of a painting: a memory or a tracing of oppositions never reconciled.

Bernice Rose has called Johns the master of modulation,[53] and the 1969 drawing *Voice* (plate 102) reminds us of this mastery. A mysterious device creates an arc of modulation just above the word "Voice," connected like some homemade contraption by wire or strings to a dangling fork. The tracing and outline of real things are excruciating in their delicacy. The white fork and the stenciled letters are polarized like wandering parts of the body. *Voice* succeeds in the nuanced

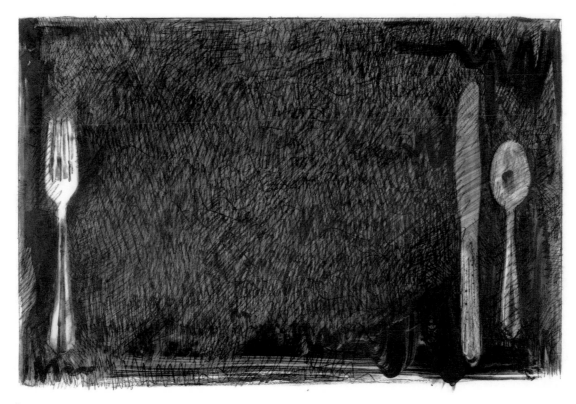

6

Illustration for Frank O'Hara/In Memory
of My Feelings. *1967.*
Pencil and graphite wash on plastic,
18 × 23¾".
The Museum of Modern Art, New York.
Gift of the artist

graphite ground that furnishes a total antilandscape to the machinery of the riddle. The lightest of
"white" drawings, it reminds one of a line from Wallace Stevens: "In ghostlier demarcations,
keener sounds."[54]

The track of the device in *Voice* is a deletion of language. The drawing's diagonals echo each
other suggestively. Where the 1960 *Jubilee* (plate 42) is a color victory in the layering of blacks
and whites, with slipping and perishing words, *Voice* is the erasure of all alphabets. Where
Jubilee is a random joy and a rainbow of grays, *Voice* is an extreme of separation and an obsessive
ritual of the slightest marks.

Souvenir 2 (1969; plate 2) bears the burden of an autobiography. Johns indicates with superb
wit the mechanics of an artificial illumination. A flashlight is drawn, positioned as if bounding light
off a mirror that will then transmit and illumine the rubbing of a self-portrait upon the "souvenir,"

the image of a plate made for the artist in Japan. The artist's self is now in the middle of this target-plate and surrounded by the vocabulary of the primaries: Red, Yellow, Blue. Most of the picture is taken up with the image of a back of a canvas and an erasure of lines that inflect the topic of a former, erased self. Rauschenberg has said that art should not be a souvenir, but here the usual nostalgias have been burnt out, and rumination itself becomes something as fresh and immediate as an object.

The drawing *According to What* (1969; plate 98) is a refutation of the idea that, in relation to the paintings, the drawings are always the site of the more seductive intimism. Here there is also a dryness and factuality. The great lyric bursts of paint of the 1964 painting are transformed; drawing is a species of elegy to painting. In the drawing at the lower left, there is a profile of Marcel Duchamp breaking through the frame of the picture-within-picture. Only the barest indication remains of the imagery of an inverted chair and leg. Where the painting contained a bent coat hanger casting a shadow, the artist has traced a life-size and placid coat hanger. The play of changing colors on the color-words that mirror each other is less palpable in the drawing and also more contemplative for the very lack of this glamour. The vertical column of rich colors is translated into dense grays. Silkscreened newsprint is mimicked in rubber stamps. The profile of the inverted figurative element (leg and chair) reminds one that Johns' encyclopedism has a shifty *deus ex machina* always lurking in the guise of the paternal mind. Meyer Schapiro has spoken of the syntax of the figure, of how frontality is like a first-person pronoun.[55] The reticent "he" of Marcel Duchamp in profile reigns like a subtle dice-playing god over the discontinuities of *According to What.* The title is the fragment of a question or the invitation to a question. The subtlety of the grays in this drawing is almost impossible to reproduce, and its large scale produces a dignity beyond any mere intimism.

Johns uses his sculpture to beautiful effect when he makes it the subject of an insistent new illusionism in making its portrait. These portraits of his sculpture, *English Light Bulb* (1970; plate 105) and *Ale Cans I* (1974; plate 113), for example, yield some of the most devastatingly suave embodiments. The bulb was already treated in the sculpture as if it were a little being above its tomb. Here the ironic label breaking through the frame is the profile of this tomb, or slab, and mounted bulb. In aqueous shadows, a precise, white outline regulates the figure. It is Johns remembering his own work, and it reminds us of the photoengravings of his works in *1st Etchings* (1967–68) that he has used as another route to autobiography. In the *English Light Bulb* drawing, he has flattened his motif except for some hints of contours in the bulb. In *Ale Cans I*, he takes sculpture and dissolves it, a humorous procedure.

No reproduction can do justice to the dark *Map* of 1971 (plate 106). It is the outlining of the whole that strikes one, the explosive chalk along the edges and the ruled lines that move underneath and at right angles to the top of the picture. The border of Virginia initiates a line that juts out straight to the sea. Kasimir Malevich's maps of disconnection are airy compared to this accretion with its densest of atmospheres. We might think of this map as closest to the

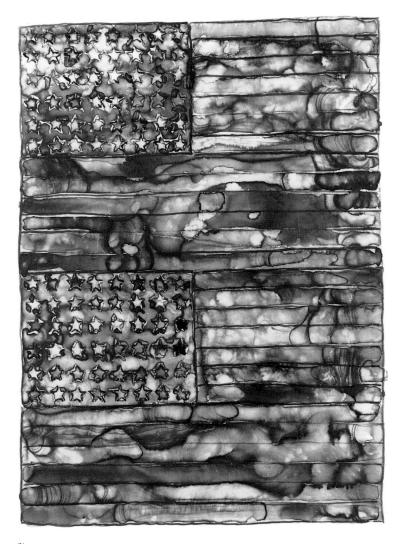

7

Two Flags. *1977.*
Ink on plastic, 11⅛ × 8⅜".
Collection the artist

neoprimitivism seen in Picasso and even in Rauschenberg's assemblages. As the numbers lie on top of each other in simultaneous presentations, here the art is in a constant crushing. The edge of California is nearly destroyed by a wave of dark strokes. His neutral M's and W's (one way of describing a Johnsian line or gesture) mark the bottom. The melancholy of this work, as with *Coat Hanger* (plate 31), is a reversal of Rauschenberg's more optimistic pictures. Even Magritte's uncanny works, with their neutral crosshatchings, seem unruffled near this piece of ferocity. The map reminds one of a story Johns tells of a dream. In it a map drops from his hand and a voice is

heard, saying: "From now on you will proceed in darkness." This drawing, like the dream, is of the nomadic and the eschatological. It is a last map of what is known.

Flags (1972; plate 108) in watercolor and pencil is extraordinary for its factual handling of color and subtle dislocations. Very simple blue fields and penciled white stars with light changes of tone regulate the piece. The whole has a dark, torn edge. The stripes are irregular, and as they mark their respective regions they waver and intervene. These two flags remind us of the play of part and whole throughout the Johnsian canon. The two flags have become bizarre symbols of reduplication itself. A pencil schema of language is legible: "A" wider than "B," etc. These studious but elusive stripes are multiplicities, valences, capable of widening and thinning as if by themselves. The strange flags of disequilibria have been translated from the usual sign of stability. The predominant event, as in his crosshatchings, where one green line does not survive a change of direction, is the turbulent theme of change itself.

There is a humor throughout Johns' work which is irrepressible. In the drawing *Ale Cans V* (1975; plate 116) in India ink on folded paper, there is an exercise in making a Rorschach test out of an ale can. The light and dark versions stand next to each other in a Morandi-like marriage. Withal, the whole is a Zen study, fast as a fold and yet a subtle joke about projection. One recalls that the ale cans were initiated as subject matter when Willem de Kooning disparaged an art dealer as a man capable of selling anything, even beer cans. Johns accepted this presumed accusation as a funny case of the lowest will be highest, the last first. It would all seem whimsical and minor if the image, both in sculpture and in ink, were not so melancholy and intent. The play of drawing and printing in the drawing makes this a fine montage, like Johns' juxtaposition of oils and encaustics elsewhere. Here is an example of wit that is not used for aggressive purposes, to humiliate the viewer or deprecate the pedant. It is part of the Johnsian strategy and tone to accept the divertimento if it is economical, not self-indulgent and mean. One doesn't want, as E. M. Forster once put it, to crush the butterfly upon a wheel, in writing about such evanescent stuff. But in drawing it is the evanescent and lyrical that has its foregrounding. Somehow both ale cans perch jauntily like two hats. As usual, Johns almost masks his true interest: the fold, the edge, the slip of the brush.

The drawing *Two Flags*, in ink on plastic (1977; plate 7), is a return to a familiar motif. We may see this as suave free play upon a field of signs, a field that might be entitled "at the sign of the sign." And, like the Manneristic stairways to nowhere in the work of the architect Peter Eisenman, we might regard this as a truthless work, making a kind of wallpaper infinity out of the usual sense of signifying emblems. Or we might see it as a deposition of free play and an analysis of such emblems by which we are too easily dominated. Either critique deletes the personal: the Johns whose father was named Jasper after a Revolutionary War hero who hoisted the flag, or the Johns who makes an emotive statement from this still life. This plural flag finally represents a maximal aesthetic in which the "two" exemplary modes of criticism are synthesized with an eruptive personal tone.

The allusion in *Periscope*, 1977, ink and watercolor (plate 121), is to Hart Crane's vision in the poem "Cape Hatteras" ("A periscope to glimpse what joys or pain/Our eyes can share or answer"[56]). In Crane one finds a myth of technological affirmation matched by a constant imagery of dissolution, paradoxically cruel as well as pantheistic. The Romanticism in Crane was deposed by his academic friend Yvor Winters as a path that led necessarily to suicide. *Periscope* is an examination in modifying inks of all accident and necessity. The "device circle" is dried out by a handprint as ominous as the casts of body parts in his *Untitled* four-panel painting of 1972. If De Kooning once said that content was tiny, a glimpse,[57] then here one prolongs the periscope's glimpse into a strategic examination.

In *Ale Cans* (1978; plate 128) one discovers a penetrating portrait of his sculpture. The Savarin paintbrushes are part of the background now and are, like the crosshatchings, rendered in glints of red and blue and secondaries. The sign of the ale cans is in a brilliant transparent red and green. The ale cans themselves are rendered realistically in a golden brown with highlights of yellow. The word Ballantine is rendered in red, the X's in red, the clustered logo in green, the top of the picture is pooled ink in black, and the whole picture is underlined heavily.

In *Cicada* (1980; plate 135), one has the most delicate rendering of one of Johns' erratic crosshatching patterns. At the bottom of the drawing, in a signatory frieze, the artist plays on folds and repetitions by giving his name in a divided fashion: "OHNS 1980 CICADA JASPER J." There is a beautiful working out from central primaries to the secondaries toward the edges. The ruling nuance, moreover, is the addition throughout of lightly reinforcing strokes of black. These strokes deepen and darken the work and steer it from a relaxed lightness, until, by a curious perceptual flip, one begins to see the whole as a color imprisoned by gray pressures. Even more complex than Frank Stella's painting *Jasper's Dilemma*, in which the analytic montage of grays and colors is posed, this work yields a dignified multiple abstraction based on the possibilities of color perspective. Does color bound the black, or vice versa? We are ruled by the pressures of the equivocal, but here ambivalence is given its charming due.

Tantric Detail (1980; plate 138) in charcoal is an extraordinary and disruptive work. When Johns' *Tantric Detail* paintings were shown in 1982 at the Blum Helman Gallery in New York, they caused a sensation. For many, the use of the testicles and partially hidden phallic images was too loaded, too sudden, too reminiscent of Philip Guston, and was horrifying in the context of what had become the more serene norm of his crosshatching. Coupled with a dark skull and an ambiguous dotted line descending from the skull, these erotic details in the paintings had a disturbing presence. The title reminds one that the root of *tantra* in Sanskrit is "to expand," and the system of scientific eroticism in Tantric art is in ways close to the scientific investigations and maximalism of Johns. The artist's sexual hints have linked him with the eroticism of Marcel Duchamp, whose *Female Fig Leaf* is imprinted on a number of Johns' works.

What could Johns be doing with the body parts introduced in these works? Perhaps he is transgressing the notion that he has become, with his *Usuyuki* and *Corpse and Mirror*, a purely

39

"abstract" artist, that he is returning to transgress his own rule system. With his earliest target (*Target with Plaster Casts*, 1955) he obtruded equivocal bones and a phallus on an audience that found them obscene. Now again he links, in an almost academic manner of Buddhist meditation, sexuality and death. The caricaturelike hair of the sexual parts, problematically rendered above the skull near the boundary of the upper rectangle, reminds one of the most extreme flouting of authority.

The Orientalist Ajit Mookerjee notes that Tantra art locates the centers of energy in the human body, and despite all claims for impersonality, Johns' strategy has been to avoid the body only to call attention to it in absence. The sense of the web in Tantric art relates to Johns and the almost secular insistence on experience in the present. Tantric mandalas are analogous to the mandalalike targets of Johns. Tantric disciples often meditated on the mediating symbols of our lives. The *Tantric Detail* reminds one of Johns' involvement, too, with Eastern ideas through his precursor, John Cage, who has often spoken of the emptiness and silence that he is trying to reach through his music.

Tantric art insists on the energy of certain colors: "emerald *(prana)*, red like the evening sun *(apana)*, milky *(samana)*, white like the dhatura flower *(vyana)*, that of fire and lightning *(udana)*."[58] Mookerjee uses a phrase that seems very close to the sense of Johns and his art-inside-the-world. "The artist expresses something that already exists, *sarvam*, of which he is a part and which he feels impelled to give back to the world."[59] As for the phallus, Mookerjee makes the classic mystical reading: "The erect penis signifies also that he is cosubstantial with the penetrating essence of the universe."[60] Johns' use of the erect penis seems an homage, a parody, and a plural elegy to such an allegorical possibility.

Johns' Tantric details may have been inspired by such a "meditation carpet" as one finds discussed by the art historian Philip Rawson: "Tibetan imagery, based on that of ninth-century Buddhist Bihar and Bengal, uses cremation grounds as standard symbols, and refers time and again to meditation on or in rotting corpses—perhaps the most intimate acquaintance possible with the horrors of mortality."[61] Rawson speaks of monks who dutifully performed their meditative rites in cremation grounds. Sexual symbolism is often associated with these graveyard rites, "as the beautiful full-breasted Kālī . . . flourishes a sacrificial sword and sits enjoying Mahākāla, the creative lord, both of them using a corpse as couch."[62] In an epoch of symbolic syncretism, it is not strange for the master of an American symbolic encyclopedism to include an Oriental motif, but note how Johns does not flirt with the possibilities of the exotic in the Tantric, but strips the motif bare as a bride. What remains is the abstract carpet interrupted by sex and death: a drawing with two balls, literally.

In *Cicada* (plate 135) and *Voice 2* (1982; plate 10), the artist attempts to tease the mind with the possibility of an endless loop. To be enclosed in such a work of art would be to recapture time. While some of the graphic marks in *Voice 2* resemble Pollock, it is fundamentally an affirmation of color and the resolution of all line-color oppositions. Is drawing to be regarded as a form of

speech? The artist might have quoted Proust: "Talking keeps one from seeing as well as hearing." That was the subject of *The Critic Sees*, but here voice is an analogue of all desire.

Ludwig Wittgenstein said, "The human body is the best picture of the human soul."[63] What is so moving in Johns is his way of importing the human into the bodies of the seemingly lifeless symbols and objects that surround us. In *Land's End* (1977; plate 122), the hand reaches in pathos toward the word "Red" and past and through "Yellow" and "Blue." In *Usuyuki (Study for Screenprint)* (1979; plate 134), one feels explicitly the sense that the crosshatching is an *event* for the body: the way colors happen.

Johns distributes colors the way Merce Cunningham distributes bodies in chaste space. Cunningham has learned to avoid the overt symbolism of Martha Graham through vocabulary of the demotic, street language, and the polyrhythmic play between hands and feet, chorus and solo. Cunningham, like Johns, presents bodies without casual narrative themes for them. The *Usuyuki* drawings do not illustrate, any more than Cunningham has ever cared for the terrain of the illustrative. The humor of Cunningham is seen in the fresh inks and in their twisting and turning. Cunningham has spoken of his admiration for tap dancing. The judges, he averred, used to sit beneath the floorboards of the stage and listen to the dancers' feet.[64] The appropriation of colloquial tap dancing in Cunningham is close to Johns' seemingly abstract compositions.

For all talk of artifice, there is nature in Johns, who lives in the country. There is not only the damaging terror of the sea implied in *Diver* and *Land's End*, but there is the sense of an outdoors in all the *Cicada* pictures with their air and freshness. As Johns is interested in the bathers of Cézanne and Picasso, the drawings of *Cicada* may be said to move from studio space to a possible clearing. If there is a kind of agoraphobia in the closed-in spaces of his mental alphabets and numerals, the late bursts of the crosshatchings imply natural, wide-open connotations. Even *Usuyuki* as a name is known by the artist to connote "thin snow," and often his ghostly white tones imply a lyrical snowfall as much as a cerebral symbolism.

The *Usuyuki* drawings have a decorative all-overness that may bring to mind the problem of their equivocal flatness. Joseph Masheck has discussed at length the philosophy of flatness and the use of what he calls "the carpet paradigm" to explain the sensuous and ambiguous flatness of much modern art.[65] Johns' art is finally never wallpaper. Always, like Cézanne, he searches for a structure of depth, since even his earliest targets are studies in both a subject doubling itself and a luminous sense of layering. But one impression is that Johns will have both flatness and depth as a simultaneous paradox. The *Usuyuki* group reveals a paradox of a wallpaper that is for all its flatness swarming, filled, busy, and expressive.

The crosshatching patterns in Johns' work began with the artist's observation of a car decorated by a neutral assembly of lines. But Johns brings a wealth of expressive variation to this motif. In the *Corpse and Mirror* drawings, one is reminded of the randomness of the folded games of the Surrealists, in which one poet wrote part of a sentence without knowing the previous words. In *Usuyuki*, one has an impossible cylinder created by the matching of edges. In *Cicada*,

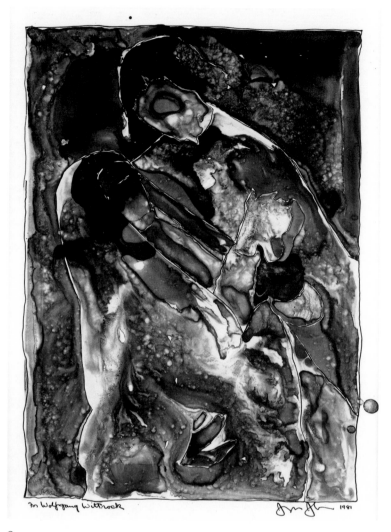

8

Tracing. *1981.*
Ink on plastic, 15½ × 12¼".
Collection Wolfgang Wittrock

the breaking forth of the primaries to the secondaries and the matching of top and bottom and side edges continues this sense of an impossible mental object. In the 1982 versions of *Between the Clock and the Bed* (plates 145–146), the crosshatchings have become expressionist metaphors for Munch's mortal bed. The change in scale in *Between the Clock and the Bed* represents that broken space that obsesses the artist in shattered perspectives.

Johns' crosshatchings have been likened to Cubist devices, decorative nonentities, hands, Pollock's all-overness, and even to lines of sexual arousal. In one *Savarin* drawing (1977; plate 126), they become a sign of art itself and an autobiographical screen. The lines are ways of tensing

42

the poles of depth and surface. They make equivocal X's and read as a map of such distinctions. They are in themselves a kind of carpet interrupted by the two balls in *Tantric Detail* or framed by the implements of desire in *Dancers on a Plane* (plate 144). They have the expressive delicacy of Pollock's putatively last picture, *Scent*, and they are also about the hunting for such equivalents, precursors. "Yet crosshatching is also a graphic symbol with a conventional significance like the letters and numbers of his [Johns'] earlier works," writes Nina Sundell.[66] "In architectural drawings it indicates a blank surface. It is an impersonal mark, a neutral wall of filling space."

Johns, like Duchamp, involves himself in a hermetic orchestration of art history. In his 1981 *Tracing* (plate 8), he offers a version of Grünewald's handling of the Virgin and Saint John the Evangelist in the Isenheim altarpiece. But the version is filled with visual puns that mislead the viewer. The coif of the Virgin leads down in the tracing in a biomorphism that seems like an attenuated shoulder of a Christ. The visage of the Evangelist has been transformed into a horrifying one-eyed monster. The hands of the Evangelist have been transformed into a few clawlike fragments.

As in *Perilous Night* (plate 147), Johns has averred that he does not want the observer to know at first the source of this tracing. His own relation to Grünewald and the expressionism of the sacred Isenheim altarpiece is complex. The drapery and its delicacy in the Grünewald Virgin detail become in Johns' hands another breaking of space. The tones of the Virgin's dark sleeves become both an aristocratic and abstract pool. The scene of grief and consolation between two humans is a rare one for Johns. Here in the embrace of abstracted forms, Johns rearranges and adapts Grünewald to yield both a lament and a balancing, a reparation. The observer must decide whether to explore the Grünewald for such a detail and appreciate the tracing for its referentiality and relation, or to analyze the tracing without the source as a field of free play. So many critical questions are raised by this, but the outstanding one is peculiarly Johnsian: what do we see without knowing, what do we know by seeing?

Johns' traces may be—in Françoise Gilot's phrase about Picasso—dialogues with the dead, and are indeed like Picasso's game of transforming Courbet, Delacroix, El Greco, and Velázquez. The tracings of Johns are not parodies, but demonstrations of the joy or eros of influence. They are demonstrations of a historical consciousness. They also render an artistic masterpiece like *The Bride* of Duchamp or *Bathers* of Cézanne as another object, like a light bulb. Johns has always enjoyed the sense of the literalness of the object, and tracing the masterpiece is another route of transforming things to humble objecthood. Tracing for such a master of line is an exercise in humility.

The variations that Johns is capable of wresting from the *Land's End* motif (plate 122) are shocking. In this version, in which agony has become as solid as a fog, a dark arm as of the drowning Hart Crane is raised. The arm is bearing the geometrical sense of rigor mortis with its ruler-straight sides. The written word "Scrape" regulates the right-hand device. The color-word "Red" in dark ink overlays the larger "Red" in red, and a carmine spot of blood, as it were, stains

the hand as elsewhere it scatters along the frame. An "E" of blue drifts reversed near an arrow. The word "Yellow" is reversed as if language itself were drowning. In this picture of oppositions and positions, of the stammering of letters and body parts, we witness not a *Tantric Detail* skull but the corpse of language. The drawing is an encyclopedia of signs: the index or tracing of a hand rivals the icon or resemblance of a warning or farewell next to the arbitrary zones of conventional symbols. All the excited vertigo of Surrealism is here made plain and vernacular as in the poetry of Edward Arlington Robinson, one of Johns' favorite poets. The hand up, the arrow down, the device sweeping; it is a large if intimate spectacle, both "theatrical" and "absorbed," dissolving those antinomies in the deluge. There is no measurement or moderation except the ruled image of the swath.

There is a multiplicity and balance in Johns' best drawings, for example, *Perilous Night*, that remind one of his peculiarly plural art. The philosopher and psychoanalyst Ludwig Binswanger noted the deficiencies of any kind of thinking that did not take into account the brute world, the world of relations, and the world of one's relations to oneself. We may say that realistic draftsmanship conquers the world as environment but deletes the world of human relations and the world of relations to oneself.[67] Expressionism stresses the self but at the expense of the civilizing and enriching apprehension of stubborn fact. Theatrical art indicates a sense of the group and relations but yields a dimmer sense of world and self.

Johns' drawings give us this triple dynamic of being-in-the-world, and they do this by the most elegant dissolutions. He avoids neither theater, nor realism, nor expressionism. His flags and targets are brute parts of a world and have none of the freedom or biomorphism that would indicate the human at play. On the other hand, these are exactly the mediating conventions that have assumed roles as symbolic companions, i.e., the target is more loving than the faces above it. The intimistic or ferocious handling of these permits the artist a range of self-expression, but one set into a dynamic spun by the other axes of his drawing. The geometric, the biomorphic, and the indeterminate are the three lines whose qualities he controls as part of a drawing of existence: the brute sword of the world, the dark arm of a friend, and the more narcissistic pools of one's own undecidability.

Even the title *Perilous Night*—an allusion to a piece by John Cage—reminds one of this expressionist territory for Johns. Judith Goldman has referred to his relation to Edvard Munch, not simply in his allusion to Munch's Madonna in the spermlike shapes in some monotypes, the spectral bed of Munch's self-portrait with its crosshatching pattern and iconography of doom, but this very topic of estrangement.[68] In Johns the symbol is like Munch's physiognomy of anxiety. He has returned to his simple objects, moreover, with the tenacity of a phobic who will not lose his fear. This drama of passivity links Munch and Johns.

The use of stenciled lettering represents one decision that seems to put Johns' drawing on the side of the impersonal. From the tracing of the Cage manuscript in *Perilous Night* back to the earliest alphabet grids, Johns shows a seeming decision to renounce aspects of the free hand, the

graphologically spontaneous. However, a steady view of any particular sequence, say *Out the Window* (1960; plate 41), reveals that this stenciling—or imitation of stenciling—is the site for the attack of the personal; the personal surrounds, masks, erodes, curls around the readymade.

In drawings such as *Perilous Night*, *Tracing* (a 1978 drawing made after a print by Jacques Villon of Duchamp's *The Bride*), *Diver*, and the *Untitled* ink drawing with images of basket and skull (1983; plate 149), the sign is perilously and doubly divorced from any easy referentiality. In these drawings we are referred to a print of a hermetic Duchamp; to traces of an impossible or despairing leap that cannot take place upon a ground itself ambiguous; to warning signs in foreign languages to unseen perils. We dwell among signs and the typographic wandering errors of a life that cannot be grasped directly.

Johns has said, "I need darkness to work in. . . . Poets need audiences too much, and they write too much, or at least they release too much."[69] His tracings of Grünewald are not intended to be "traced" to the source. The sign, in German, French, and (once) English, in his *Untitled*, 1983, pictures is adapted from a Swiss road sign. Each one is a forbidding drawing with skull and crossbones above a basket (or hamper?) and faucets. Since he enjoys the passage in Francoise Gilot where Picasso says it is subtler to place a skull next to leeks than near bones or other usual iconography,[70] I find it montagelike to have this skull near a basket: as if a dangerous picnic were being held. The *Untitled* drawing (plate 149)—which turns to a species of dark brown upon which blacker, drier lines can regulate outlines—is a companion, in a sense, to *Perilous Night*. One half is a tracing in crosshatchings and horizontal bars from a Grünewald, the other, a *vanitas* of schematic skull and two strange faucets. The "fall of ice" *(Chute de Glace)* is cut off in its French presentation; and the whole is a representation of quiet horror.

In 1983 the artist reworked this tracing into a picture of insidious peril *(Untitled*, 1983, plate 150). "Gletscherabdruch (sic)," "Chute de Glace," and now the unsettling torn "Be ware" (sic) repeat the topic of attention. The skull above reminds one that even vanity is based on a lack of attention, just as sin has been described theologically as falling wide of the target. The faucets have become as infernal, sexual, and heraldic as anything in Johns. The man who was able to make a crown out of a garbage can lid here makes his faucets into a resonant image of some torturing device. Again all is quiet as the illegible allusion to Grünewald, with a central region seemingly explicit as an inverted face (at least, a region of two eyelike shapes paralleling the skull). The barlike banners of the left side contrast with the diffused tones of the right. The tonalist has become a master of contrasts; and the colorist here receives his persuasion toward the most expressive of imageries. Sign within sign maintains an imagery from the earliest duplicated and triplicated flags, *Disappearance II* and *Wilderness II*. Death is a conventional sign, this picture seems to say, with what might be called a caustic charcoal. The terror of this picture, tighter in charcoal than in the other ink version, suggests a unity in Johns' drawings from the broken targets to *Diver*, *No*, and *Periscope*: only the unhappy consciousness, threatened by broken space, can make a sufficient whole. Johns concludes not with a complaint but a complex reparation.

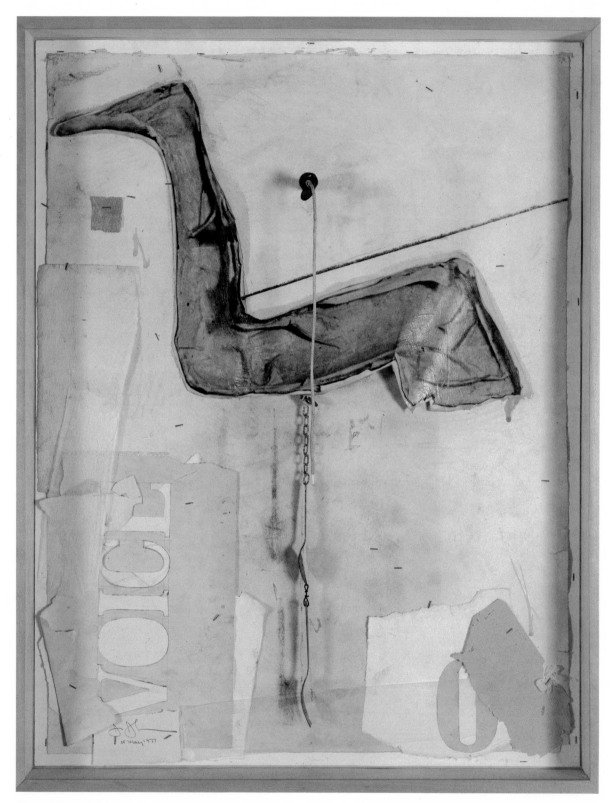

9
Untitled. *1977.*
Acrylic, charcoal, and collage with objects,
41½ × 32½".
Collection the artist

Conclusion: An Art of Memory

Johns has reached some brilliant conclusions in these dark drawings. First, he has memorialized our culture and its mediating symbols. Second, he has given us a shattering self-portrait, no matter how reticent. And finally, he has warned us through the most conservative of memories and with an intense and rupturing imagery of our possible lack of a future. He has traced the glaciers for us, as it were, and defended us through form.

Johns' drawings show a staggering diversity in medium, scale, composition, and color; they are a lesson in unity out of multeity. In *Perilous Night*, little stick figures similar to those seen in Franz Kafka's drawings show the artist's ability in caricatures; suddenly, however, one realizes that this gaiety is juxtaposed with a tracing of Grünewald, a black arm, and a John Cage manuscript. In an unpublished page from his sketchbook notes, one finds the swift penciled strokes of a "No" with equally swift deletions and notations toward assemblage. In *Dancers on a Plane*, graphite is used and seems almost as colorful as watercolor; in *Tantric Detail*, charcoal is used to make a menacing skull and some very decorative crosshatching. Could this be the same charcoal imprinted in the *Skin* series? In *Ale Cans I* (1974; plate 113) ink falls in spatters, though in *Ale Cans III* (1974; plate 114) the same medium is used to make a kind of architectural rendering with a parody of commercial verve and wit. In *Untitled* (1977; plate 9), charcoal, collage, and acrylic create the most casual, torn, least elegant of objects with a dangling real fork and spoon and string and an image of an inverted leg. In scale, *Diver* is the equal of the most monolithic canvases of the Abstract Expressionists and makes its scale a truly necessary part of the subject and the medium of smeared charcoal. Primary and secondary colors have been explored almost infinitely in the *Usuyuki* drawings and *Cicada*, and explored critically, analytically, after a period in which he has been mostly praised as a tonalist, not a colorist. There is no piece here that is not stained by the peculiar physiognomic expressivity of the artist in crises and growth.

Much of Johns is wrapped up in the theme of the double, the doubled shadow, the doubled object, the object as *Doppelgänger*. Otto Rank, in his book *The Double*, refers to the anthropological work on this subject, adducing such superstitions as the German one in which he who casts a double shadow on the day of Epiphany must perish, or the fear of one who casts a headless shadow.[71] Shadows have been accepted as a natural origin for the idea of a guardian spirit. The sense of these shadows as interpretable as a split-off part of the unconscious is agreed upon, as Rank says, even by the folklorists. The double is finally explained by Rank in terms of narcissism and the defense against destruction. This is one way to account for the uncanny powers of the double and triple flags in Johns' drawings: they are strong and libidinal defenses against the idea of annihilation. And in his attack on these very emblems, we have what Rank calls "fear of

one's own self," the pursuing of the double or mirror image. This doubling is obsessive throughout Johns' drawing from the earliest *Flag Above White*, in which the white field functions as a ghost, to the later repetition of ale cans. The basic sense of the crosshatching, as explicitly denoted in the title *Corpse and Mirror*, is the threat of the double.

One does not turn to Johns' drawings to have the pleasure of the linear as opposed to color. Here the linear offers a field of color even in the thin field of a neutral stroke. Freud summons this up specifically and about specificity: "If we wish to do justice to the specificity of the psychic, we must not seek to render it through linear contours, as in a drawing or in primitive painting, but rather through blurred fields of color, as in modern painting."[72] Freud then offers a description that is as apt concerning *Between the Clock and the Bed* as about any mind: "After we have separated, we must permit what we have separated to coalesce once again. Do not be too hard on this initial attempt to make the difficult and elusive domain of the psychic intelligible. . . . "[73] The changes in scale in *Between the Clock and the Bed* and its elusive circularity are attempts to permit separation and coalescence. And the directional stripes of the drawing and the painting make for a constant play of separation and coagulation. No more straightforward text can exist than this, but it is filled with the necessary echoes, changes of scale, and reversals that indicate the obstructions of everyday unhappiness.

Johns' use of flags and flagstones seems like the bravest iconography of flatness, and yet one recalls that "to flag" is a verb that can signify the waving of a flag "to incite the animal's attention or curiosity." The symbol is always a decoy for the innocent, deerlike observer. The flags of Johns are not that far from the expressive banners in Hölderlin's poem "Half of Life": "In the wind the flags are full of noise."[74] And in Rilke's "Presentiment" we find the most extraordinary statement of the flag as self-portrait: "I am like a flag framed by deep space."[75]

Not much of Johns is about the stubborn factuality of an object. Duchamp spoke of using a Rembrandt as an ironing board. Johns' iron(y) results in his imprinting the can of paint and even the bottom of an iron (an implement used in encaustic painting to soften the surface) on some of his paintings. The iron and can imprints are what are *already* there, part of the tradition of studio and still life. But in Johns these stubborn studio objects are rendered in a way that makes them multiple in broken space. More obvious ironic handling of recontextualized clichés is evident, as at the bottom of his 1979 *Cicada* drawing (plate 132), where Johns has written: Pope Prays at Auschwitz/"Only Peace!" A bit of well-meaning newsprint, as it were, well montaged with skulls.

Like the skeins of paint in Pollock, Johns' lines in his drawing are always color, and color is always directionality. For all that we think of the two painters of *Scent* as opposites, Johns the introspective ironist and Pollock the master of an exteriorizing mannerism, they are both in their mature works congruent in one respect. Both Pollock and Johns master the irony of parts of their subject matter. Pollock, like Johns, presents a cold presentational painting and escapes the imagery of Picasso, the beasts and gods of Jung, and mere ironic anecdote. We might say that Johns has found in *Usuyuki* and *Cicada* crosshatchings a way of demonstrating if not mastered

10

Voice 2. *1982.*
Ink on plastic, three panels, 35½ × 24" each.
Collection the artist

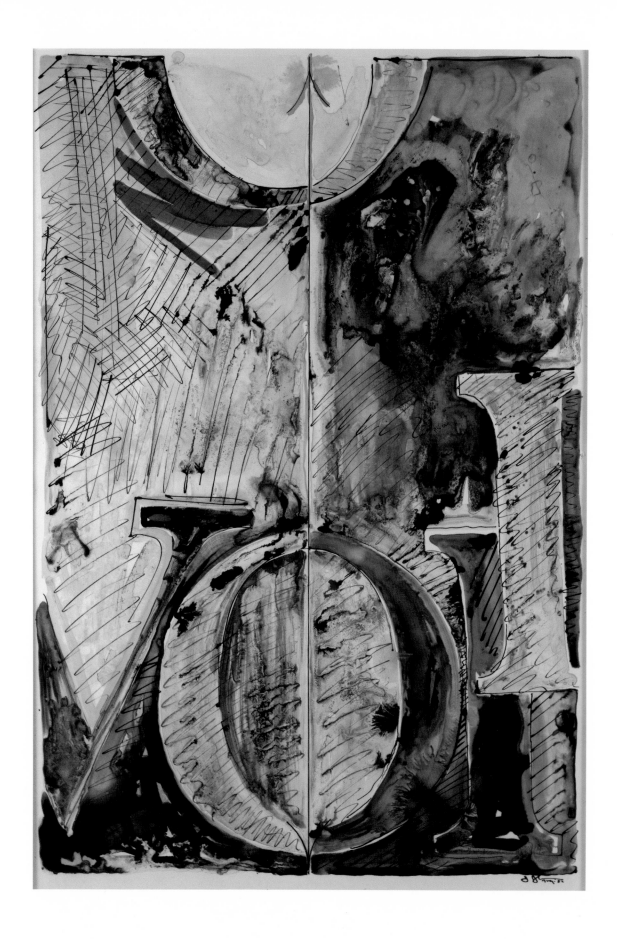

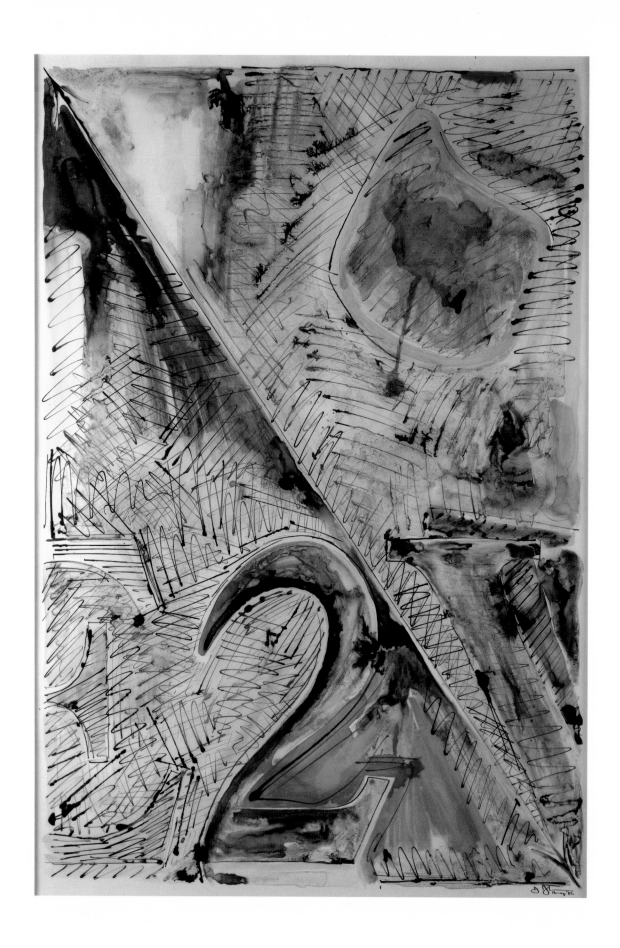

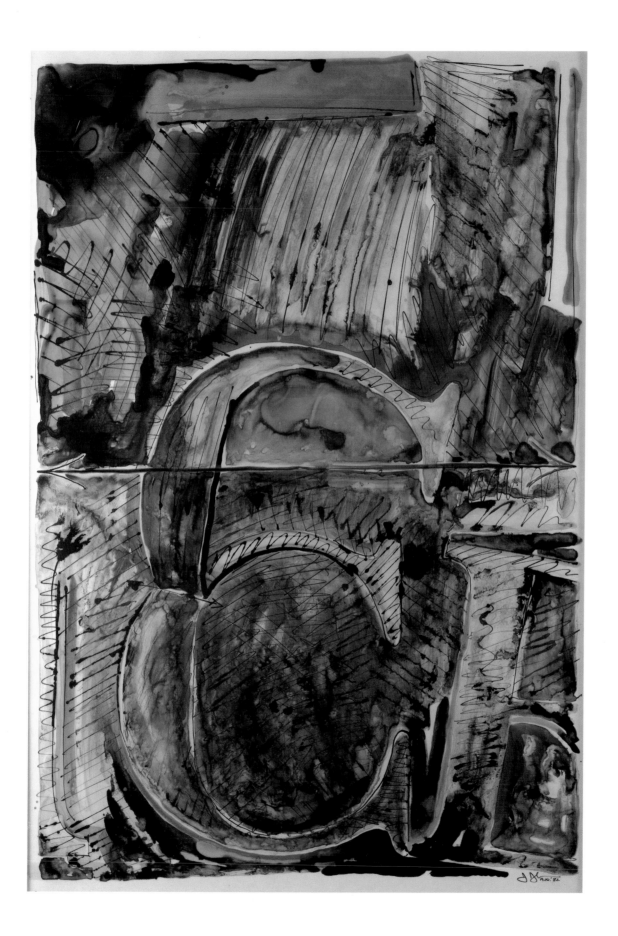

irony then the present process of showing the mastering of irony. These patterns are no longer a melancholy streaking over the requirements of the given. Here the "purity" and "danger" of the individual temperament and the rules seem to coincide in an extraordinary truce. Sometimes, as in *Corpse and Mirror* (plate 117), a pink passage will gleam over the rule system; and in *Usuyuki* (plate 141), a can imprint will break space. Johns has reconciled the decorative and nondecorative as in the toughest abstractions of Pollock. No chiaroscuro, no mere modulation, no tonal erasures. Their canvases both seem to give an almost unbearable amount of information.

Johns practices what has been called by Lévi-Strauss, in relation to primitive art, "split representation."[76] Like the Kwakiutl art analyzed by Franz Boas and Lévi-Strauss, Johns furnishes instance after instance in which objects are presented with extreme bifurcation, two-profiled as it were. Lévi-Strauss has indicated that this kind of rendering is congruent with situations of extreme masking and unmasking, societal constraints, and situations in which any more fluent plasticity might tear the individual apart. Johns and his plural flags and stiffened body parts present a situation rigid with anxiety. His corpse and mirror drawings are all parts of this interpenetration of the graphic with seemingly sculptural concerns. Split representation is Johns' way, in the formulation of Lévi-Strauss, of "flattening out as well as displaying the mask at the expense of the individual wearing it."[77] It is a presentation of dualisms: "person and impersonation, individual existence and social function, community and hierarchy." Johns' "double drawings" are thus already as provocative as the infinite wallpaper presentations of Warhol. They speak of a tension, of dissociation, and of the social. This is probably why Johns was so fruitful in selecting the public icons as the necessary ground for a meditation on privacy: there was simply no "single" mask that could express the enmeshed condition of the artist. Each line in Johns' *Cicada* drawings is cut in his split representations, and through such splitting he arrives at his integrity.

There are those critics who find themselves impatient with the humble subject matter of Johns and his insistence on returning to the same motifs over and over. Johns' art is that of the lyrical poet who knows he cannot go too far from the studio, the beer cans, and Savarin tins of everyday life, but each day he creates and gets these items of his lived world into better or changing focus. Johns conducts his rigorous analyses and adds new layers to the basic primary representational configuration. Thus, if one were to ask what is the best drawing of Johns, one would have to say his collected works, just as there is no single poem of Frank O'Hara's that does not somehow point to the idea of a lyrical, factual autobiography. Johns' autobiography, like the case histories of Freud analyzed by Steven Marcus, is fractured, nonlinear, and obsessive as the workings of voluntary and involuntary perceptions, but it is history, nonetheless, and an homage and elegy to Cézanne's sensation. The title *In Memory of My Feelings* could be the title of any or all of these drawings.

In an interview with David Sylvester, Johns was quoted as saying: "The most conventional thing, the most ordinary thing—it seems to me that those things can be dealt with without having to judge them; they seem to me to exist as clear facts, not involving aesthetic hierarchy."[78] The irony in relation to Johns' drawings is that almost each makes the conventional a bit difficult, less

clear, more filled with judgment, more involved in the problems of perception. We may say that Johns is polarized as a complex artist. Like certain of the Minimalists whom he has influenced (Donald Judd or Dan Flavin, for instance), he begins with a taste for the antimetaphorical, for the here and now, for the signifier without connotation: a target. For Johns, however, the very concept of an object is often in doubt, and therefore he tears at it, puts a patina on it, cuts through it, and associates it with many fears and sensations. Elsewhere for Johns an object is more dryly itself. This is what constitutes his skepticism. The *Flag* of sixty-four stars (1955; plate 14) is a "doubtful" object; its stripes extend or are torn as if by chance. The most conventional and ordinary thing here excites us to perceptions concerning hierarchy. The unfinished stripes are clear markers against facile modes of clarity. "I doubt, therefore I am" seems to be their emblem. A fictive flag moves beyond the domain of the actual to the possibilities of the mind.

Both Johns and his father were named after a Revolutionary War hero, Sergeant William Jasper (c. 1750–1779), remembered for twice raising the fallen flag, in Charleston and in Savannah. Johns, with his shattered family history, remembers a statue of that hero pointed out by his father. The flag must then be said to be a private dream-image with enormous psychic weight. It is an extraordinary instance of the restorative powers of art that the son could create a portrait of lost time with this image that seems to be *testing the real*. Barbara Rose has spoken of the functionless images of frustrations in Johns.[79] An unemployed word is the word at the edge of sense; the flag that cannot be saluted becomes the image of lost paradise, childhood. All this is, at least, one way to begin to understand the obsessive charm and pathos of these images.

Jasper Johns' drawings have a curious relationship with traditional draftsmanship. Compared, for example, with Seurat's drawings, one begins to see how curiously congruent he is both with Seurat's sense of everyday life in his bathers, models, and parades, and the sense of caricature and darkness that in both explodes any naiveté in their classical handling of motif and composition. There is a darkness in Johns seen before in Rembrandt, as in his series *The Three Crosses*, and again in Goya, whose dark period intrigues the artist. In Johns the darkness has become more literal, more a matter of the factuality of hand and material, and a parody of atmosphere as opposed to the mimetic drive in the old masters and Romantics and Neo-Impressionists. The antimimetic drive of much modernism, however, is opposed in Johns by the passion in him for the real, the desire to incarnate. In this passion for plastic imagination rather than any mere representation, in this passion for the shattering of mirrors and the revelation of devices, Johns is indeed a late Romantic. One begins to understand his passion for Blake, moreover, an admiration that seems to some a fascination with the technical element in his printmaking. Blake, like Johns, was an indomitable master of an antisystem of perception and he knew "the Eye altering alters All."

For Johns the topic has always been that of *erotic and perceptual ambiguity*. From the beginning of his work, there has been a theme of desire, shown by body parts, dismayingly disrupted or shown as impressions, souvenirs, traces of the body. As in *Diver*, it is difficult to

know whether the imagery is about suicide or violent Eros. What has been questioned, however, is whether Oedipal triangulation is the driving force of much of the imagery, since even the flag may stand, as we know from Johns' biography, for contact and violence with the name of the absent father. Playing with numbers or conventional signs is a kind of sexual triumph over the givens of authority. Johns was forced to accept the given as Oedipus was forced to accept Laius on the highway: with defiance and erotic *hubris*. The triumph with and over the forces of the given is a dark confrontation, indeed. The secret of Johnsian ambiguity is the melancholy at murdering the conventional authority. His later confessions of relative weakness *(Souvenir, Perilous Night)* are the necessary expiations of a prince of art.

One of the ways of understanding Johns' drawings is in relation to Paul Schilder's theories of the building up and destroying of the image of the body: "There exists not only a tendency to build up the postural model of the body but also a tendency to destroy this image."[80] Much of Johns' *Studies for Skin*, for example, may be regarded as part of a self-lacerating attack on the image of the body. This might seem self-evident, but Schilder's studies go far to relating Johns' use of signs with the sense of body image.

Language, too, is a wandering part of the body. Schilder says: "We are dealing with the spreading of the body-image into the world. More complicated is the problem of voice and language. The sound produced by me is not completely independent of me. It still remains a part of myself, and we are again dealing with the spreading of the body into the world. . . . The organization of the body-image is a very flexible one."[81] Thus, even Johns' numeral five is indeed a body, a figurative work in every way. His *Figure* drawings have even elicited from the artist a sense that he was making his own species of portraiture: the bodies of numbers.[82] As for Johns' use of single body parts, Schilder may be used in explication: "Single parts of the body are personified. Children and nurses of children personify fingers. It seems that all protruding parts can gain this relative independence in the postural model of the body. . . . The male genitals especially are often personified."[83] Schilder reminds us not to regard all dread in relation to the genitals as a castration anxiety but also as a pregenital fear of losing the inside of the body. Much of Johns' ferocious exteriorization might be regarded as so suggestive because it is such a resonant system of defense against this vast early dread.

Meyer Schapiro has employed Schilder in trying to understand Picasso's resonant use of bodily distortion to give us some sense of the body as felt from within: the "internality of the body."[84] Johns succeeds paradoxically not through obvious distortions, not through surreal elongations or etiolations, not through that spatial change that might symbolize the different interior mapping of, say, a headache or an arousal. Johns uses changing tones in his dark stains of hands (see *Land's End*, plate 122) to present a change in the feeling-tone of the body image and the instability of our inner picture of these most sensitive zones.

In his use of language and signs, Johns finds his own body by projection in the outer world. This gives an enormous sense of stability compared to the dismembered friezes that predominate in

Surrealist paranoias of, say, Dali. Johns too presents a frieze of body parts, but above a target that maintains the stability of a strong if not cruel body. Where the body seems almost absent, in his blankest beer cans or sullen dry flags, one may be permitted to find an analogy with the highest pitch of melancholy.

Johns has been placed in the company of literary men such as Hart Crane, Frank O'Hara, and Samuel Beckett, but perhaps the poet closest to his own mode is John Ashbery. Both Johns and Ashbery have come close to announcing cliché or the public given as a paradoxically precious possession, and yet both have created a much more sustained and capacious art than any reduction to parody or "Pop" might indicate. Ashbery begins a poem such as "Decoy," a title used curiously enough by Johns, too, with the harping on cliché: "We hold these truths to be self-evident,"[85] but the truths are those of exile and moral estrangement from those very truths.

Both Ashbery and Johns were influenced by the idea of the random in Pollock and Cage. Ashbery speaks of the great liberties he found in Cage's simultaneous pieces; he himself has composed a domestic comedy of the ego in poems with double columns such as "Litany." Neither Johns nor Ashbery was converted to the religion of the random, however, and both have concentrated on a field in which personal expressivity emerges from seemingly impersonal or abstract modes. Both are masters of the fragment accepted as a fragment. Ashbery comically called one of his most sustained pieces "Fragment." In both, the theme of self-mutilation and a nostalgia for the possible states of wholeness are persistent. Ashbery has said that he resembles Johns "in the lazy exploration of himself,"[86] laziness signifying the persistent investigatory way. Both could have remained satisfied with a Joseph Cornell-like miniaturization of their talents, and both have succeeded in moving on to works of great scale. Influenced alike by Duchamp, both have been unwilling to duplicate his negations. Both are American Surrealists holding the everyday as the marvelous.

The *memento mori* has never been far from Johns and is always part of his drawings. In *Perilous Night* the trace of the sword tilts to a resurrected Christ that we do not see, plunged in the random night of such music: John Cage bespeaking worldly loneliness. The dark arm shows us our rotating view of discontinuous time. In a representation of Cézanne, we are given a Peto-like view of a postcard as a memory of art history and an homage to it. The *No* of Johns may be a Japanese "of" as the artist has asserted, but it seems to us a resounding negative. In *Dancers on a Plane* we are given the frame of deadened utensils: as if, from Eliot's "The Hollow Men," we were to hear: "Shape without form, shade without colours/Paralysed force, gesture without motion."[87]

Other *memento mori* abound for an artist who loves the skulls of Cézanne. Is not the flag itself the imperial skull? Claes Oldenburg has spoken of keeping his common objects as a kind of doomsday book or registry of the collective will, and Johns precedes him in this perhaps unconscious desire. *0 Through 9* is a way of erasing or destroying an encyclopedia of numbers; the reference to the Pope at Auschwitz is one notation of *Cicada* that also includes the darkest skull and crossbones. Still life as *vanitas* presides: the beer cans arose from a deposition of their

triviality. *Land's End* and *Periscope* are both images of struggle, the struggle to trace and erase. And in *Diver*, we have not so much images of vanity but suicide and the cruel sea itself.

We may compare Johns' work with what certain Freudians call "isolation." Isolation may be seen in the disjunction between ideas and emotion, in certain rituals and their strange relation to emotion, and in the breakdown in the flow of ideas. From the beginning, Johns' work has had an obsessional characteristic. His seriality is not merely a meditation on mechanical reproduction, but from the first targets a practice in disjunction: body parts isolated in their boxes next to a target cut off from the reality of *practice*. The numerals, alphabets, flags are all images cut off from use. They are rituals of isolation and are a critique of a culture of signs and even more a so-called culture of hate, in which man enraged confronts a horizon of conventional meanings and conventional critics (see *The Critic Sees*, plate 63).

Johns' art is one of maturation and sublimation. As such it is the drawing of Freud's *Civilization and Its Discontents*, because the sublimated mature artist alone can know the price it takes to speak in ordinary tones. Johns may know of Freud's dictum that he wanted to teach others how to pass from "hysterical misery to ordinary unhappiness" or everyday misery. We may note that the flag, the target, the beer cans are signs of an ordinary unhappiness, but they are the ways that Johns has tamed expressionism in its more or less hysterical varieties.

When I first viewed Johns' works in the late 1950s, they struck me as the most hauntingly purgatorial images. In many funeral rituals, effigies of men are used as primitive mannequins to ritualize notions of death. In this, perhaps, lies the relation between his earliest targets and recent preoccupations with the skull; Johns is always engaging in the ritual of the effigy or relic. This might make his work seem an allegorical *Trauerspiel* or play of mourning: a theater of memory.

But there is a positive aspect of Johns' work in his preference for reviving, underlining, and restoring everyday life. He draws a target, a flag, a beer can, or even a postcard of Cézanne, because these things have become deadened or invisible objects. Even the number eight can become as invisible as street noise or everyday gestures. As Johns has attempted to deautomatize our responses, even this is a critical mode. His imagery is at once grave and alive and establishes a fundamental unity.

Everything is a metaphor, even the word *metaphor*, and even the word *literal*, as in the art of Jasper Johns.

Notes

1. Ludwig Wittgenstein, *On Certainty*, translated by Denis Paul and G. E. M. Anscombe (New York: Harper & Row, 1972), p. 19e.
2. Judith Goldman, *Jasper Johns: Prints 1977–1981*, Thomas Segal Gallery Catalogue, Boston, October 24–December 2, 1981.
3. Lloyd Goodrich, *Albert P. Ryder* (New York: George Braziller, Inc., 1959), p. 11.
4. *Ibid.*, pp. 14–15.
5. *Ibid.*, p. 21.
6. Max Kozloff, *Jasper Johns* (New York: Harry N. Abrams, Inc., 1969), p. 47.
7. Richard Rorty, *Philosophy and the Mirror of Nature* (Princeton, New Jersey: Princeton University Press, 1979), pp. 357–394.
8. Arthur C. Danto, "The Transfiguration of the Commonplace" in *The Journal of Aesthetics and Art Criticism*, XXXIII/2, Winter 1974, p. 148.
9. Angus Fletcher, *Allegory: The Theory of the Symbolic Mode* (Ithaca: Cornell University Press, 1964).
10. Danto, *op. cit.*, p. 148.
11. Gilles Deleuze, *Proust and Signs*, translated by Richard Howard (New York: George Braziller, Inc., 1972), p. 4.
12. *Ibid.*, p. 16.
13. *Ibid.*, p. 67.
14. Author's interview with Jasper Johns, December, 1982.
15. Barbara Rose, "Johns: Pictures and Concepts" in *Arts*, Vol. 52, November, 1977, pp. 148–153. See James Gibson, *The Senses Considered as Perceptual Systems* (Boston: Houghton Mifflin Company, 1966).
16. Ellen Johnson in *Jasper Johns Drawings*. The Arts Council of Great Britain, 1974–1975.
17. Robert W. Hanning and David Rosand, *Castiglione: The Ideal and the Real in Renaissance Culture* (New Haven: Yale University Press, 1983).
18. Author's interview with Jasper Johns, December, 1982.
19. Rudolf Arnheim, *The Power of the Center: A Study of Composition in the Visual Arts* (Berkeley: University of California Press, 1982).
20. Jasper Johns, "Sketchbook Notes" in *Art and Literature*, No. 4, Spring, 1965, pp. 185, 187.
21. Roberta Bernstein, "'Things the Mind Already Knows': Jasper Johns' Paintings and Sculpture, 1954–1974" (Ph.D. diss., Columbia University, 1975), p. 122.
22. *Ibid.*, p. 123.
23. William Rubin, "Cézannisme and the Beginnings of Cubism" in *Cézanne: The Late Work* (New York: The Museum of Modern Art, 1977), p. 162.
24. Meyer Schapiro, *Modern Art: Nineteenth and Twentieth Centuries* (New York: George Braziller, Inc., 1978), p. 45.
25. Bernstein, *op. cit.*, p. 125.
26. *Ibid.*, p. 127.
27. Yves Bonnefoy, "Imperfection is the Summit," translated by Anthony Rudolf in *The Random House Book of Twentieth-Century French Poetry* (New York: Random House, 1982), p. 445.
28. Schapiro, *op. cit.*, pp. 1–38.
29. Barbara Novak, *American Painting of the Nineteenth Century* (New York: Praeger, 1969), p. 211.
30. Thomas B. Hess, *Willem de Kooning* (New York: George Braziller, Inc., 1959), p. 23.
31. Author's conversation with Jasper Johns, 1971.
32. D. W. Winnicott, *Playing and Reality* (New York: Tavistock Publications, 1971), pp. 1–25. See Peter Fuller's discussion of Winnicott in *The Naked Artist: 'Art and Biology' & Other Essays* (London: Writers and Readers, 1983), pp. 233–240.
33. Author's interview with Lois Long, 1983.
34. Frank O'Hara, "In Memory of My Feelings" in *The Collected Poems of Frank O'Hara* (New York: Alfred A. Knopf, 1971), p. 256.
35. Jasper Johns in an interview with David Sylvester in *Jasper Johns Drawings*. The Arts Council of Great Britain, 1974–1975, p. 8.
36. Kozloff, *op. cit.*, p. 47.
37. Wallace Stevens, "The Man on the Dump" in *The Collected Poems of Wallace Stevens* (New York: Alfred A. Knopf, 1954), p. 203.
38. Bernice Rose, *Drawing Now* (New York: The Museum of Modern Art, 1976), p. 30.
39. Schapiro, *op. cit.*, pp. 111–120.
40. Kozloff, *op. cit.*, p. 46.
41. Viktor Shklovsky, "Art as Technique" and "Sterne's

Tristram Shandy: Stylistic Commentary" in *Russian Formalist Criticism: Four Essays*, translated by Lee T. Lemon and Marion J. Reis (Lincoln: University of Nebraska Press, 1965), pp. 3–57.

42. Nina Sundell, *The Robert and Jane Meyerhoff Collection: 1958–1979* (Copyright © 1980 by Jane B. Meyerhoff and Nina Sundell), p. 31.

43. *Ibid.*, p. 31.

44. *Ibid.*

45. Wittgenstein, *op. cit.*, p. 2e.

46. Bernstein, *op. cit.*, p. 179.

47. *Ibid.*, p. 188.

48. *Ibid.*, p. 240.

49. Franz Kafka, *Letter to His Father*, translated by Ernst Kaiser and Eithne Wilkins (New York: Schocken Books, 1966), p. 77.

50. Goldman, *op. cit.*

51. O'Hara, *op. cit.*, p. 258.

52. Michael Crichton, *Jasper Johns* (New York: Harry N. Abrams, 1977), p. 49.

53. Rose, *op. cit.*, pp. 30–37.

54. Stevens, "The Idea of Order," *op. cit.*, p. 130.

55. Meyer Schapiro, *Words and Pictures: On the Literal and the Symbolic in the Illustration of the Text* (The Hague: Mouton, 1971), pp. 37–49.

56. Hart Crane, "Cape Hatteras" in *The Bridge* (New York: Liveright, 1970), p. 40.

57. Willem de Kooning, "Content is a Glimpse" in Harold Rosenberg, *De Kooning* (New York: Harry N. Abrams, 1978), p. 205.

58. Ajit Mookerjee, *Tantra Art: Its Philosophy and Physics* (New York: Ravi Kumar, 1966), p. 19.

59. *Ibid.*, p. 35.

60. *Ibid.*, p. 110.

61. Philip Rawson, *The Art of Tantra* (New York: Oxford University Press, 1978), p. 116.

62. *Ibid.*, p. 122.

63. Ludwig Wittgenstein, *Philosophical Investigations*, translated by G. E. M. Anscombe (New York: Macmillan, 1953), p. 178e.

64. Author's conversation with Merce Cunningham.

65. Joseph Masheck, *The Carpet Paradigm: Prolegomena to a Theory of Flatness (From the Reform of Victorian Design to Modern Painting)* (New York: Out of London Press, forthcoming).

66. Sundell, *op. cit.*, p. 31.

67. Ludwig Binswanger, "The Existential Analysis School of Thought," translated by Ernest Angel in *Existence: A New Dimension in Psychiatry and Psychology*, edited by Rollo May, Ernest Angel, Henri F. Ellenberger (New York: Simon and Schuster, 1958), pp. 191–213.

68. Judith Goldman, *Jasper Johns: 17 Monotypes* (West Islip, New York: Universal Limited Art Editions, 1982), unpaged.

69. Author's conversation with Jasper Johns, 1983.

70. Author's conversation with Jasper Johns, 1982. See Françoise Gilot and Carlton Lake, *Life with Picasso* (New York: Avon Books, 1964).

71. Otto Rank, *The Double: A Psychoanalytic Study* (New York: New American Library, 1979), p. 49.

72. Samuel Weber, *The Legend of Freud* (Minneapolis: University of Minnesota, 1982), p. 2.

73. *Ibid.*

74. Friedrich Hölderlin, "Hälfte des Lebens," author's translation.

75. Rainer Maria Rilke, "Vorgefühl," author's translation with Christopher Hawthorne.

76. Claude Lévi-Strauss, *Structural Anthropology*, translated by Claire Jacobson and Brooke Grundfest Schoepf (New York: Basic Books, 1963), pp. 245–268.

77. *Ibid.*, p. 262.

78. Sylvester, *op. cit.*, p. 7.

79. Barbara Rose, "The Graphic Work of Jasper Johns" in *Artforum*, September, 1970, pp. 65–74.

80. Paul Schilder, *The Image and Appearance of the Human Body: Studies in the Constructive Energies of the Psyche* (New York: International Universities Press, 1950), p. 188.

81. *Ibid.*, p. 188.

82. Bernstein, *op. cit.*, p. 43.

83. Schilder, *op. cit.*, p. 189.

84. Meyer Schapiro, "Picasso: Three Lectures," Columbia University, 1980.

85. John Ashbery, "Decoy" in *The Double Dream of Spring* (New York: The Ecco Press, 1976), p. 31.

86. Author's conversation with John Ashbery.

87. T. S. Eliot, "The Hollow Men" in *The Complete Poems and Plays, 1909–1950* (New York: Harcourt Brace and Company, 1958), p. 56.

Plates

11

Untitled. *1954.*
Pencil on stained paper, 9 × 7¼".
Collection the artist

12

Target with Plaster Casts. *1955.*
Pencil on paper,
9 × 7⅝".
Collection Antoinette Castelli

13

Target with Four Faces. *1955.*
Pencil on paper,
9¼ × 7⅞".
Collection the artist

14
Flag. *1955.*
Pencil on paper,
6⅝ × 8¾".
Collection the artist

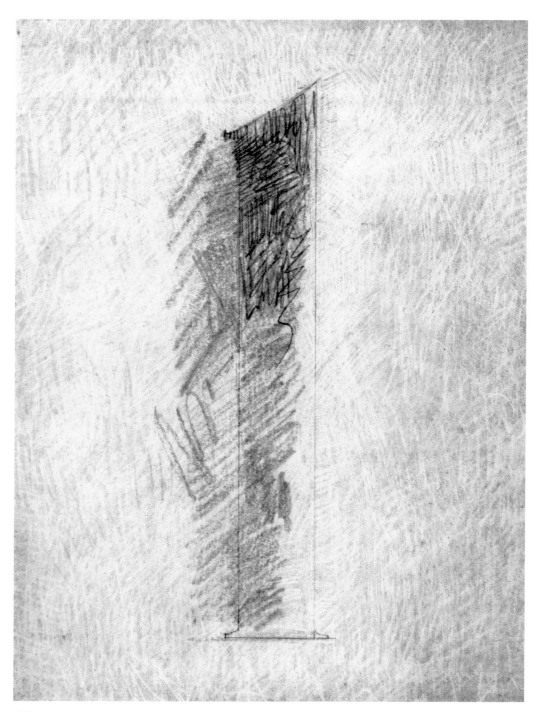

15

Figure 1. *1956.*
Pencil on board,
9½ × 7½".
Collection Praxis Group

16

Target. *1956.*
Pencil on board,
9⅞ × 7⅞".
Collection Dan Flavin,
East Hampton, New York

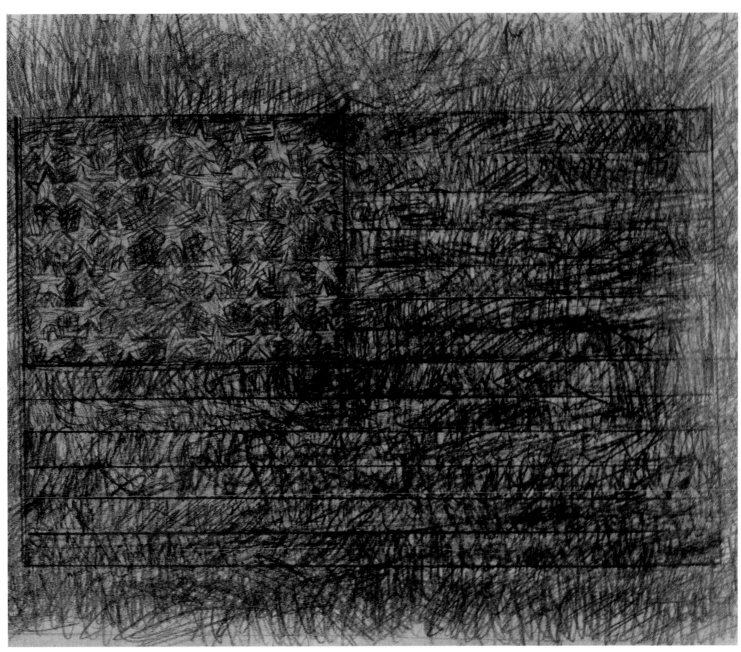

17

Green Flag. *1956. Pencil, crayon, and collage on paper,*
$5^{3}/_{4} \times 8''$.
Collection Lois Long

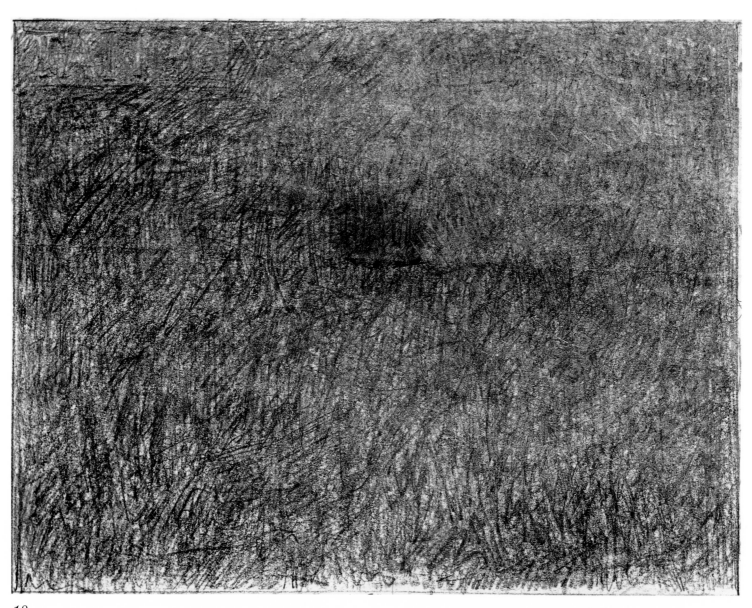

18

Tango. *1956.*
Pencil on paper,
5⅜ × 7".
Collection Akira Ikeda

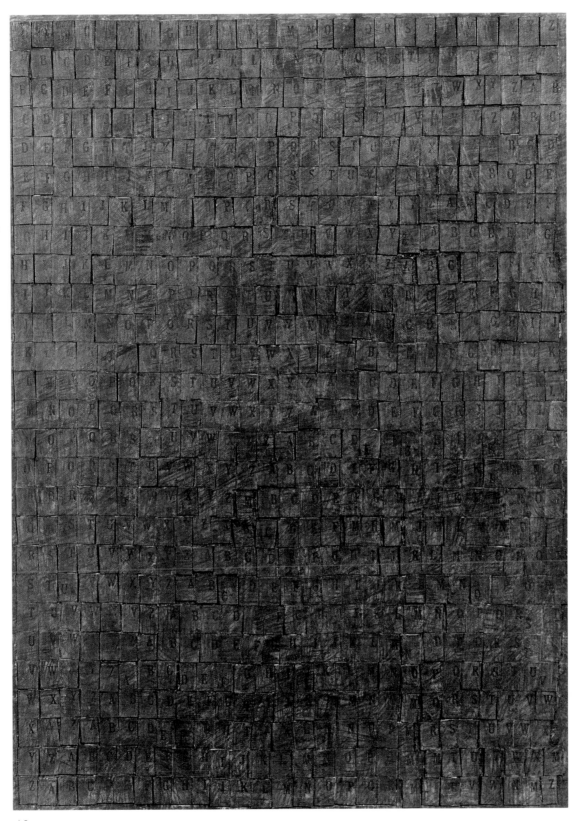

19

Alphabets. *1957.*
Pencil and collage on paper,
15 × 10⅞".
Collection Robert and Jane Rosenblum, New York

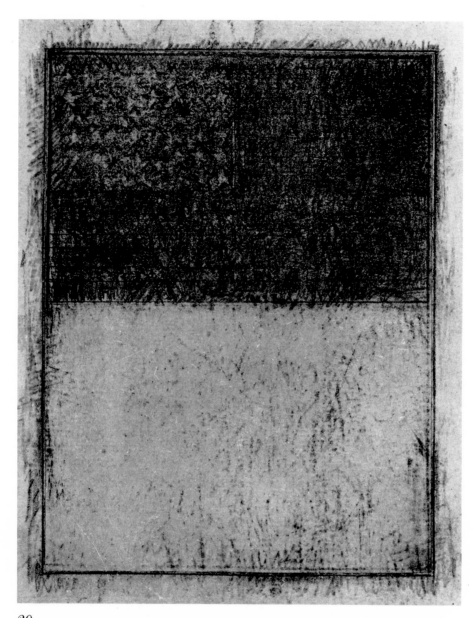

20

Flag Above White. *1957.*
Pencil on paper,
4⅝ × 3¾".
Collection the artist

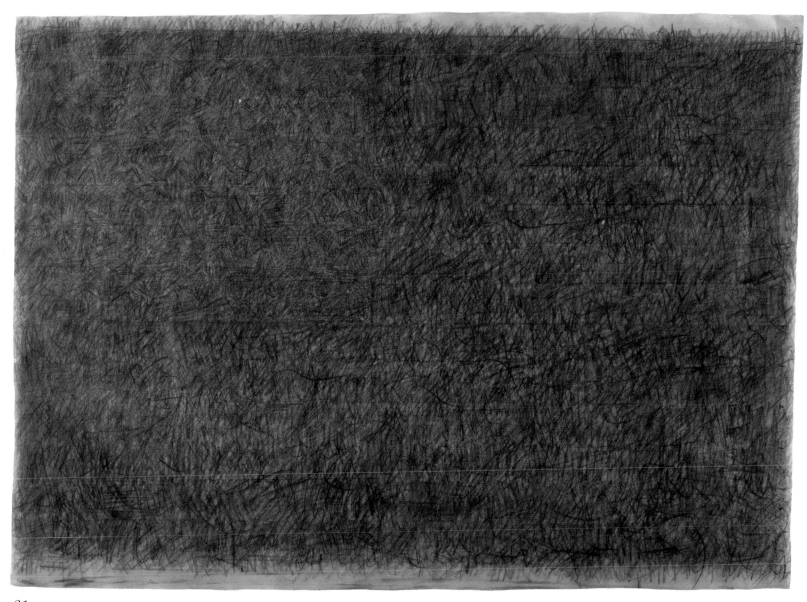

21

Flag. *1957.*
Pencil on paper,
10⅞ × 15¼".
Collection the artist

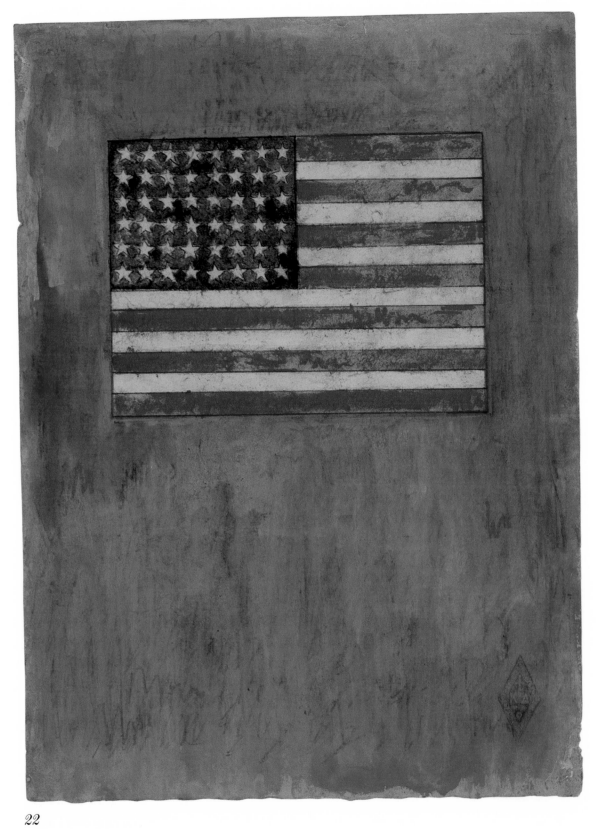

22

Flag on Orange Field. *1957.*
Fluorescent paint, watercolor,
chalk, and pencil on paper,
10½ × 7¾".
Collection Janie C. Lee

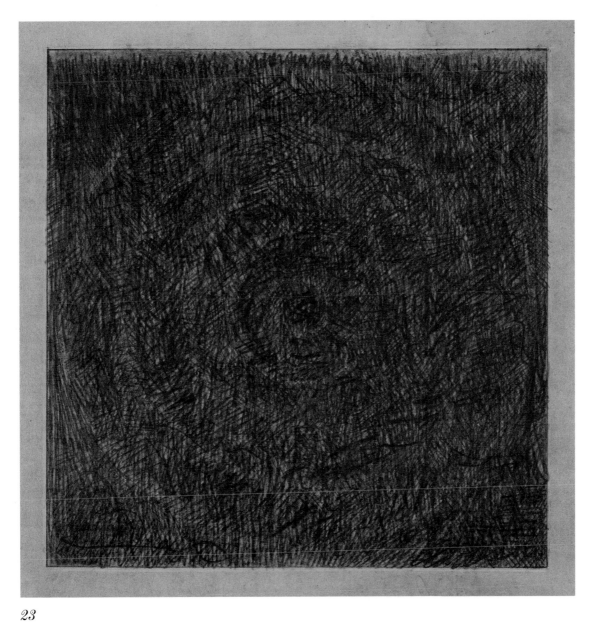

23

Green Target. *1958.*
Pencil and wash on board,
6¾ × 6¾".
Collection Mr. and Mrs. Leo Castelli

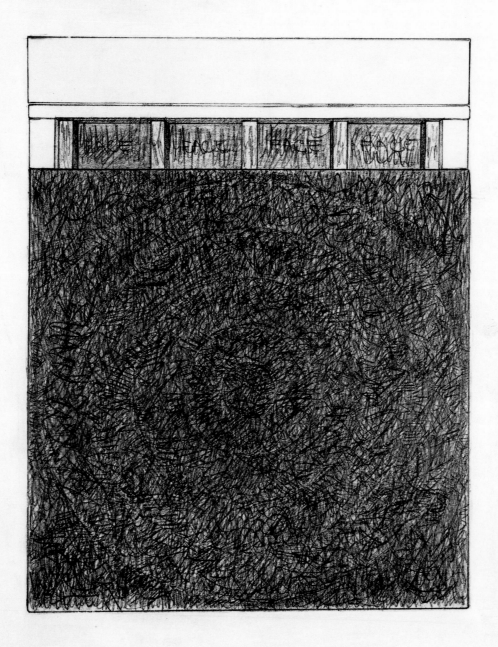

24

Target with Four Faces. *1958.*
Pencil and gouache on paper,
13⅜ × 10¼".
Private collection

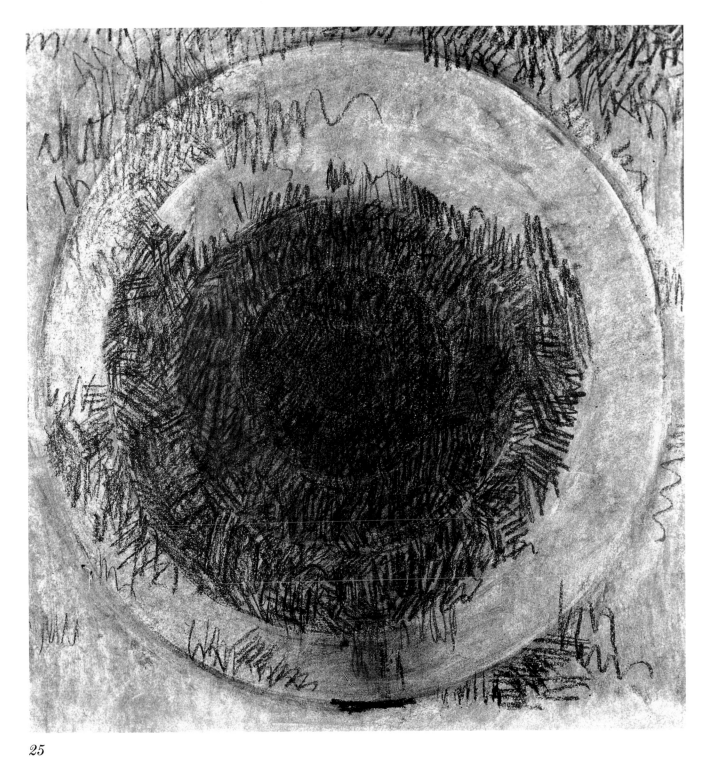

25

Target. *1958.*
Conté crayon on paper,
15¼ × 14⅝".
Collection Mr. and Mrs. Andrew Saul

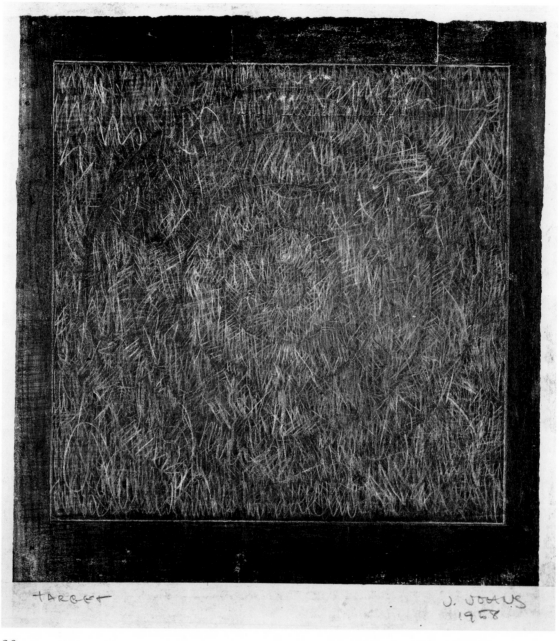

26

Target. *1958.*
Pencil, wash, and collage on paper,
13½ × 12".
The Fort Worth Art Museum, Texas

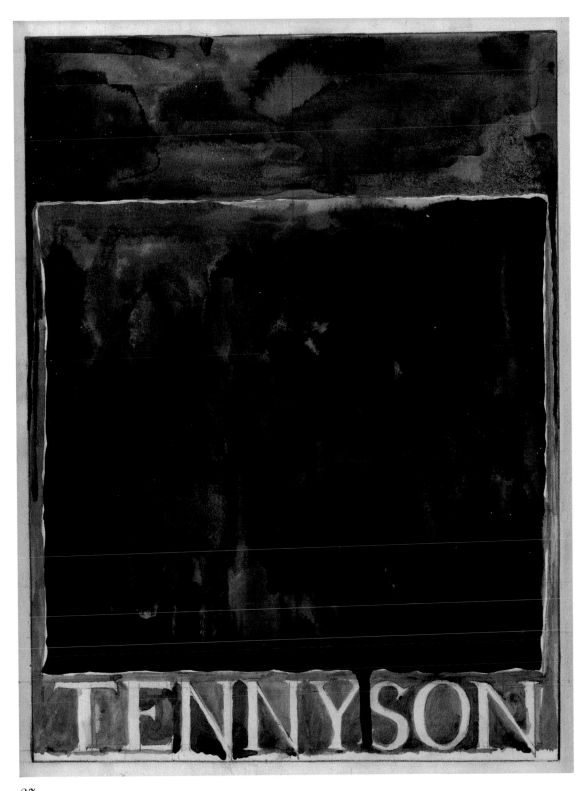

27

Tennyson. *1958.*
Ink on paper,
11⅝ × 8¾".
Collection the artist

28

Hook. *1958.*
Conté crayon on paper,
17 × 20¾".
Private collection

29

Study for "Painting with a Ball." *1958.*
Conté crayon on paper,
15⅛ × 14⅝".
Collection the artist

30

Numbers. *1958.*
Conté crayon on paper,
30½ × 24".
Ohara Museum of Art,
Kurashiki-City, Japan

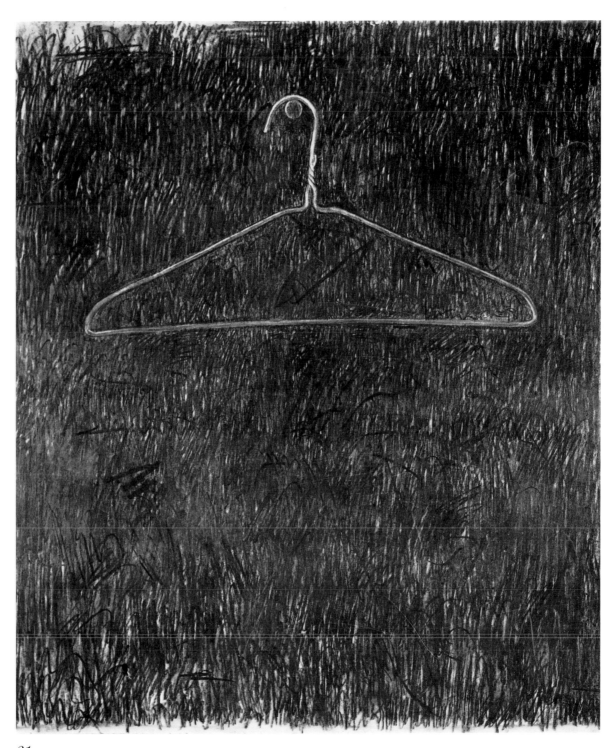

31

Coat Hanger. *1958.*
Conté crayon on paper,
24¼ × 21½".
Private collection

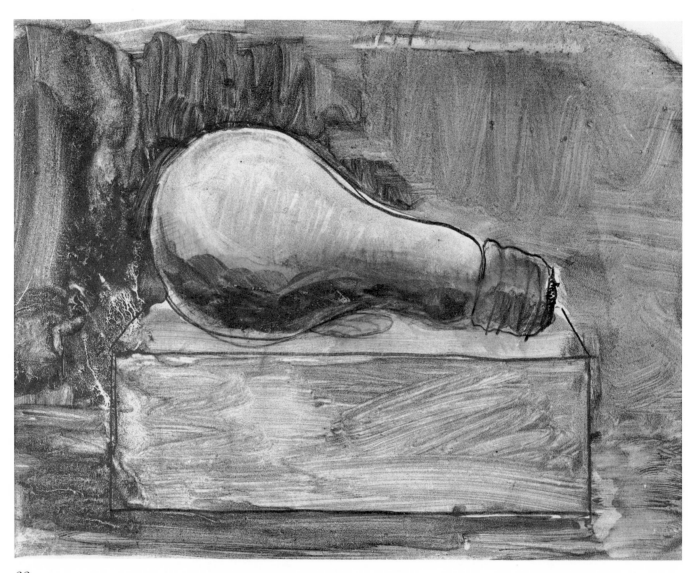

32

Light Bulb. *1958.*
Pencil and graphite wash on paper,
6⅝ × 8⅝".
Private collection

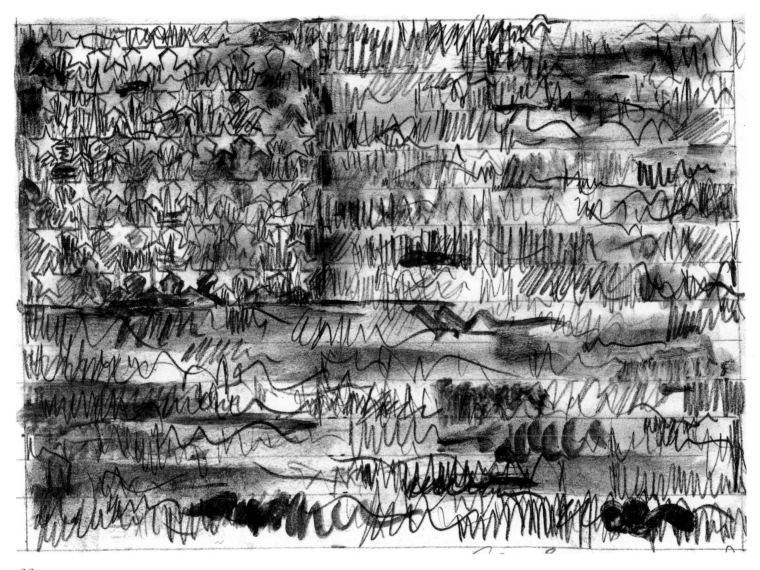

33

Flag. *1958.*
Pencil and graphite wash on paper,
7½ × 10⅝".
Collection Mr. and Mrs. Leo Castelli

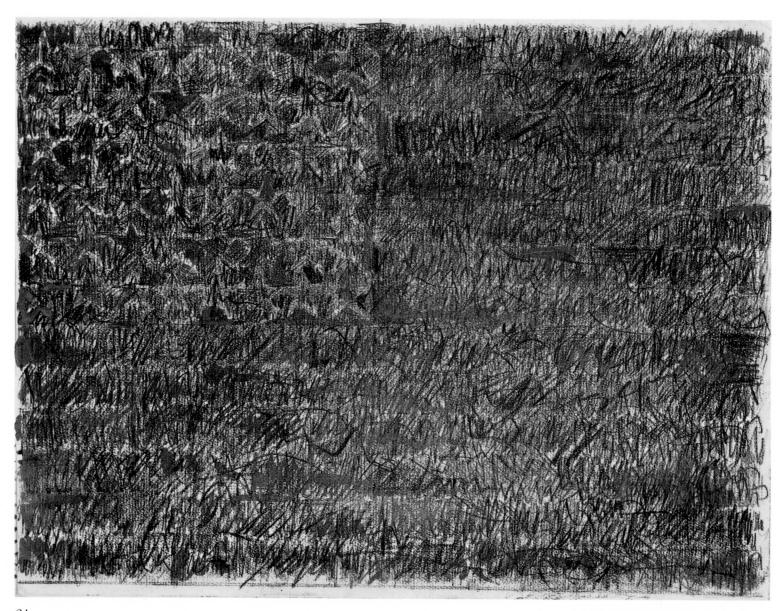

34

Flag. *1959.*
Pencil and graphite wash on paper,
11 × 15⅝".
Collection Mildred S. Lee

35

Flag. *1959.*
Pencil and graphite wash on paper,
7³⁄₈ × 11".
Private collection

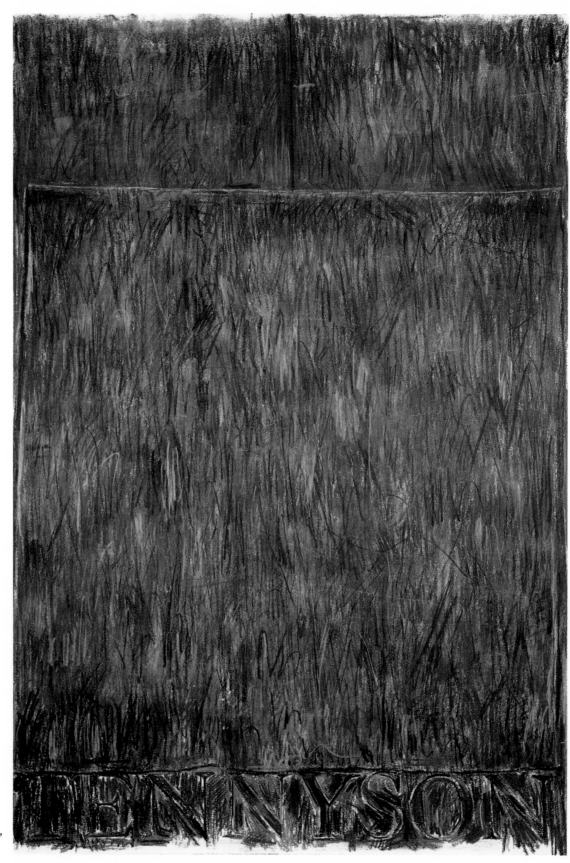

36

Tennyson. *1959.*
Chalk on paper,
25½ × 17½".
Hirshhorn Museum
and Sculpture Garden,
Smithsonian Institution,
Washington, D.C.

37
Flag. *1959.*
Graphite wash on paper,
10⅜ × 15".
Collection Robert C. Scull

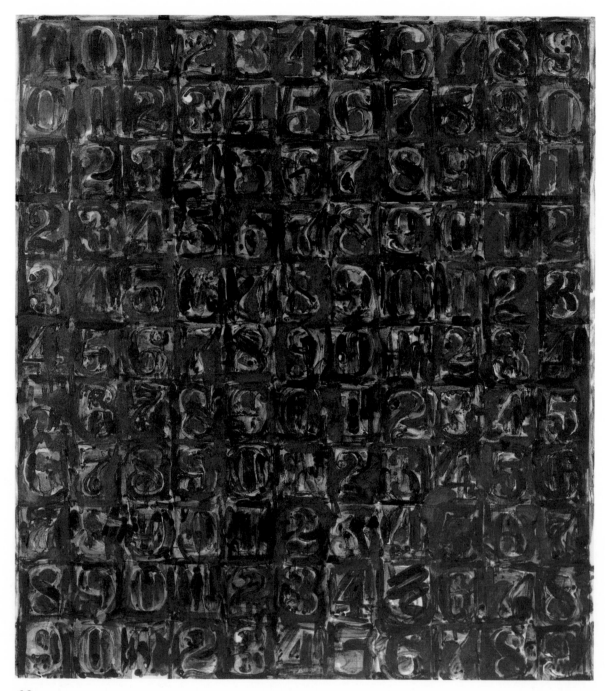

38

Numbers. *1960.*
Graphite wash on paper,
21 × 18".
Private collection, Boston

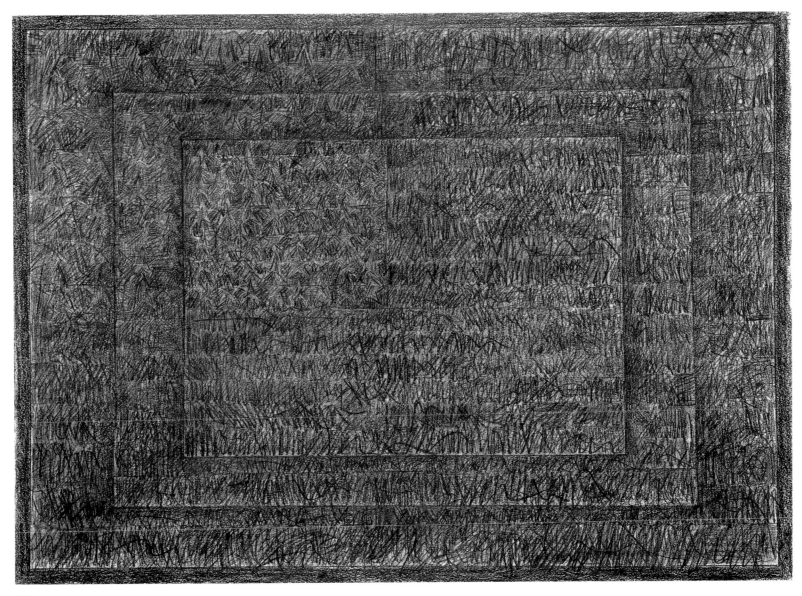

39

Three Flags. *1959.*
Pencil on paper,
14 × 19¾".
Victoria and Albert Museum,
London

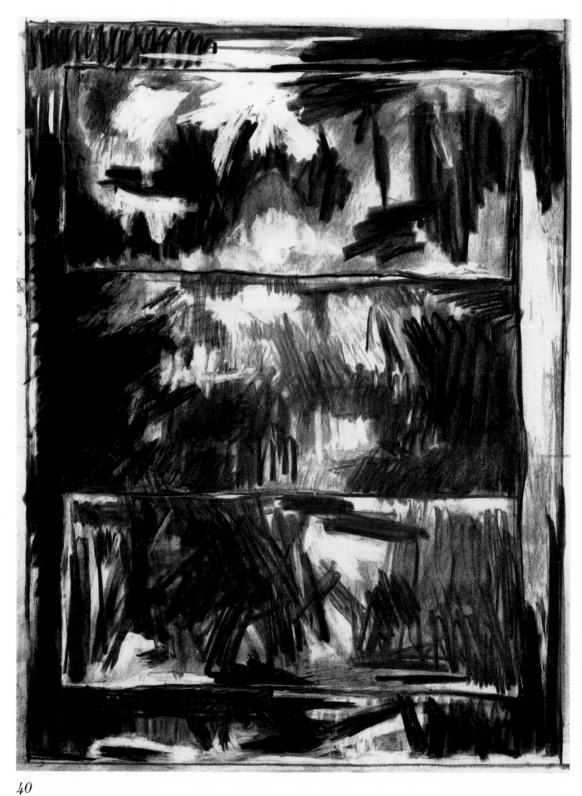

40

Reconstruction. *1960.*
Charcoal on paper,
26¾ × 20¼".
Collection Mr. and Mrs. Victor W. Ganz

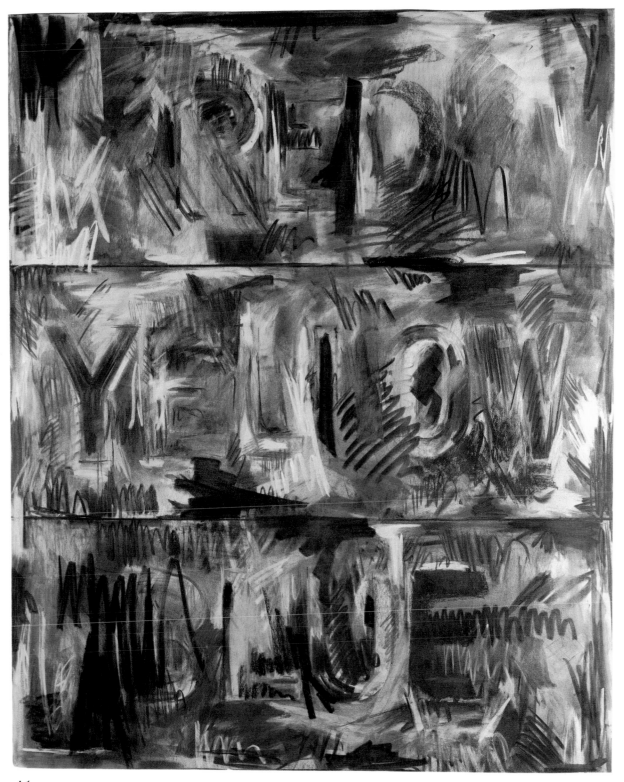

41

Out the Window. *1960.*
Charcoal and chalk on paper,
34⅜ × 28⅜".
Private collection

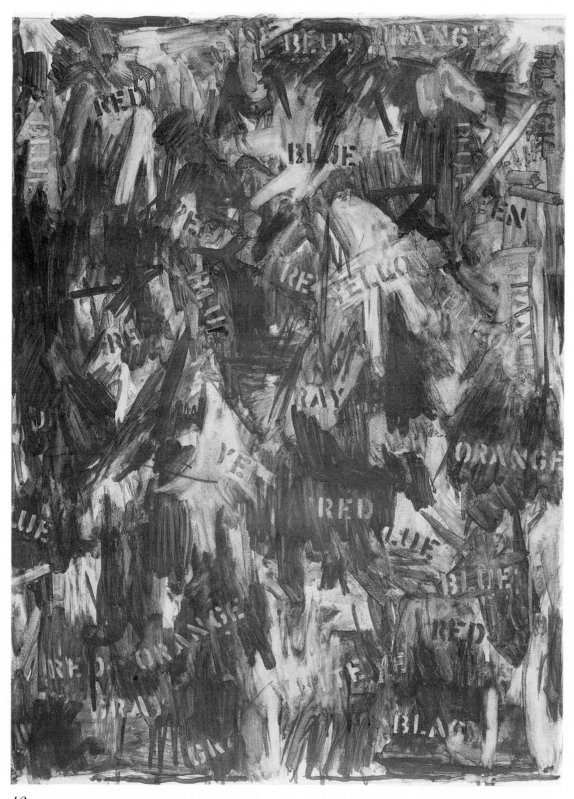

42

Jubilee. *1960.*
Graphite wash on paper,
28 × 21".
The Museum of Modern Art, New York.
The Joan and Lester Avnet Collection

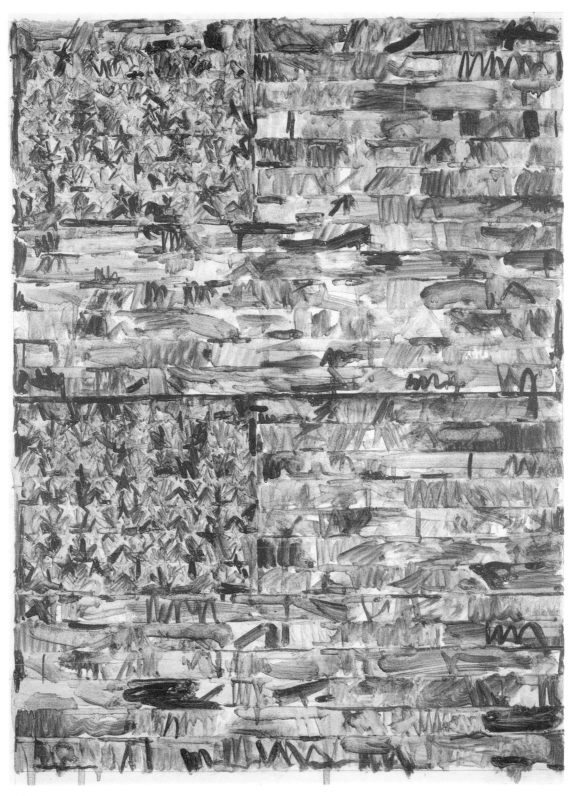

43
Two Flags. *1960.*
Graphite wash on paper,
27 × 20½".
Collection the artist

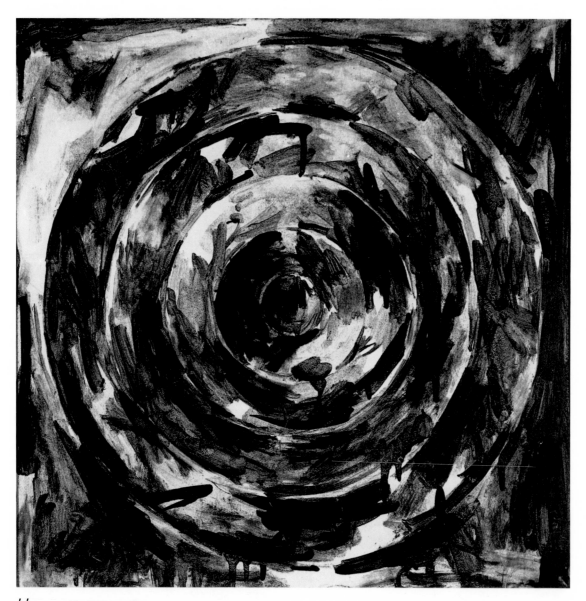

44

Target. *1960.*
Graphite wash on paper,
13¼ × 13¼".
Allen Memorial Art Museum,
Oberlin College, Ohio.
Fund for Contemporary Art
and National Foundation for Art
and Humanities Grant, 68.31

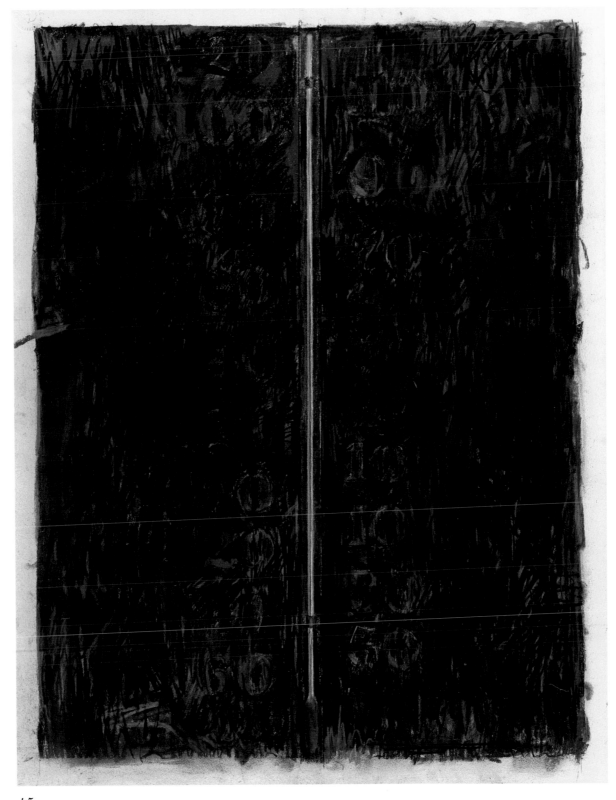

45
Thermometer. *1960.*
Charcoal and chalk on paper,
20¾ × 15⅞".
Collection the artist

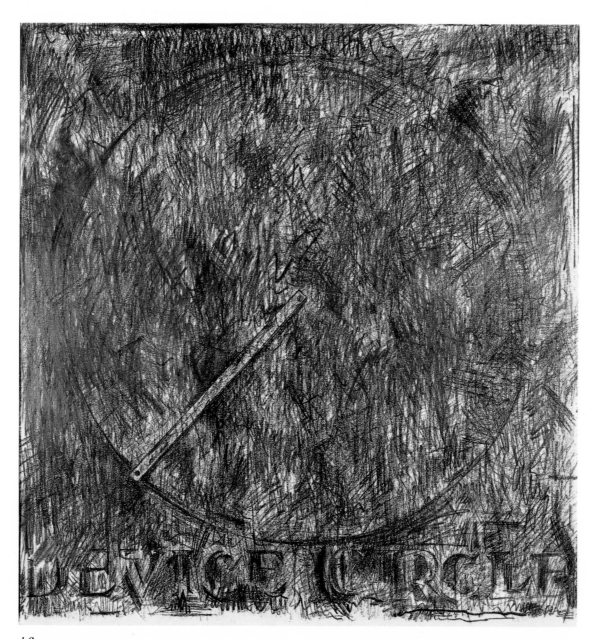

46

Device Circle. *1960.*
Pencil on paper,
15⅛ × 15⅛".
Private collection

47
0 Through 9. *1960.*
Charcoal on paper,
29 × 23".
Collection the artist

48

Three Flags. *1960.*
Pencil on board, mounted on three levels,
11⅞ × 16⅝".
Collection Hannelore Schulhof

49

Night Driver. *1960.*
Charcoal, chalk, and collage on paper,
45 × 37".
Collection Robert and Jane Meyerhoff,
Phoenix, Maryland

50

Figure 5. *1960.*
Charcoal on paper,
18 × 13½".
Collection Gerard Bonnier, Stockholm

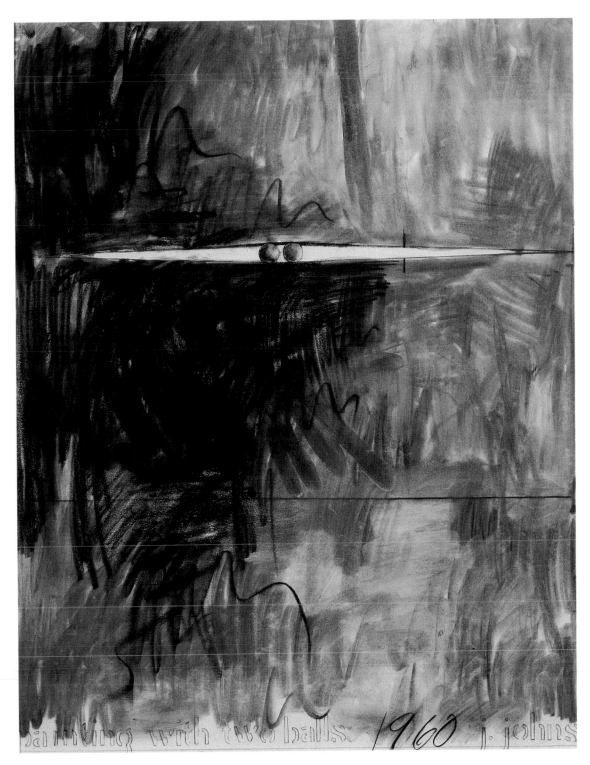

51

Painting with Two Balls. *1960.*
Charcoal, chalk, and pencil on paper,
19⅝ × 15⅜".
Hirshhorn Museum and Sculpture Garden,
Smithsonian Institution, Washington, D.C.

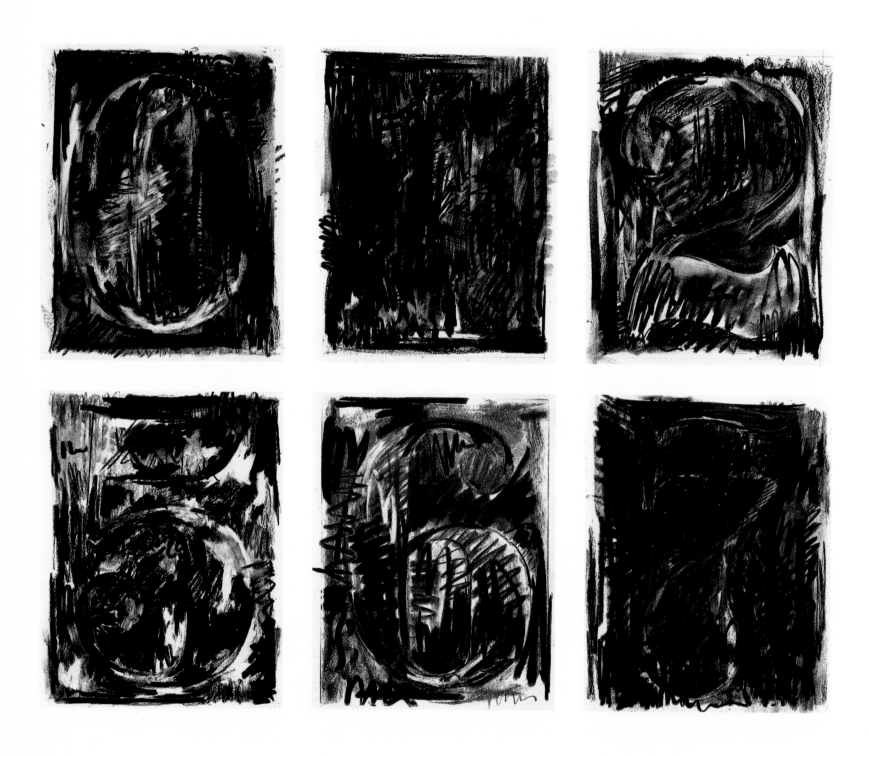

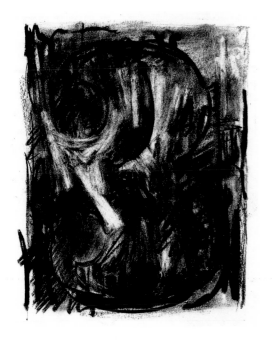
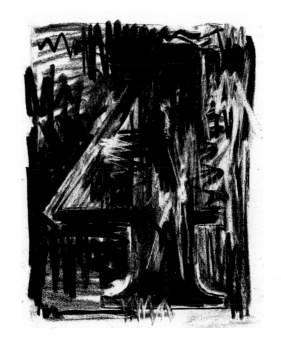
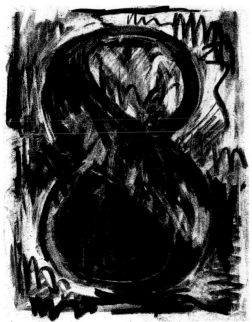
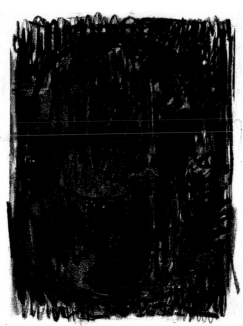

52
Ten Numbers. *1960.*
Charcoal on paper,
9½ × 7½″ each.
Collection the artist

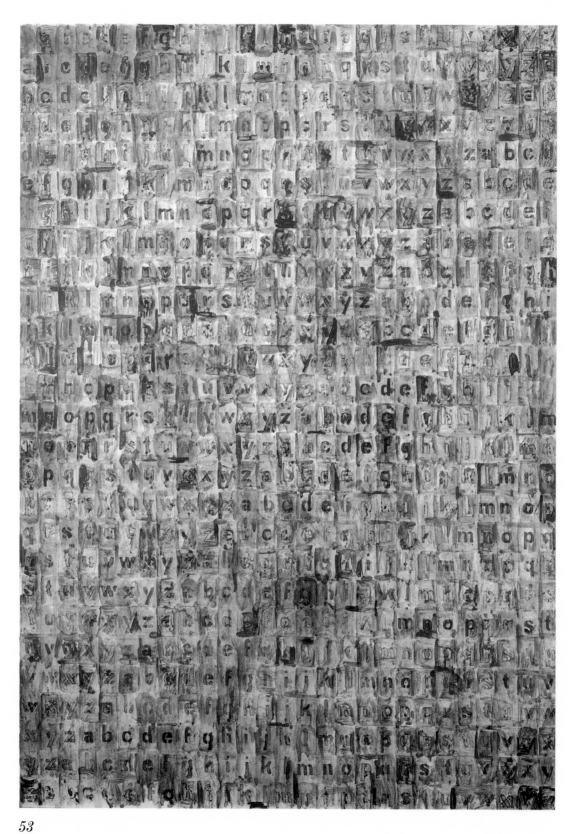

53

Gray Alphabets. *1960.*
Graphite wash on paper,
33½ × 23⅞".
Collection Antoinette Castelli

54

0 Through 9. *1961.*
Charcoal and chalk on paper,
54 × 45".
Collection Robert C. Scull

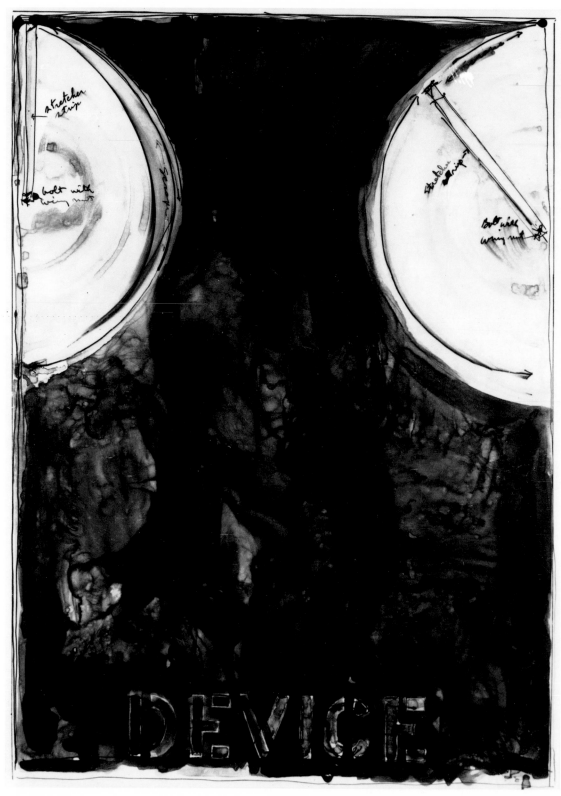

55

Device. *1962.*
Ink on nylon film,
21 × 15½".
Collection Mr. and Mrs. Leo Castelli

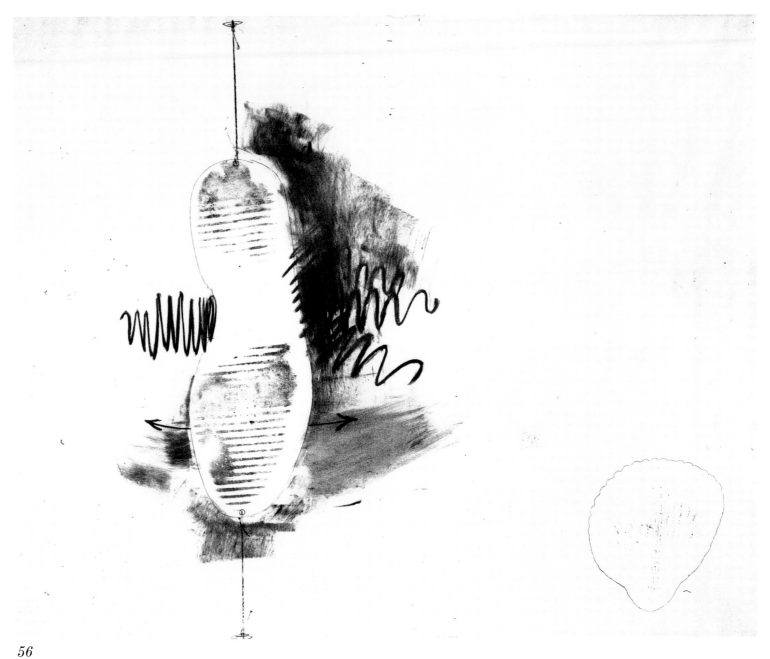

56

Edisto. *1962.*
Charcoal and pencil on paper,
21 × 27".
Collection the artist

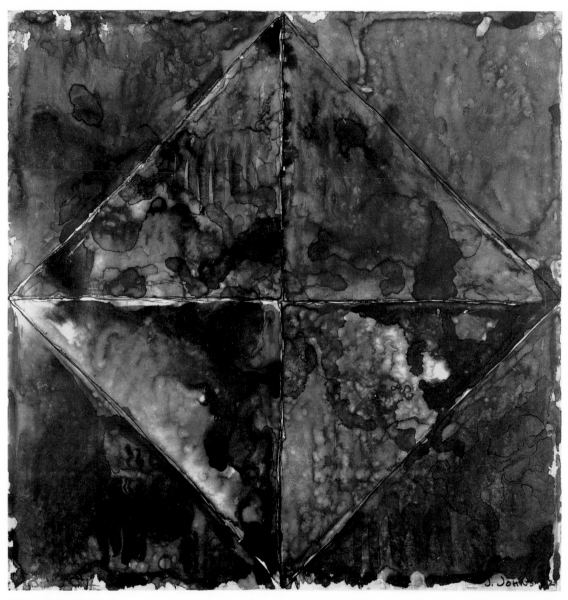

57

Disappearance II. *1962.*
Ink on nylon film,
18 × 18".
Collection the Honorable and Mrs. Gilbert Hahn, Jr.

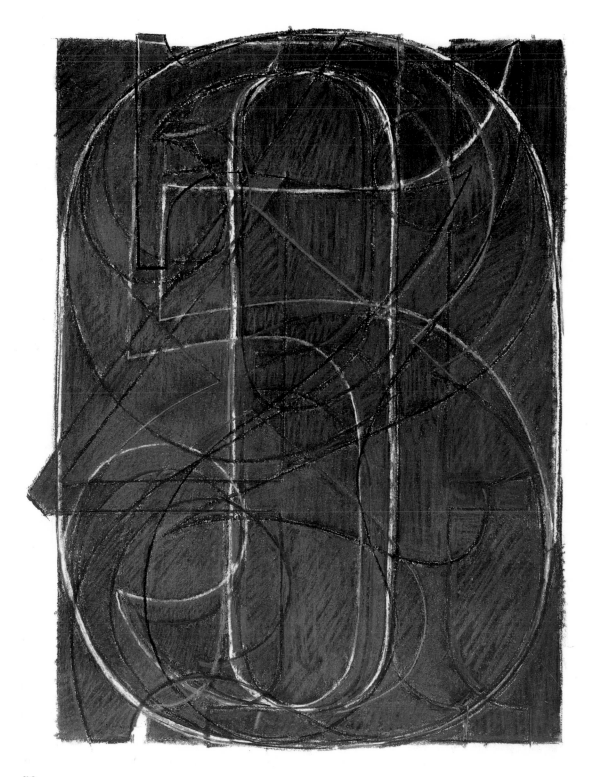

58

0 Through 9. *1962.*
Chalk on paper,
30 × 22⅛".
Hirshhorn Museum and Sculpture Garden,
Smithsonian Institution, Washington, D.C.

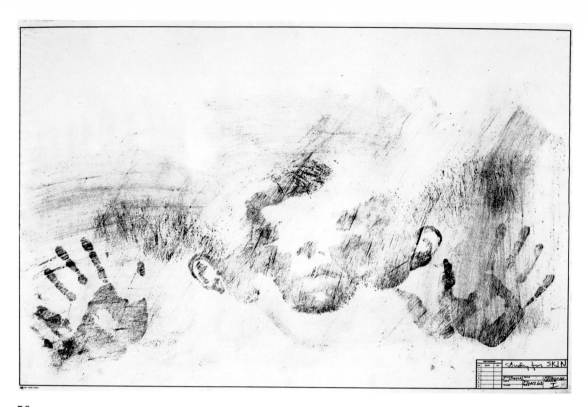

59

Study for "Skin I." *1962.*
Charcoal on paper,
22 × 34".
Collection the artist

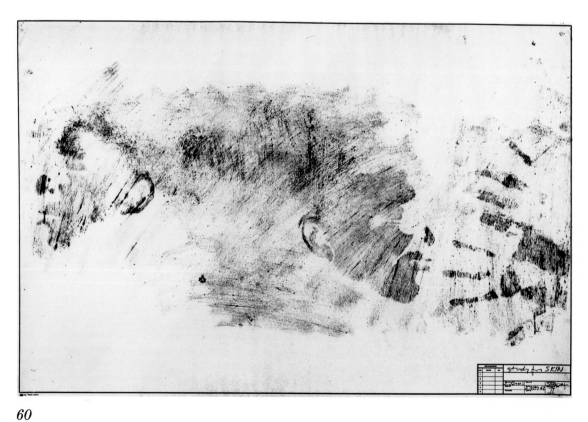

60

Study for "Skin II." *1962.*
Charcoal on paper,
22 × 34".
Collection the artist

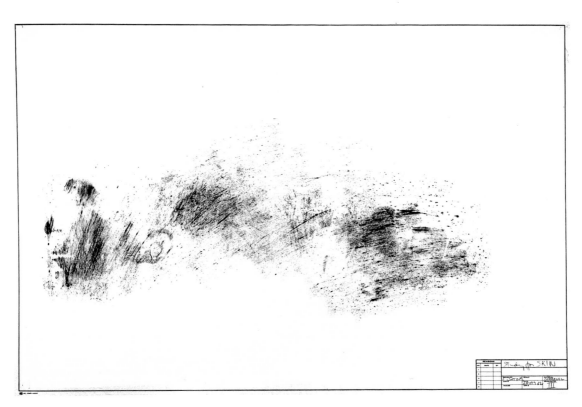

61

Study for "Skin III." *1962.*
Charcoal on paper,
22 × 34".
Collection the artist

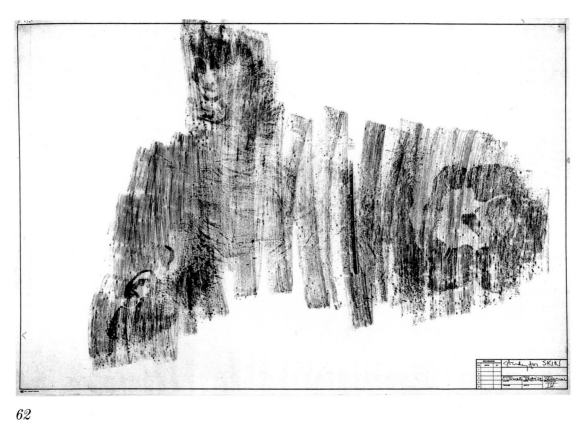

62

Study for "Skin IV." *1962.*
Charcoal on paper,
22 × 34".
Collection the artist

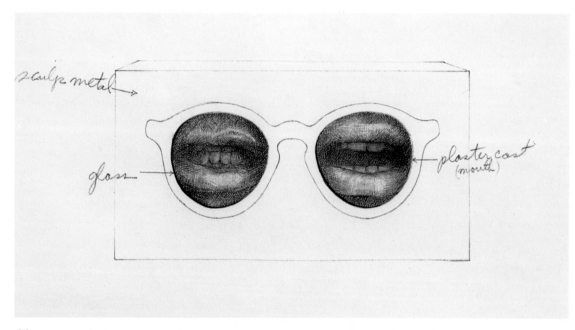

63

The Critic Sees. *1962.*
Pencil and collage on paper,
6⅜ × 11⅞".
Collection Mr. and Mrs. Leo Castelli

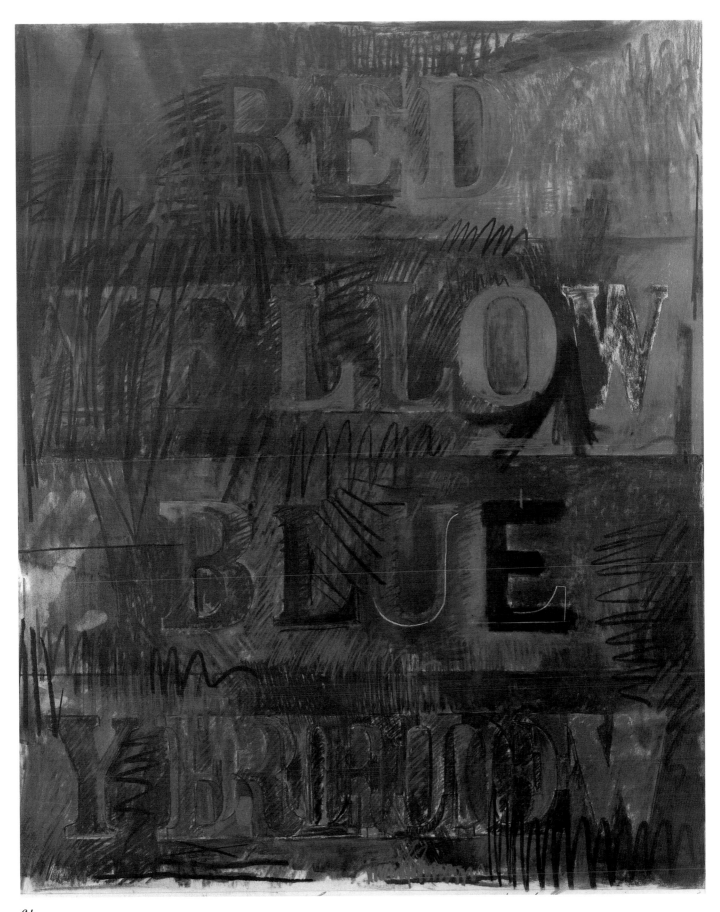

64

Folly Beach. *1962.*
Charcoal and chalk on paper,
36 × 29⅜".
Private collection

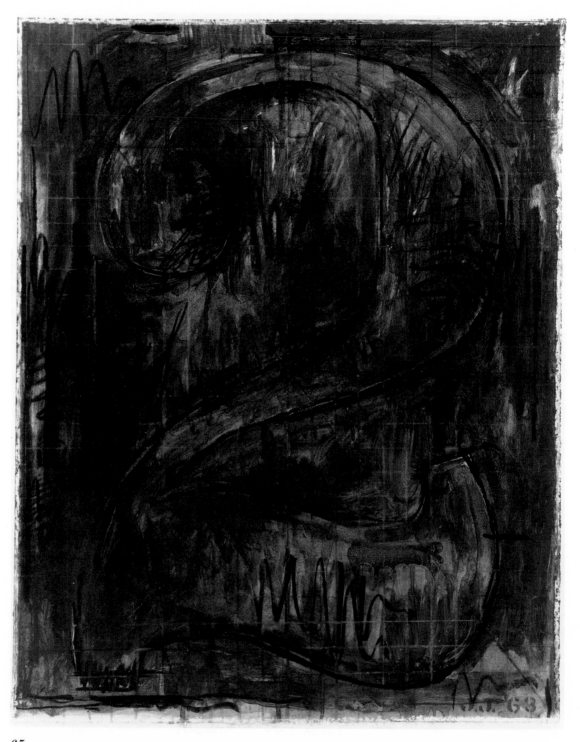

65

Figure 2. *1963.*
Graphite wash, charcoal, and chalk on paper,
26⅛ × 21¼".
The Minneapolis Institute of Arts.
The William Hood Dunwoody Fund

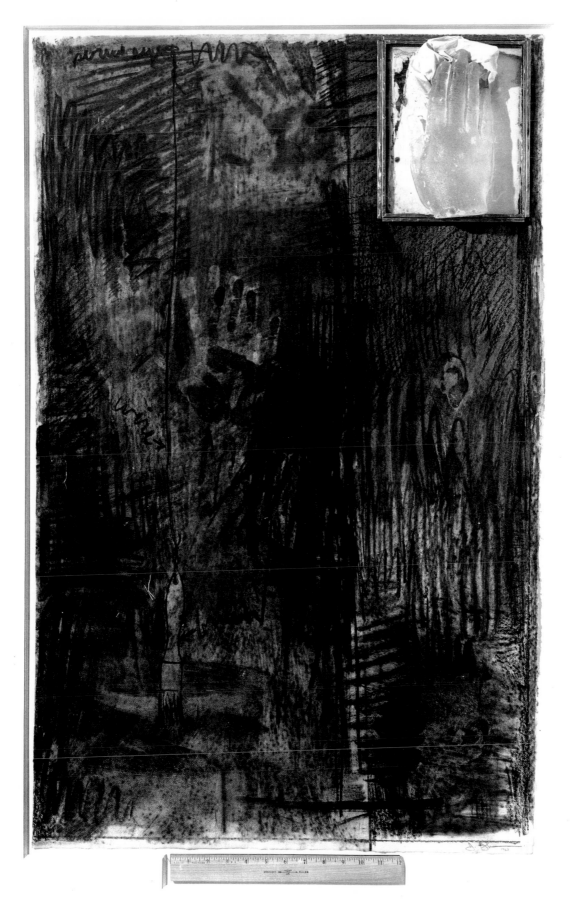

66
Wilderness II. *1963.*
Mixed media,
42¾ × 25¾".
Collection the artist

67

Diver. *1963.*
Charcoal, chalk, and paint on paper,
86½ × 71¾" (two panels).
Collection Mr. and Mrs. Victor W. Ganz

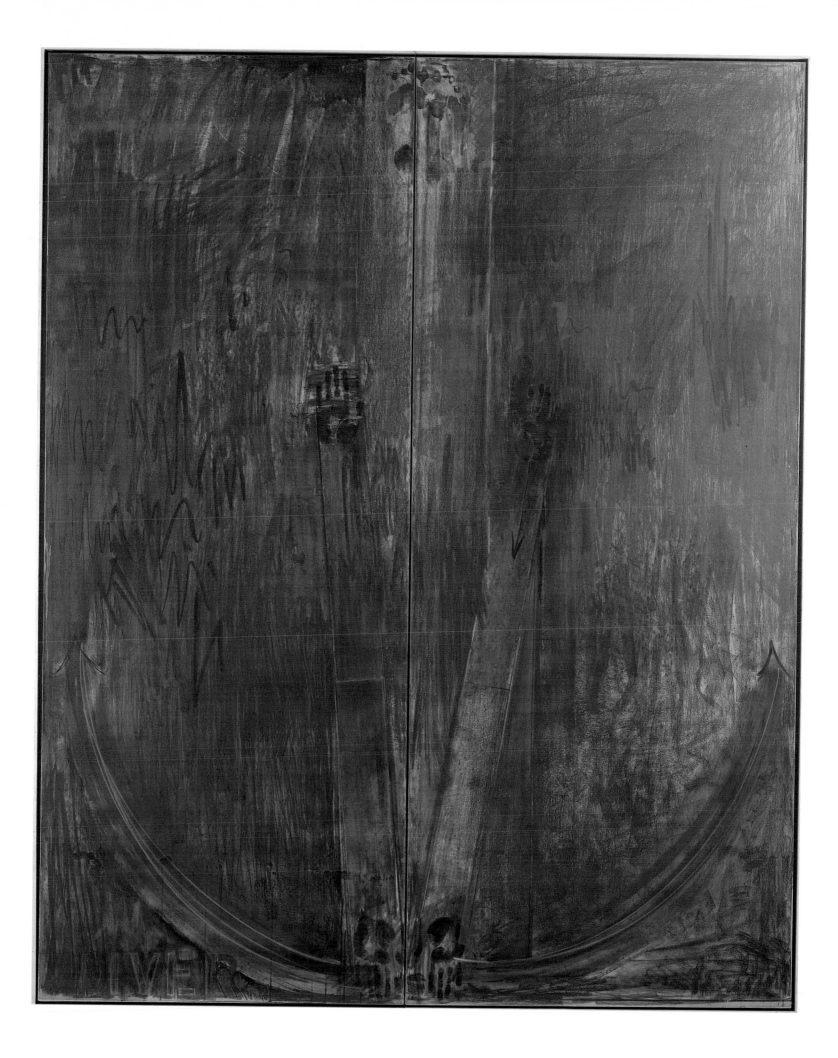

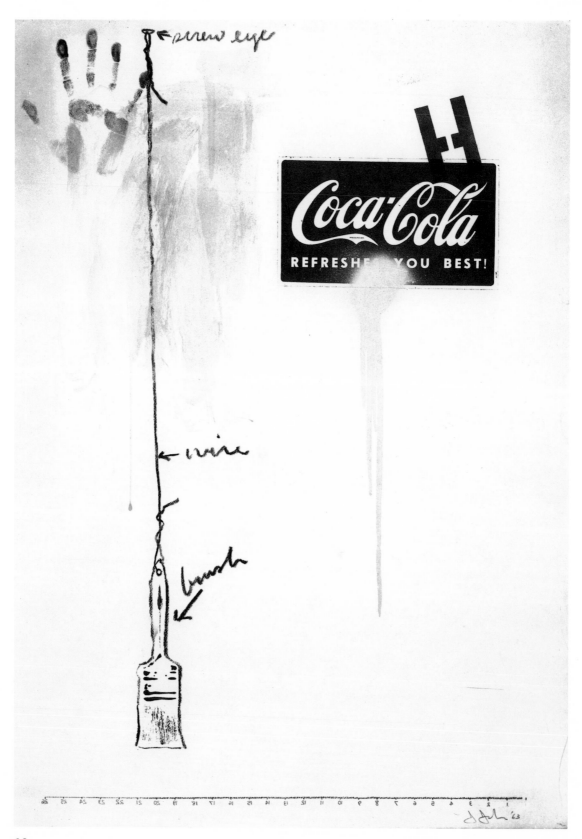

68

Untitled. *1963.*
Charcoal, collage, and paint on paper,
42½ × 30".
Private collection

69

Untitled. *1963.*
Charcoal, collage, and paint on paper,
42½ × 30".
Collection Mr. and Mrs. Victor W. Ganz

70

M.D. *1964.*
Collage and pencil on paper,
21¾ × 17¾".
Collection the artist

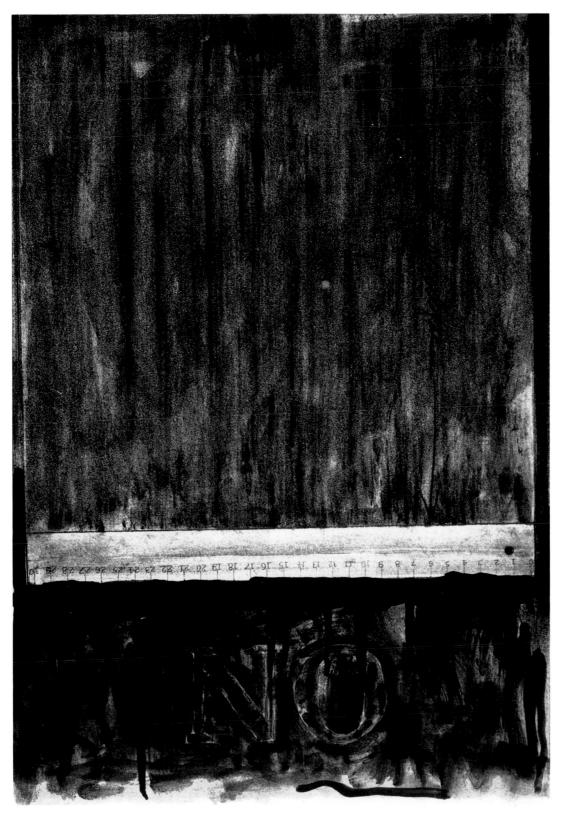

71

No. *1964.*
Graphite, charcoal, and tempera on paper,
18⅜ × 13″.
Private collection, Kansas City

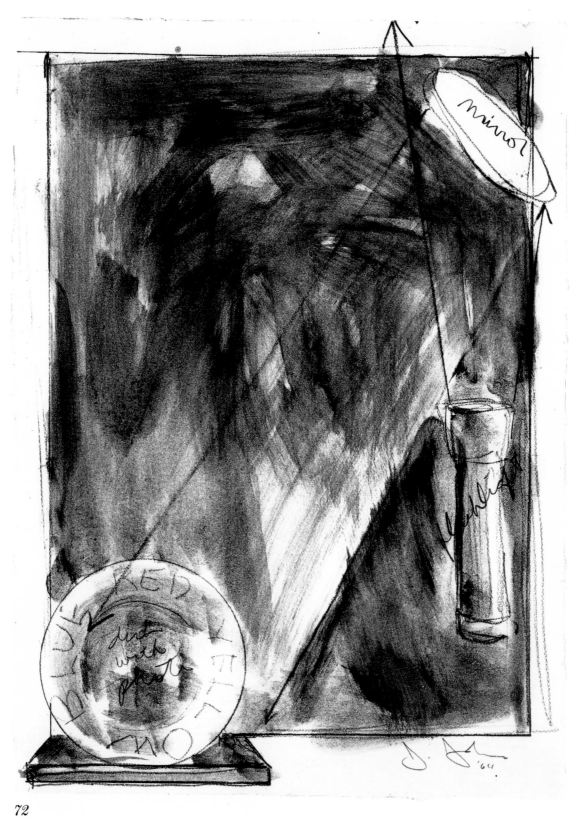

72

Souvenir. *1964.*
Pencil and graphite wash on paper,
19⅝ × 14⅛".
Collection the artist

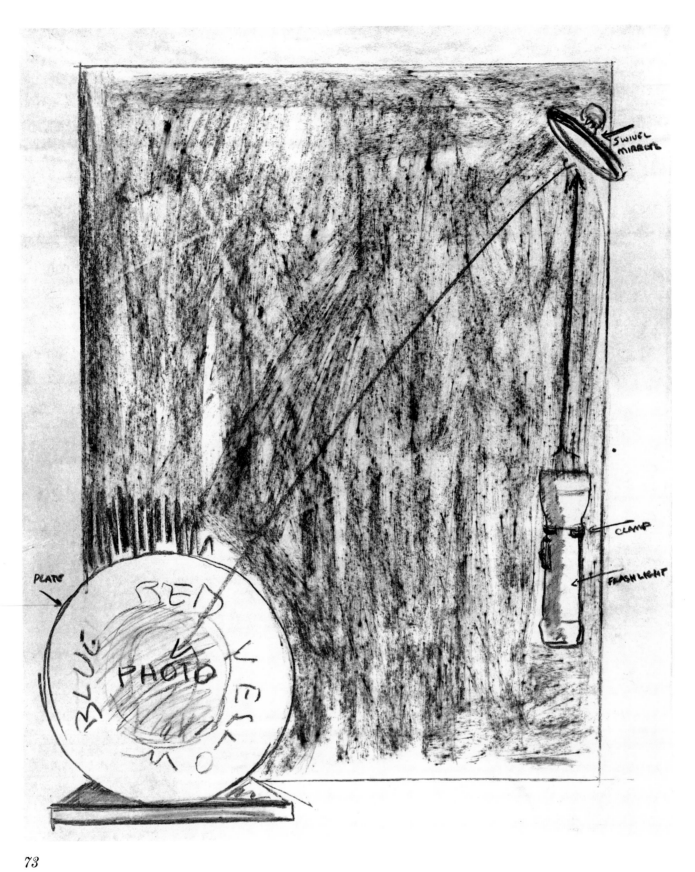

73

Souvenir. 1964.
Charcoal on paper,
34⅞ × 27¼".
Collection the artist

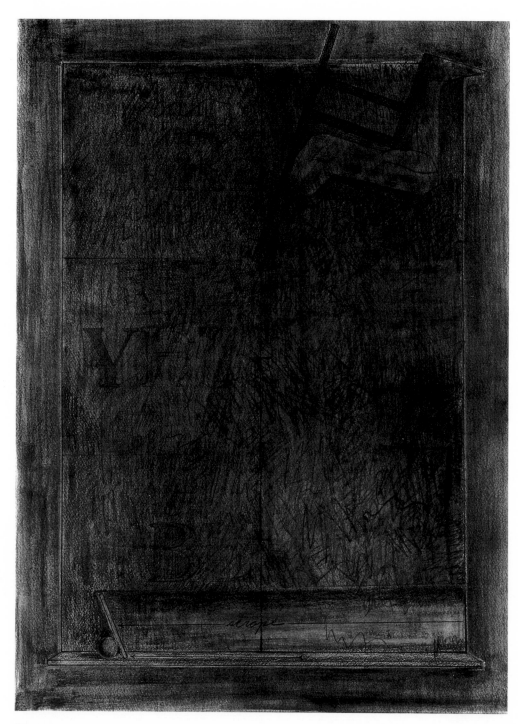

74

Watchman. *1964.*
Pencil on paper,
18⅜ × 13⅜".
The Sogetsu Art Museum, Tokyo

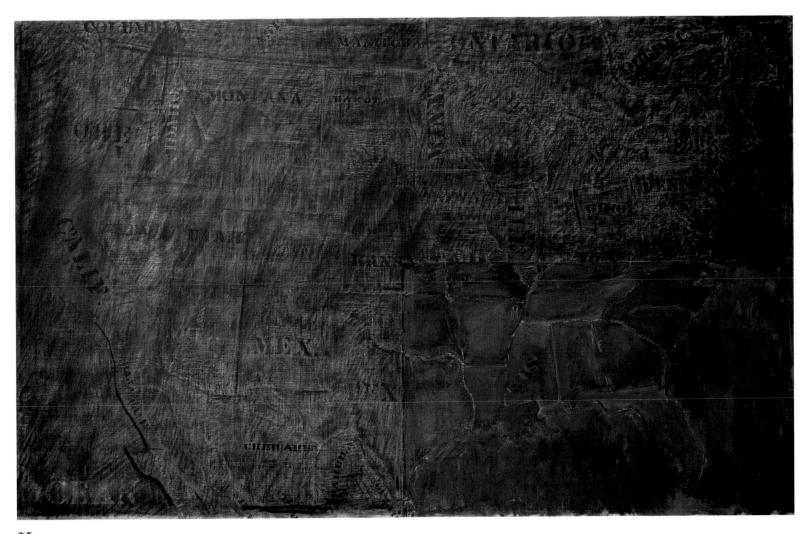

75

Map. *1965.*
Charcoal and oil on canvas,
43¾ × 70¼".
Collection Kimiko and John Powers

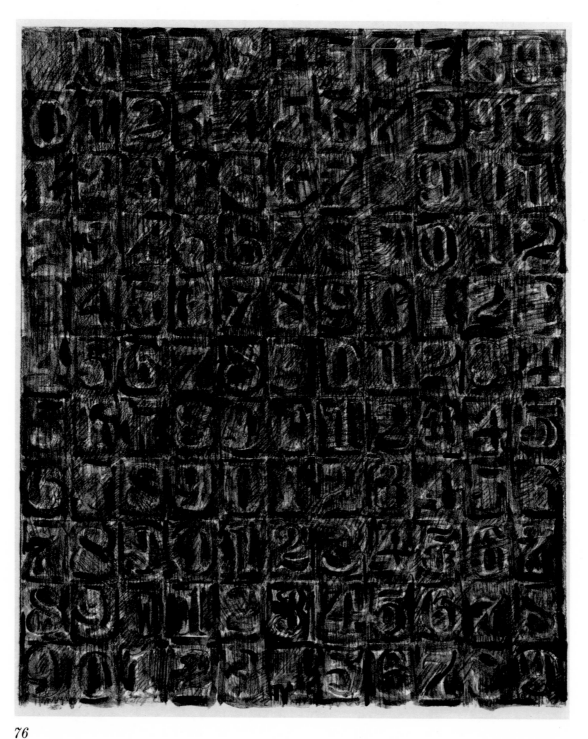

76

Numbers. *1965.*
Pencil and graphite wash on paper,
22½ × 18½".
Collection Kimiko and John Powers

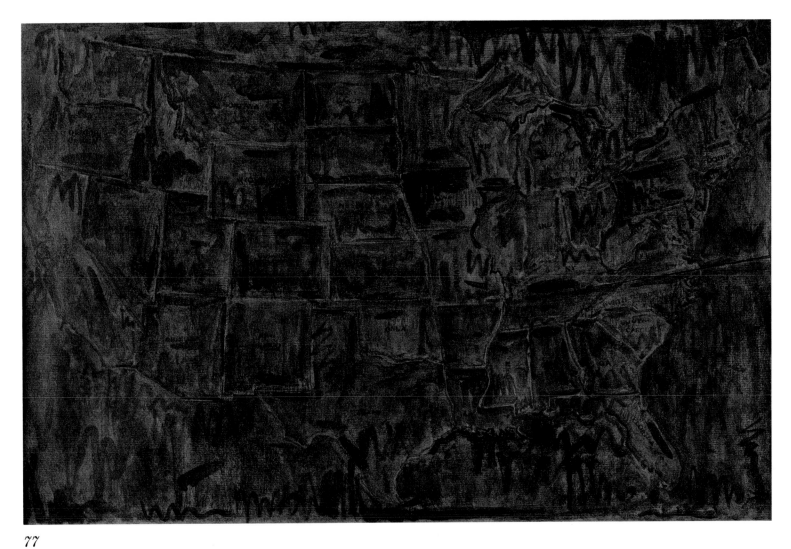

77

Map. *1965.*
Graphite wash and metallic powder on paper,
13¼ × 20¾".
Collection the artist

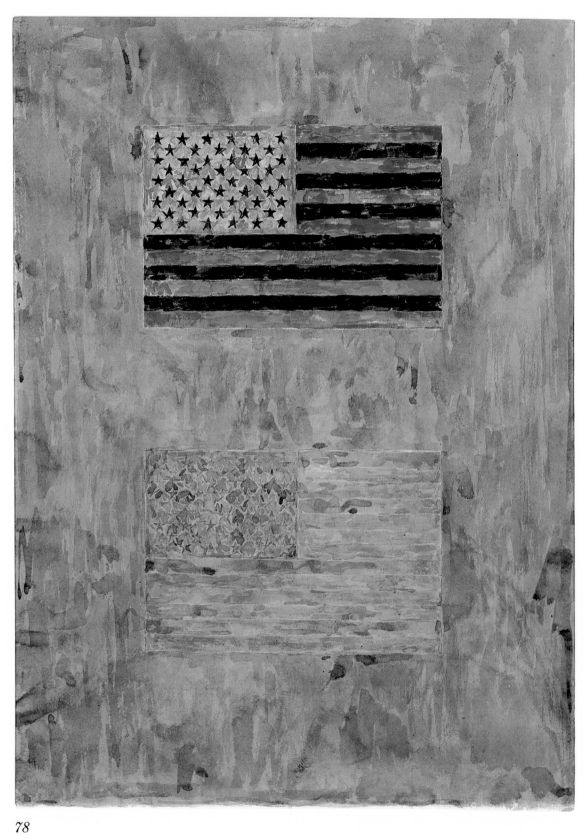

78

Flags. *1965–66.*
Watercolor on paper,
29 × 21".
Collection Betty Asher

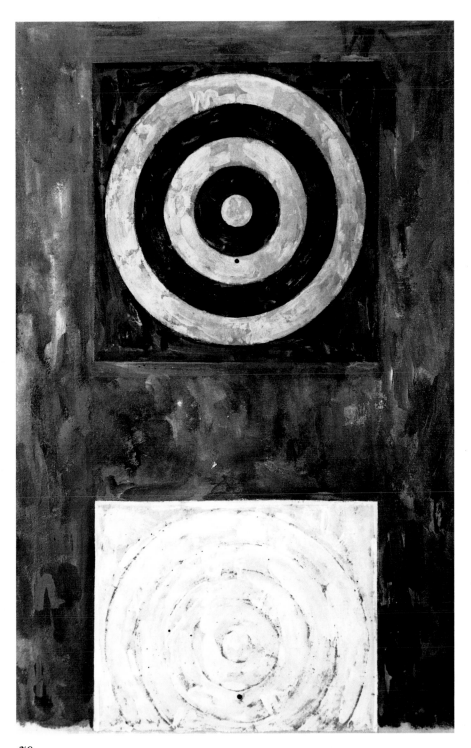

79

Targets. *1966.*
Hyplar on plastic,
15 × 9½".
Private collection

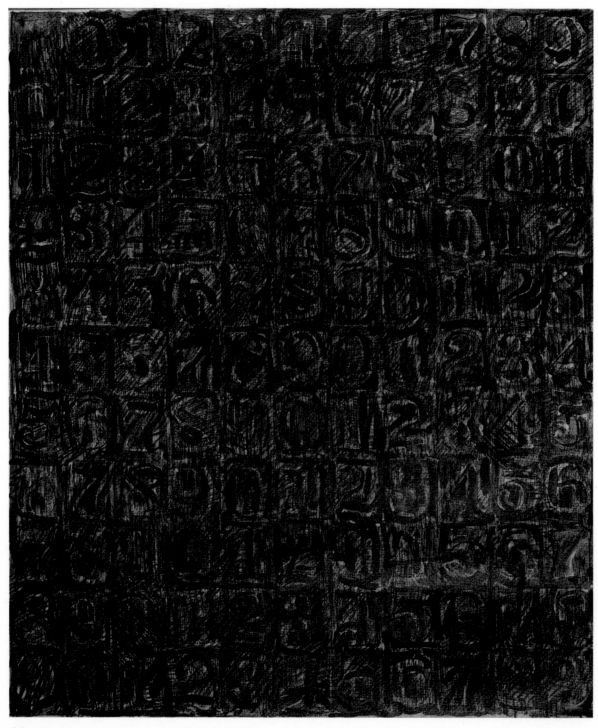

80

Numbers. *1966.*
Pencil and graphite wash on paper,
21 × 18¼".
The Museum of Modern Art, New York.
Gift of Mrs. Bliss Parkinson
in honor of René d'Harnoncourt

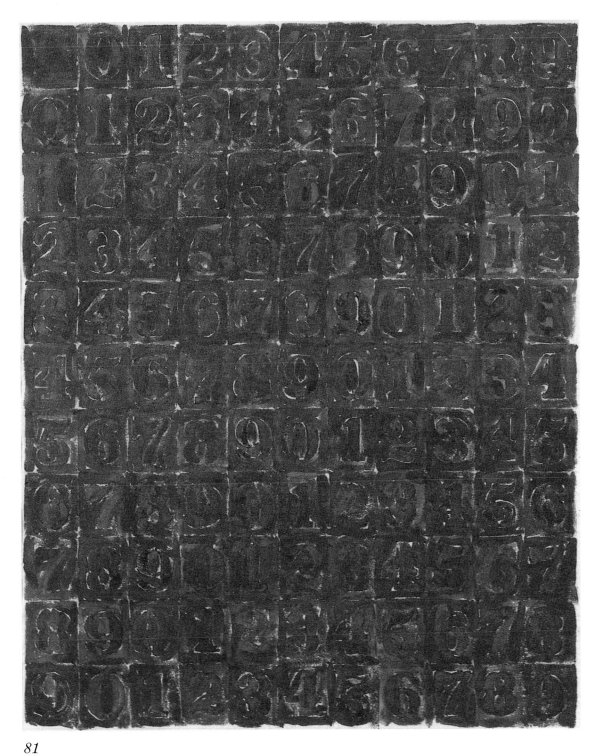

81

Numbers. *1966.*
Metallic powder on plastic,
16⅝ × 13½".
Collection Mr. and Mrs. Leo Castelli

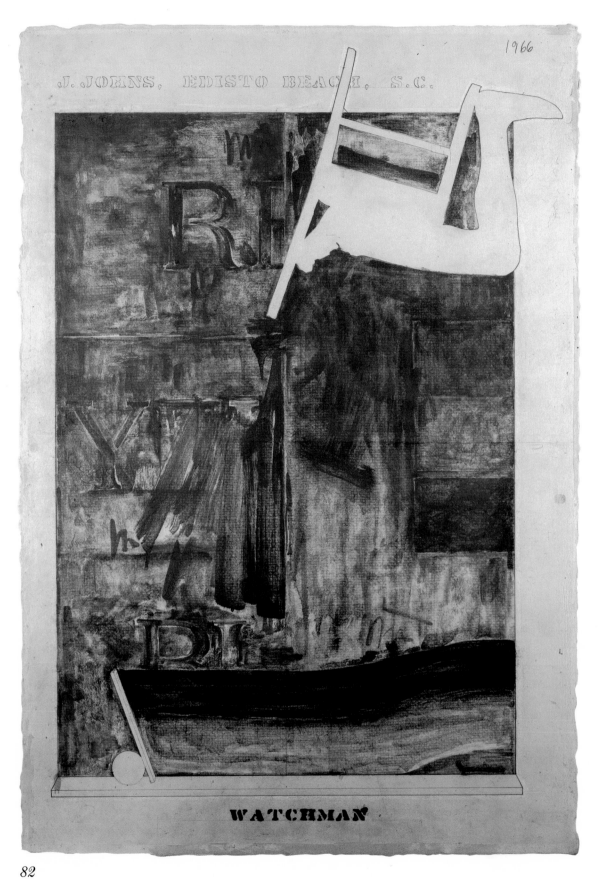

82

Watchman. *1966.*
Graphite wash, metallic powder, pencil,
and chalk on paper, 38 × 26½".
Collection Mr. and Mrs. Victor W. Ganz

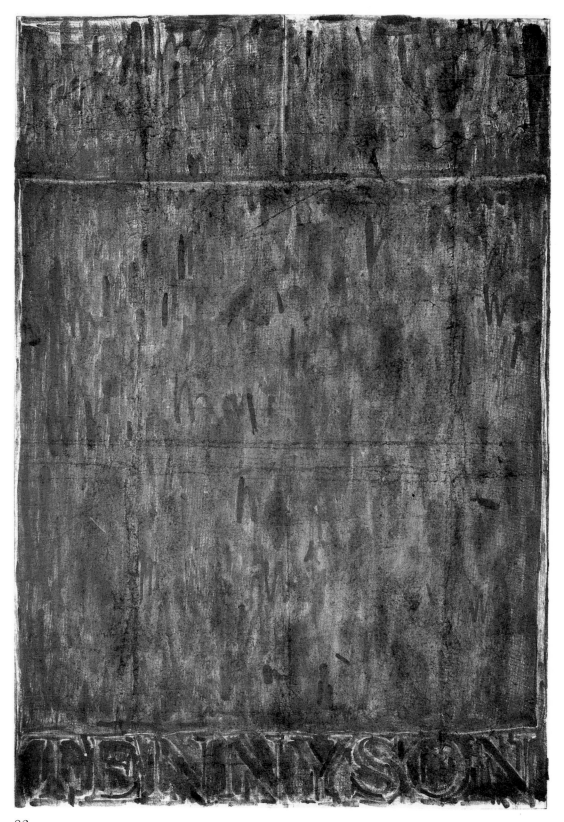

83

Tennyson. *1967.*
Graphite wash and gouache on paper,
29½ × 20½".
Collection Mr. and Mrs. Victor W. Ganz

84

Figure 3. *1962–67.*
Charcoal and chalk on paper,
26¼ × 21¼".
Collection John Bedenkapp

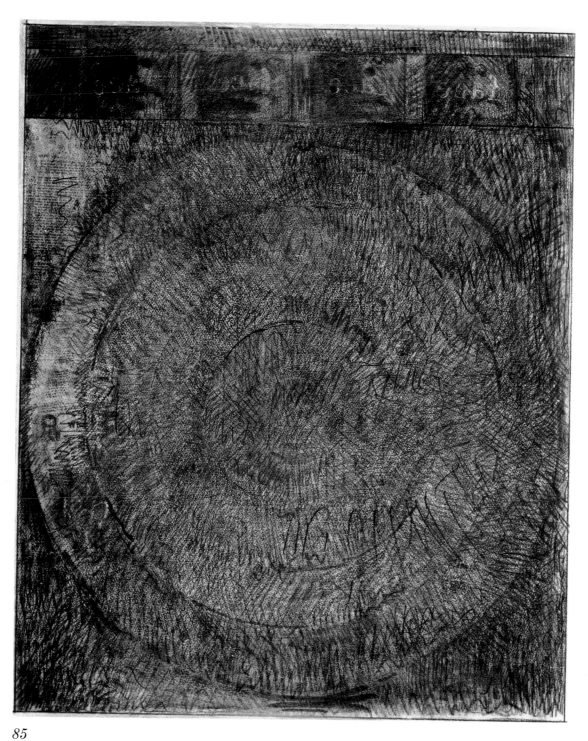

85

Target with Four Faces. *1968.*
Graphite and chalk on paper,
32⅜ × 27⅛".
Collection Antoinette Castelli

86

Evian. *1968.*
Graphite, gouache, and chalk on paper,
20 × 21¼".
Private collection

87

Harlem Light. *1968.*
Graphite, chalk, and tempera on paper,
22¼ × 47⅞".
Collection Mr. and Mrs. Victor W. Ganz

88

Scott Fagan Record. *1969.*
Ink on plastic,
12½ × 12⅝".
Private collection

89
Study for "Wall Piece." *1968–69.*
Graphite, gouache, ink, and collage on paper,
20⅜ × 29".
Collection Kimiko and John Powers

90

Wall Piece. *1969.*
Graphite, collage, chalk,
and watercolor on paper,
20½ × 31¾".
Collection the artist

91

Wall Piece. *1969.*
Ink on plastic,
20 × 31".
Collection Mr. and Mrs. Victor W. Ganz

92
From "Eddingsville." *1969.*
Ink on plastic,
19 × 25".
Destroyed

93

Flags. *1969.*
Graphite on paper,
20¼ × 29½".
Collection Mr. and Mrs. Richard Selle

94
Untitled. *1969.*
Charcoal on paper,
15⅝ × 20¾".
Private collection

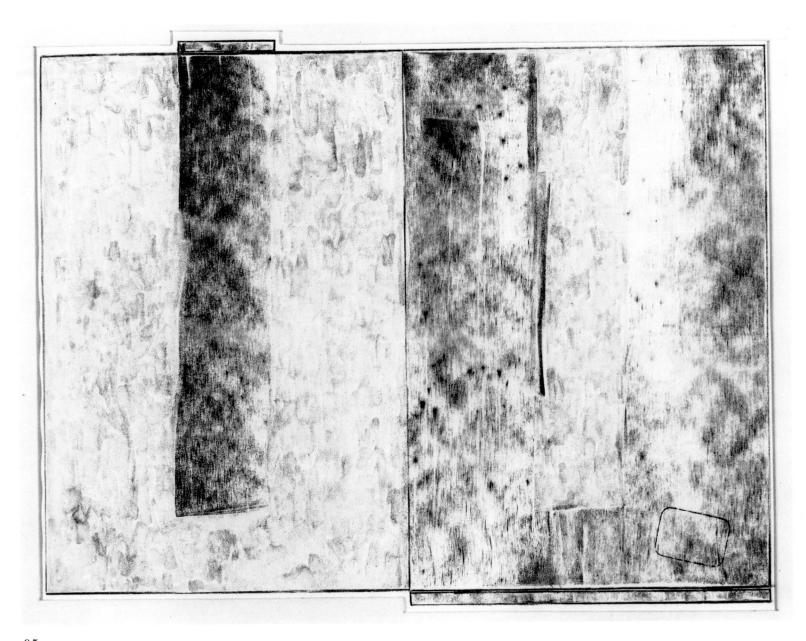

95

Untitled I. *1969.*
Graphite and charcoal on paper,
20⅞ × 27½".
The Art Institute of Chicago.
Gift of The Society for Contemporary Art

96

Screen Piece. *1969.*
Graphite on paper,
34½ × 25⅞".
Collection Kimiko and John Powers

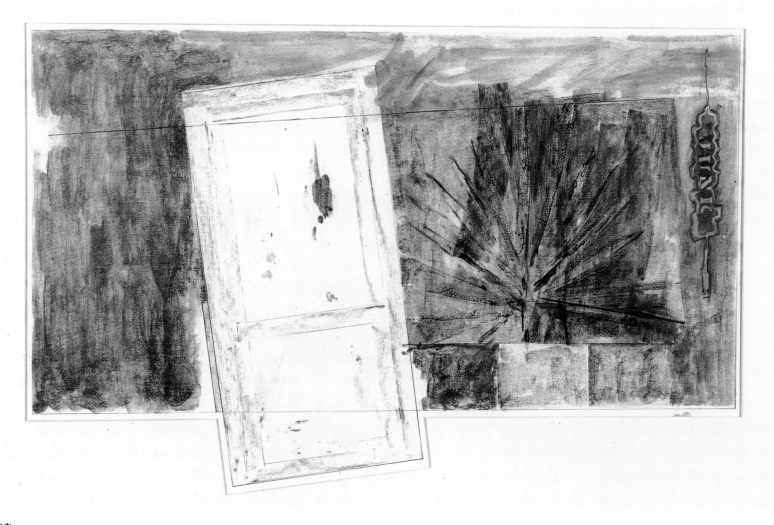

97
Studio. *1969.*
Graphite and gouache on paper,
21½ × 27".
Collection Mr. and Mrs. Ira Riklis,
New York

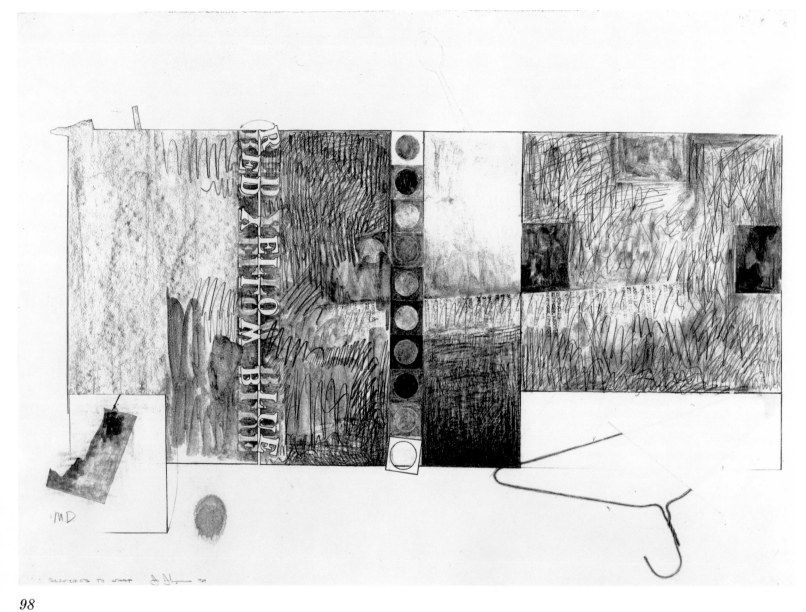

98

According to What. *1969.*
Graphite on paper,
29⅝ × 41⅜".
Collection the artist

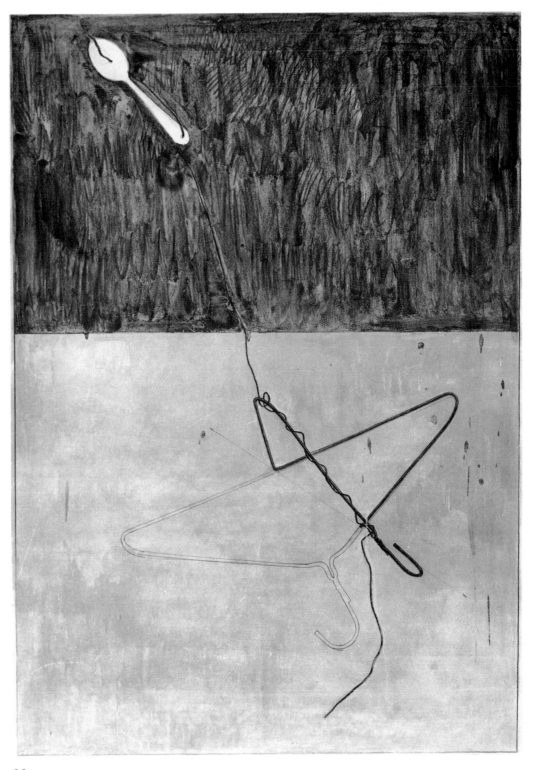

99

Study "According To What." *1969.*
Graphite and tempera on paper,
34 × 26".
The Baltimore Museum of Art.
Thomas E. Benesch Memorial Collection

100

Flag. *1969.*
Pencil and graphite wash on paper,
19⅜ × 13⅜".
Collection Kimiko and John Powers

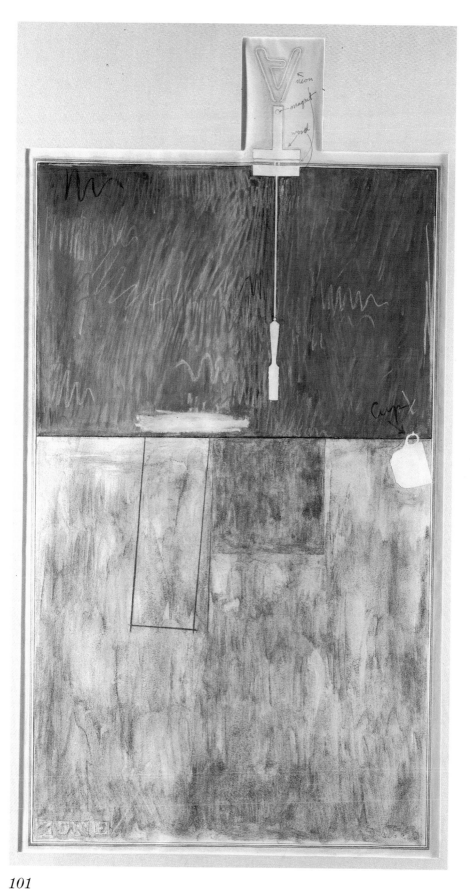

101

Zone. *1969.*

Graphite, chalk, and tempera on paper,

32¾ × 17⅝".

Collection the artist

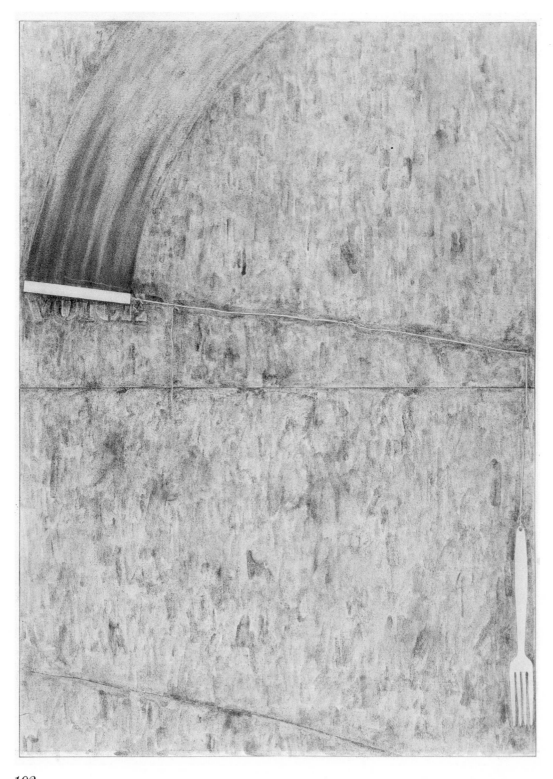

102

Voice. *1969.*
Graphite on paper, 28¼ × 20⅜".
The Museum of Modern Art, New York.
Purchase

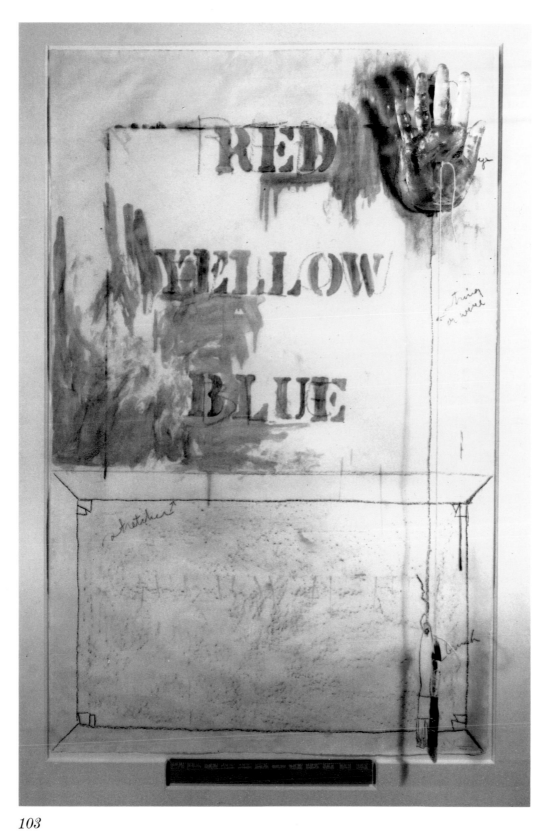

103

Wilderness I. *1963–70.*
Mixed media,
41⅛ × 26⅛".
Collection McCrory Corporation,
New York

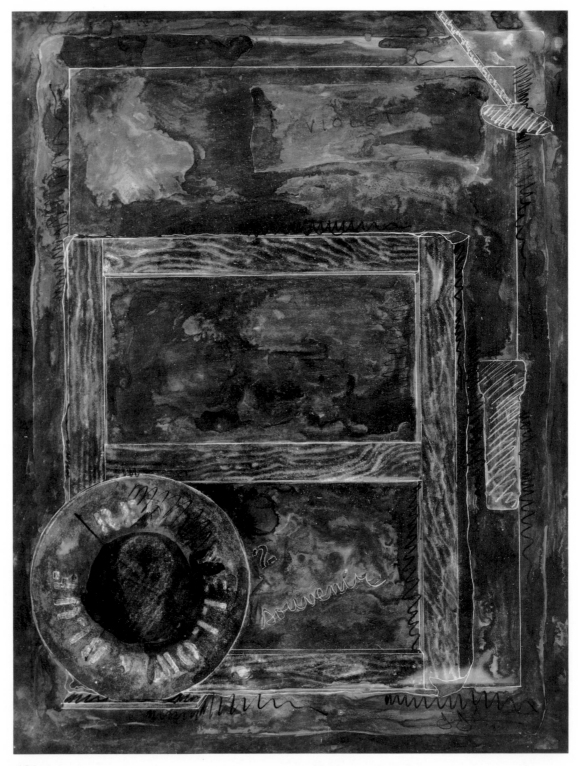

104

Souvenir 2. *1970.*
Ink, pencil, and chalk on plastic,
25¼ × 19".
Private collection

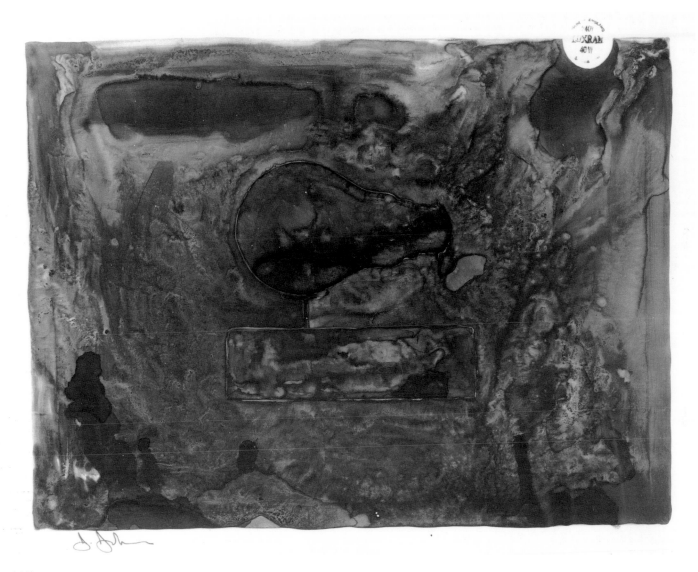

105

English Light Bulb. *1970.*
Ink on plastic,
10½ × 14".
Collection the artist

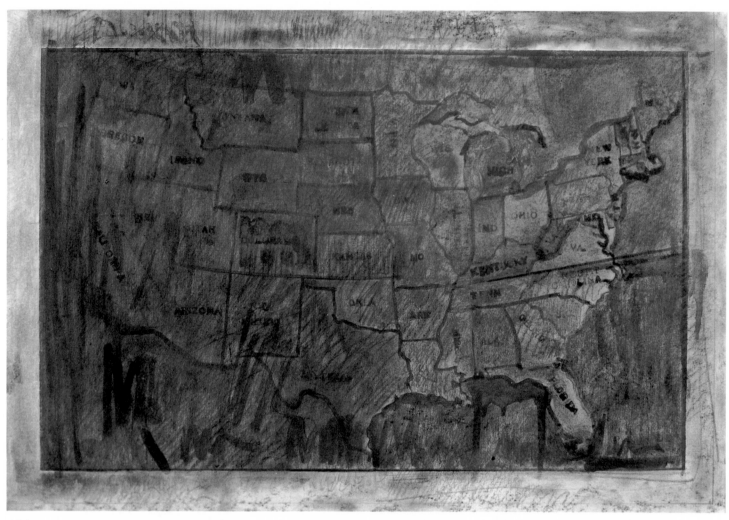

106

Map. *1971.*
Graphite on paper,
14¼ × 21".
Collection Dr. and Mrs. Aaron Esman

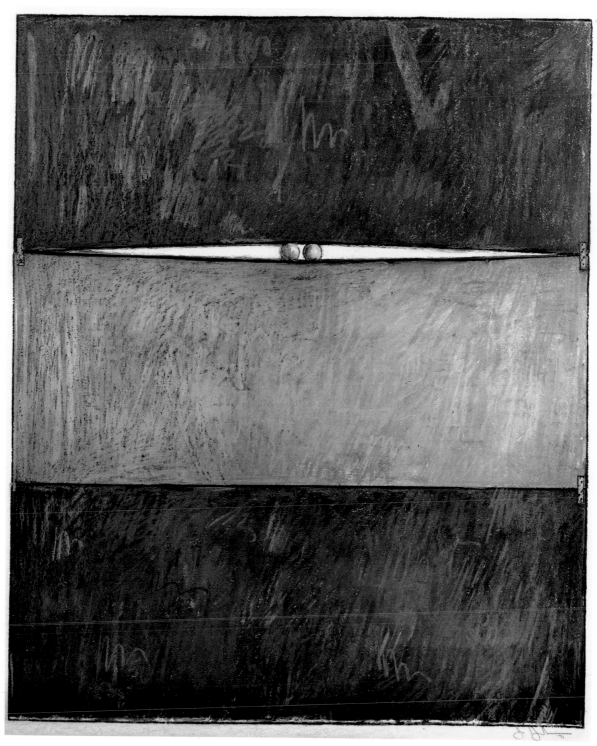

107

Painting with Two Balls. *1971.*
Chalk and oil crayon on paper,
31 × 26″.
Private collection

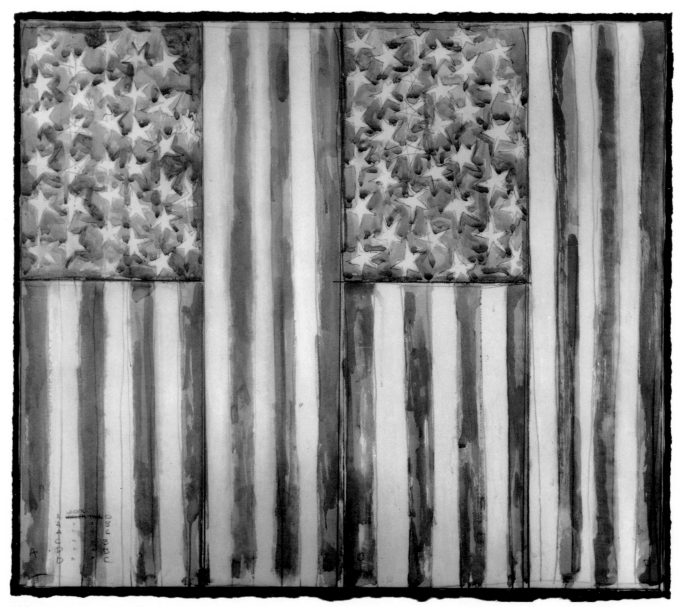

108

Flags. *1972.*
Watercolor and pencil on paper,
25¼ × 30⅛".
Collection the artist

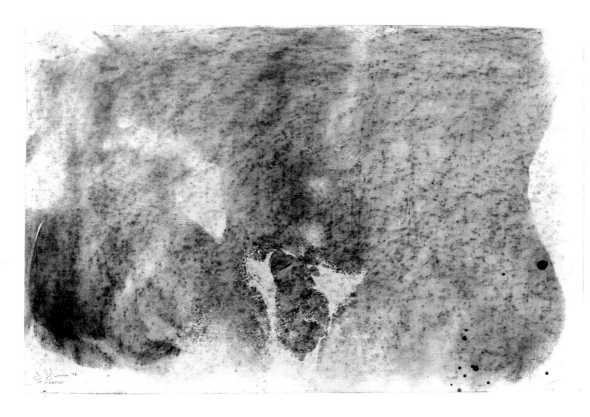

109

Skin I. *1973.*
Charcoal on paper,
25½ × 40¼".
Collection the artist

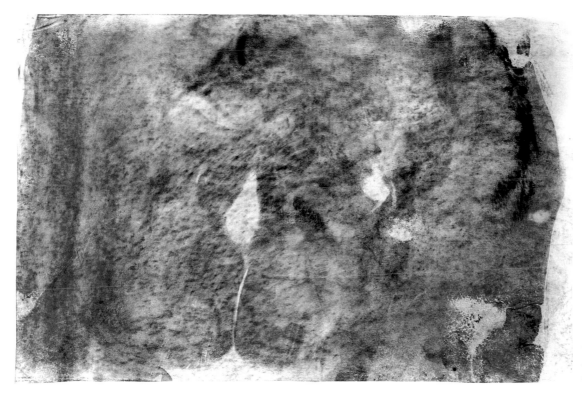

110

Skin II. *1973.*
Charcoal on paper,
25½ × 40¼".
Collection the artist

111

Untitled. *1973.*
Oil and pencil on paper,
41¼ × 29½".
Private collection

112

Untitled. *1973.*
Charcoal on paper,
41¼ × 29½".
Collection Mrs. Larry Aldrich

113

Ale Cans I. *1974.*
Ink on plastic,
11¾ × 13⅝".
Courtesy Morgan Gallery

114

Ale Cans III. *1974.*
Ink on plastic,
10¼ × 12".
Collection the artist

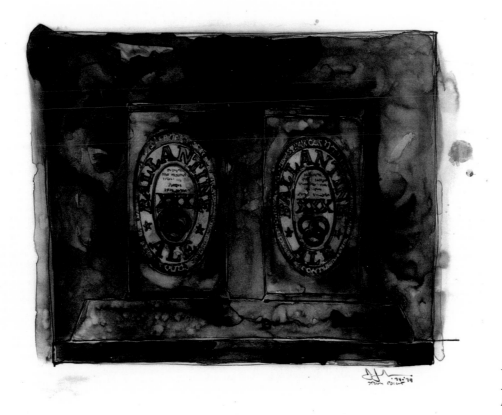

115

Ale Cans IV. *1974–75.*
Ink on plastic,
10¼ × 12".
Private collection, Fukuoka, Japan

116

Ale Cans V. *1975.*
Ink on paper,
18 × 22¼".
John and Mable Ringling Museum of Art,
Sarasota, Florida.
Purchased with matching funds
from the National Endowment for the Arts,
and Mrs. William Cox
and Mr. and Mrs. A. Werk Cook

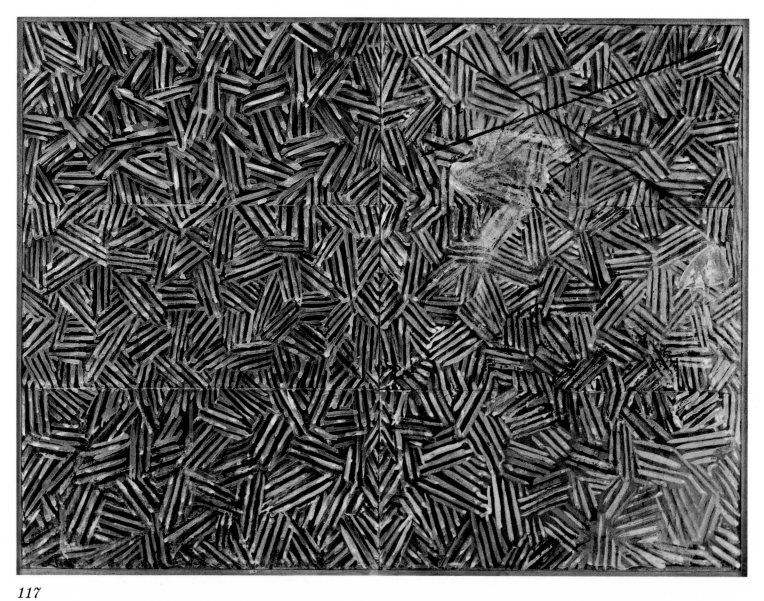

117

Corpse and Mirror. *1974–75.*
Graphite and gouache on paper,
16⅛ × 21¾".
Collection the artist

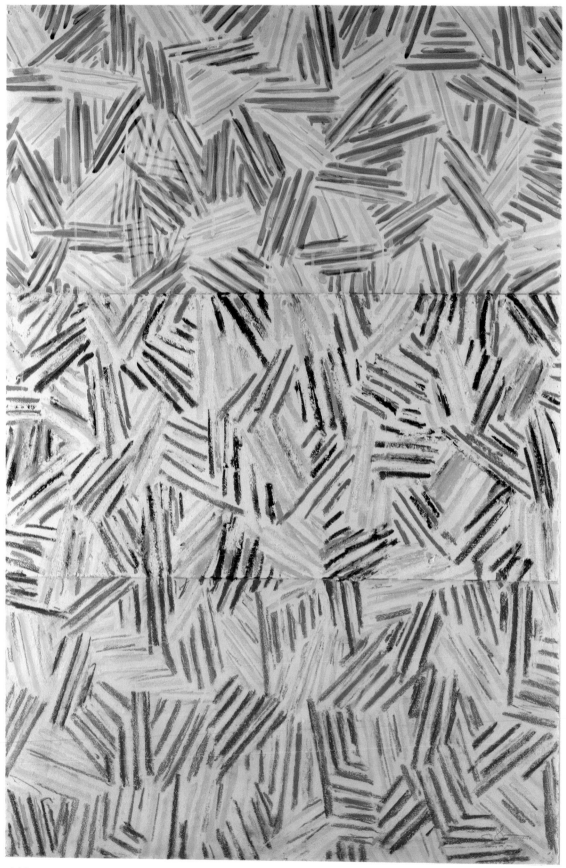

118

Corpse. *1974–75.*
Ink, Paintstik, and pastel on paper,
42½ × 28½".
Private collection

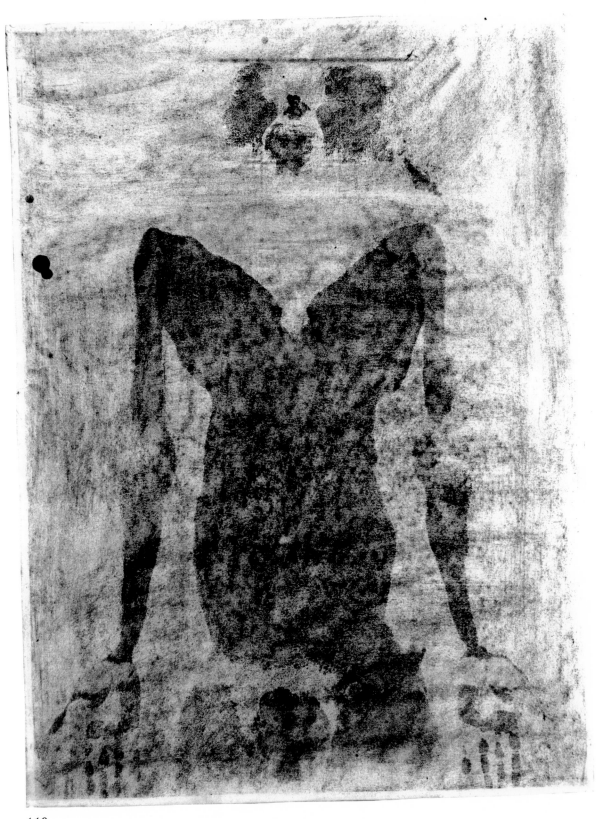

119

Skin. *1975.*
Charcoal on paper,
41¾ × 30¾".
Collection Richard Serra

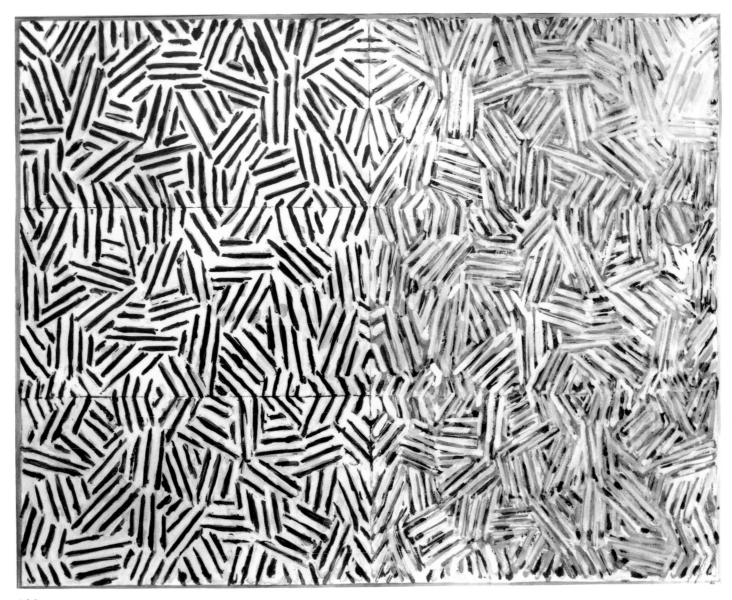

120

Corpse and Mirror. *1975–76.*
Watercolor on paper,
16½ × 21½".
Collection Mr. and Mrs. S. I. Newhouse, Jr.

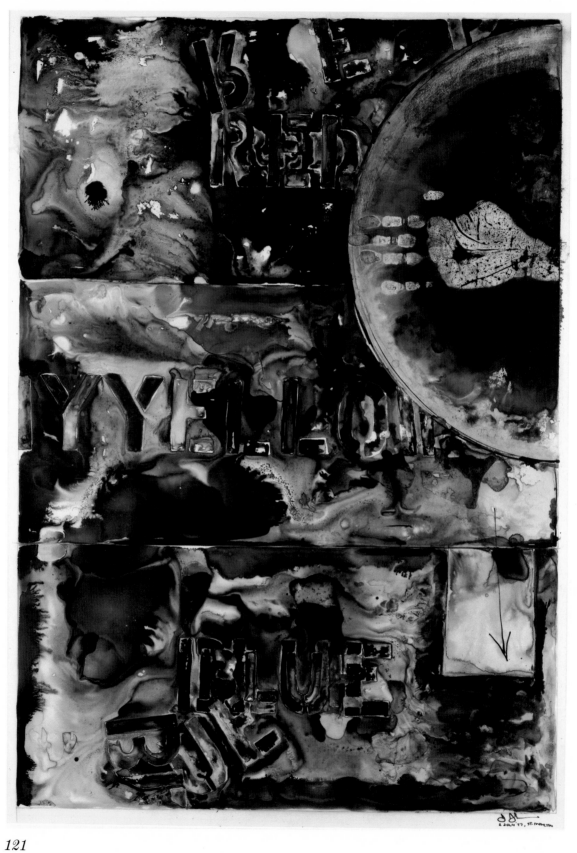

121

Periscope. *1977.*
Ink and watercolor on plastic,
35 × 25".
Private collection

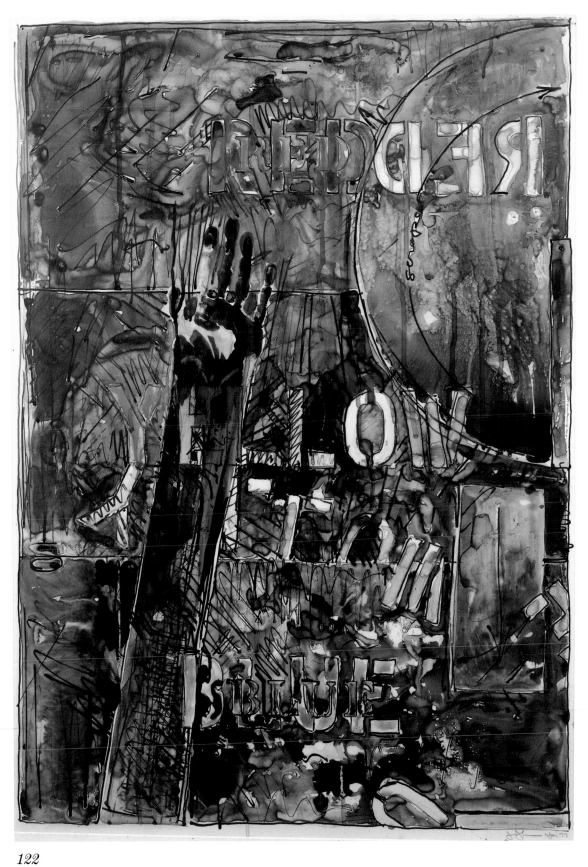

122

Land's End. *1977.*
Ink and watercolor on plastic,
34⅝ × 24⅜".
Collection Mrs. Magda Reisini

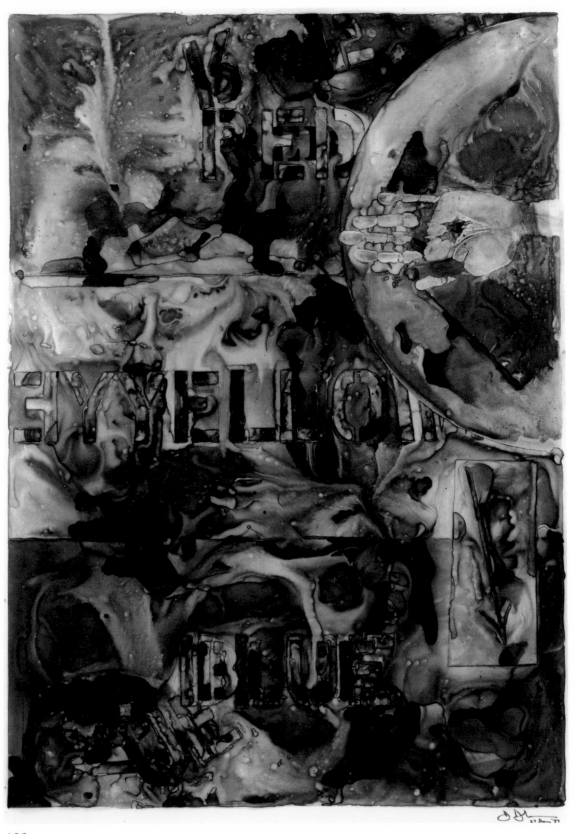

123

Periscope. *1977.*
Ink on plastic,
35 × 24½".
Courtesy Morgan Gallery

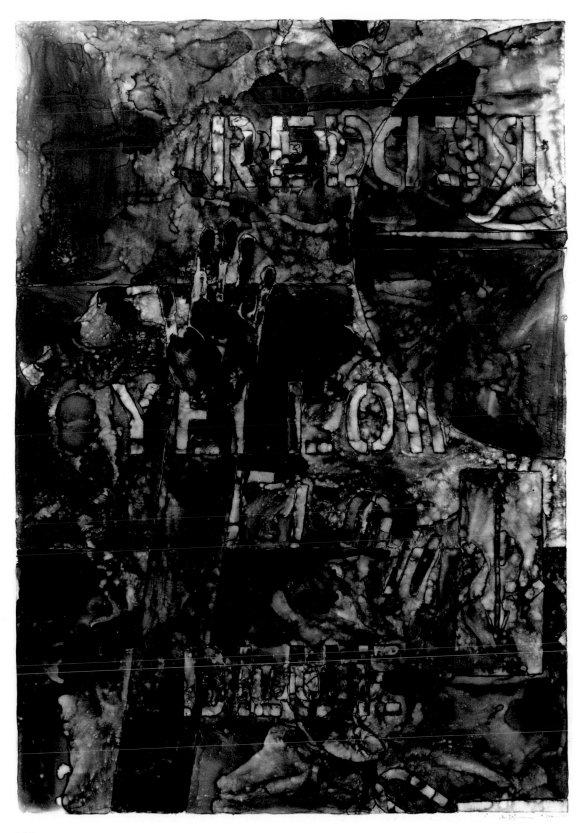

124
Land's End. *1977.*
Ink on plastic,
34⅜ × 24⅜".
Collection Kimiko and John Powers

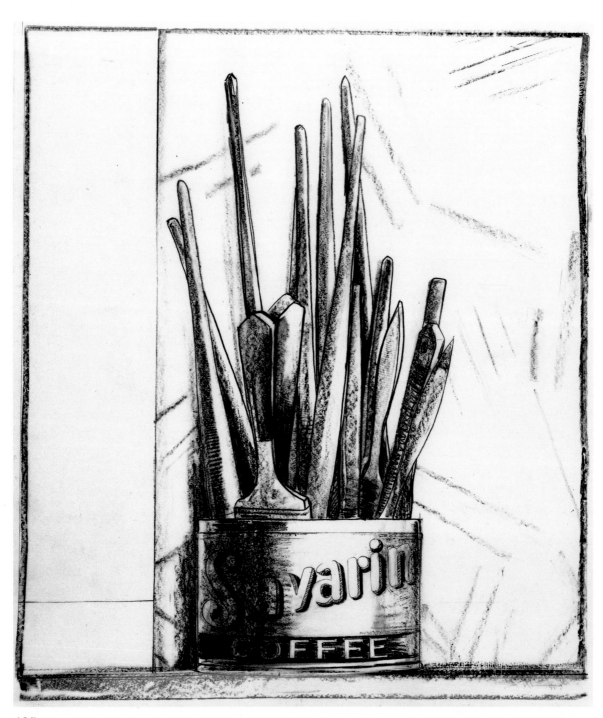

125
Savarin. *1977.*
Pencil and crayon on plastic,
33¾ × 28⅞".
Private collection

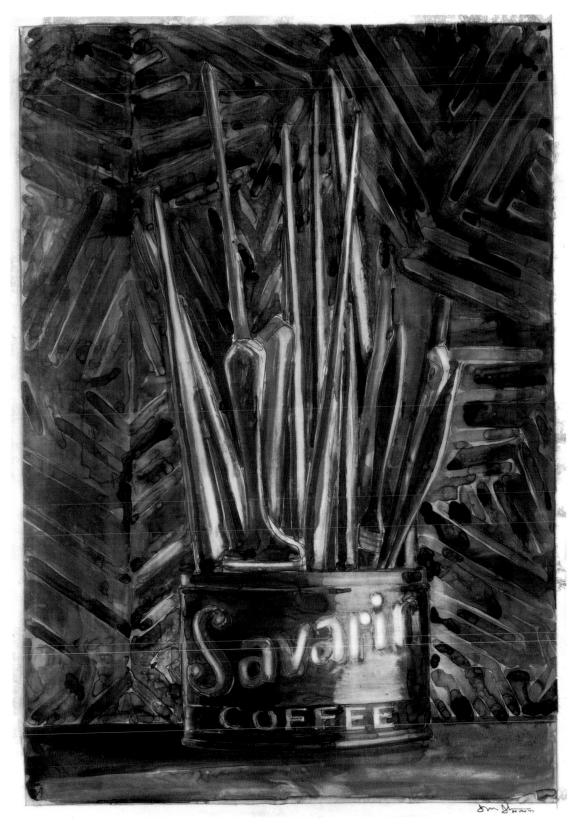

126
Savarin. *1977.*
Ink on plastic,
34⅝ × 24⅜".
The Museum of Modern Art, New York.
Gift of the Lauder Foundation

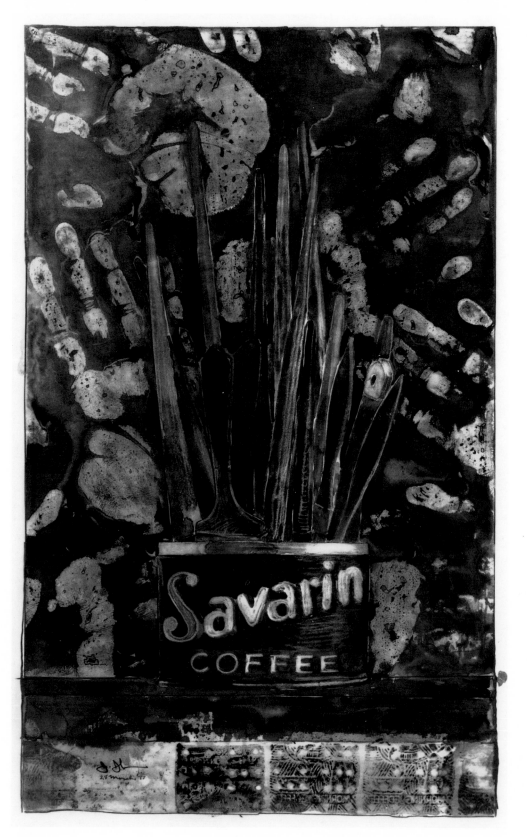

127
Untitled. *1977.*
Ink, watercolor, and crayon on plastic,
19¼ × 12".
Collection Margo Leavin, Los Angeles

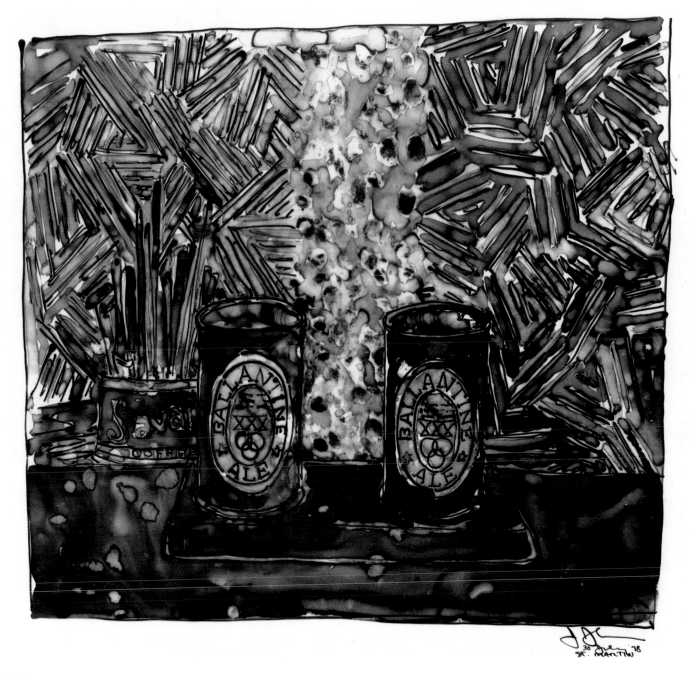

128

Ale Cans. *1978.*
Ink on plastic,
15⅛ × 16⅝".
Collection Robert and Jane Meyerhoff,
Phoenix, Maryland

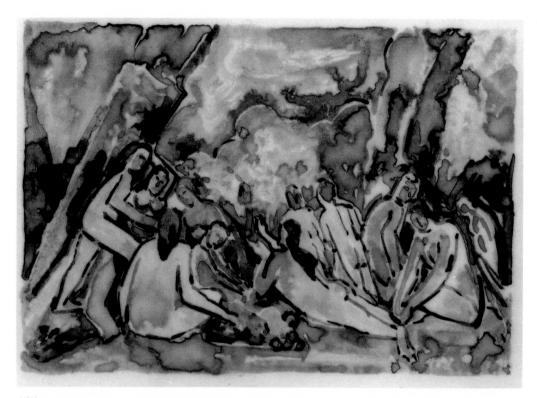

129
Tracing. *1977.*
Ink on plastic,
4⅛ × 5⅞".
Private collection

130
Tracing. *1978.*
Ink on plastic,
20½ × 12⅞".
Collection the artist

131

Target with Four Faces. *1979.*
Ink on plastic,
26 × 20½".
Private collection

132
Cicada. *1979.*
Watercolor and pencil on paper,
38½ × 28".
Collection the artist

133

Usuyuki. *1979.*
Ink and acrylic on plastic,
28¼ × 47".
Private collection, Kansas City

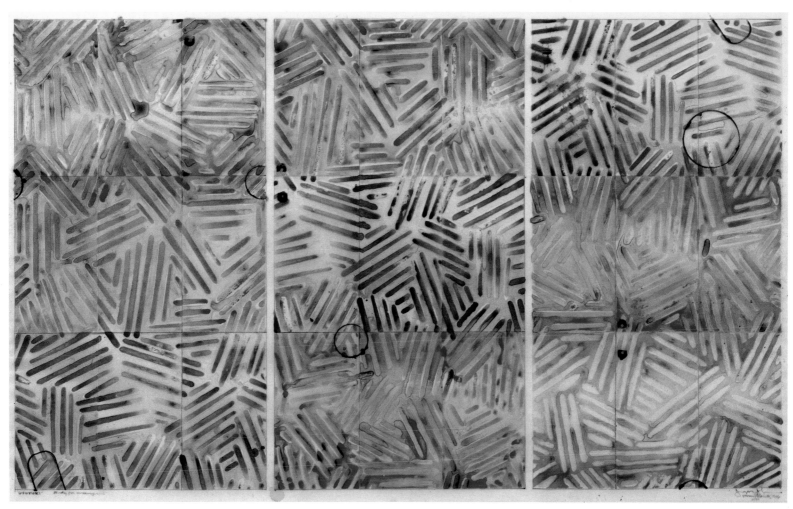

134

Usuyuki (Study for Screenprint). *1979.*
Ink on plastic,
28¾ × 47¼".
Collection Robert K. Hoffman, Dallas, Texas

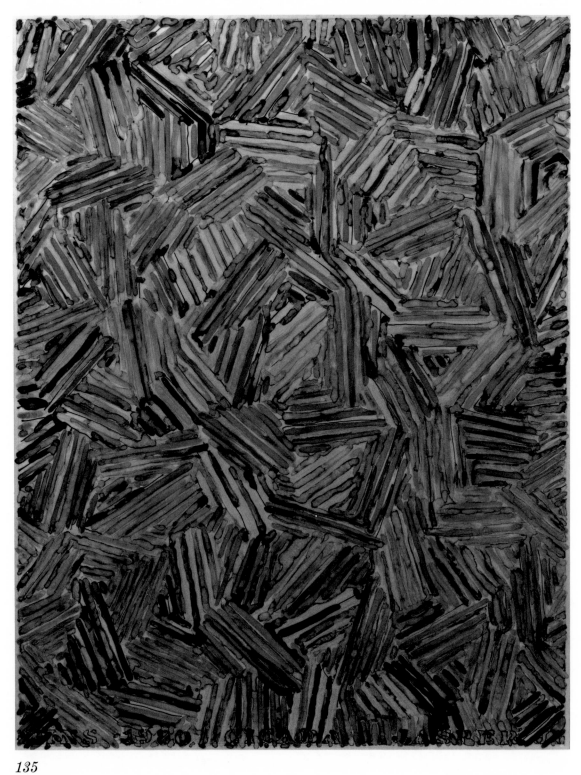

135

Cicada. *1980.*
Ink on plastic,
26⅞ × 20¾".
Collection the artist

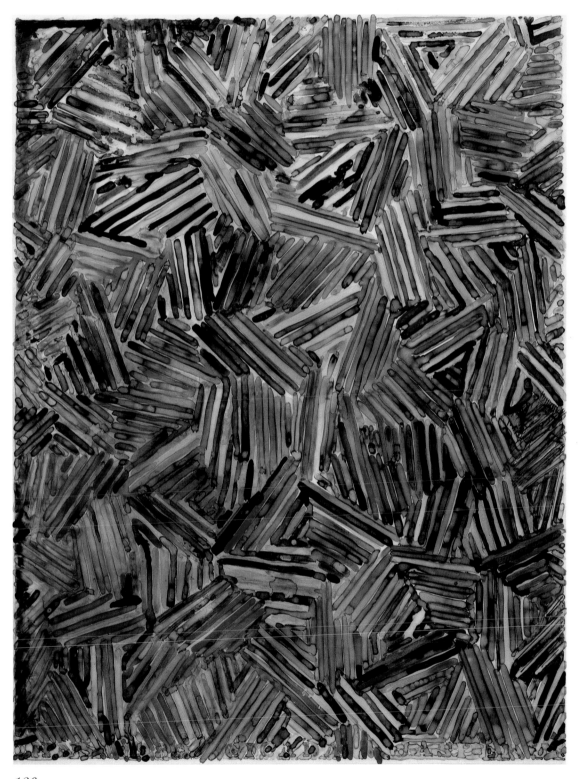

136

Cicada. *1980.*
Ink on plastic,
26¾ × 20⅝".
Collection Frederick M. Nicholas,
Beverly Hills, California

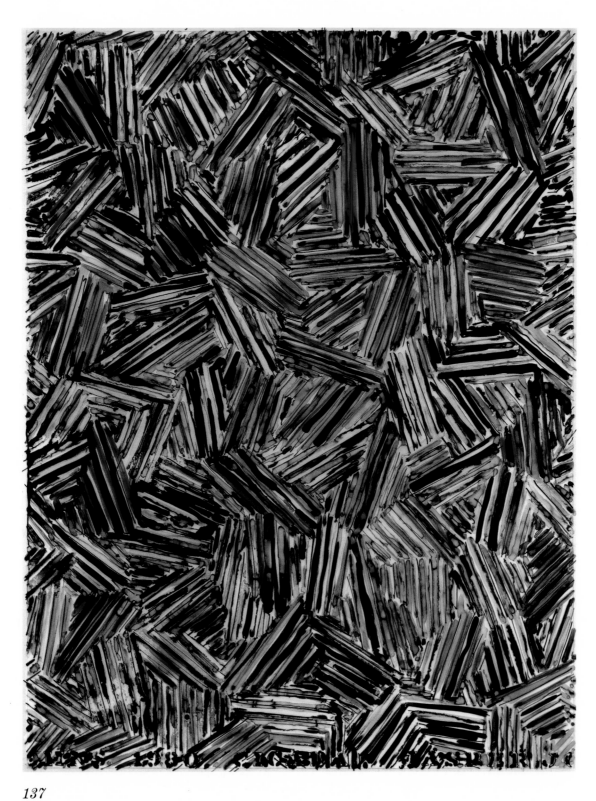

137

Cicada. *1980.*
Ink on plastic,
26¾ × 20⅝".
Collection Antoinette Castelli

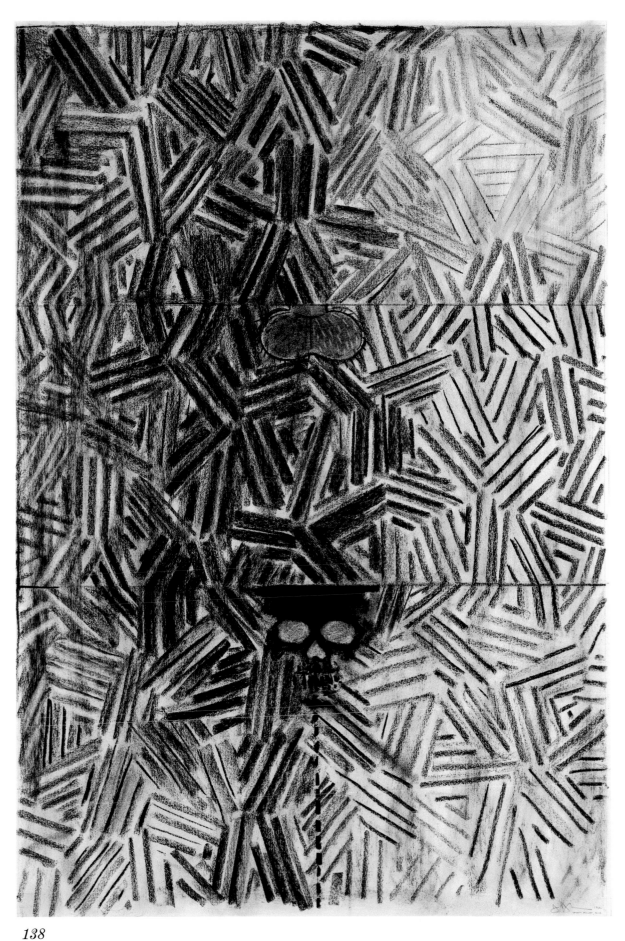

138

Tantric Detail. *1980.*
Charcoal on paper,
50½ × 34½".
Collection the artist

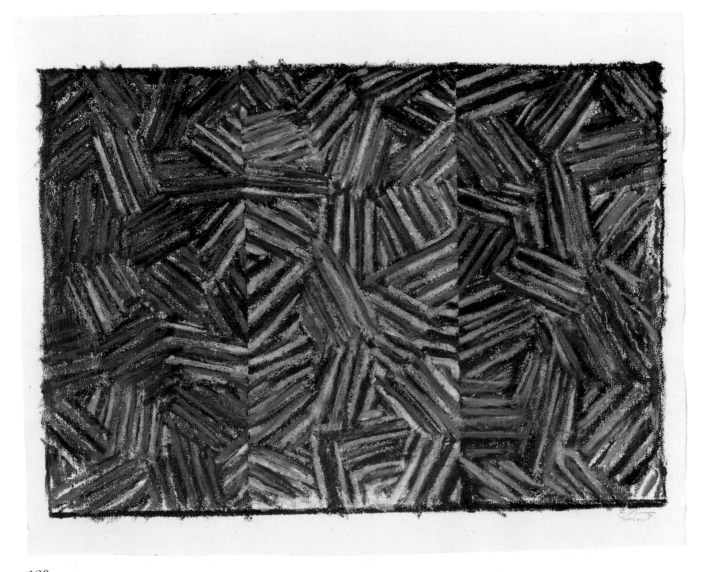

139
Untitled. *1980.*
Paintstik on paper,
23 × 33".
Collection the artist

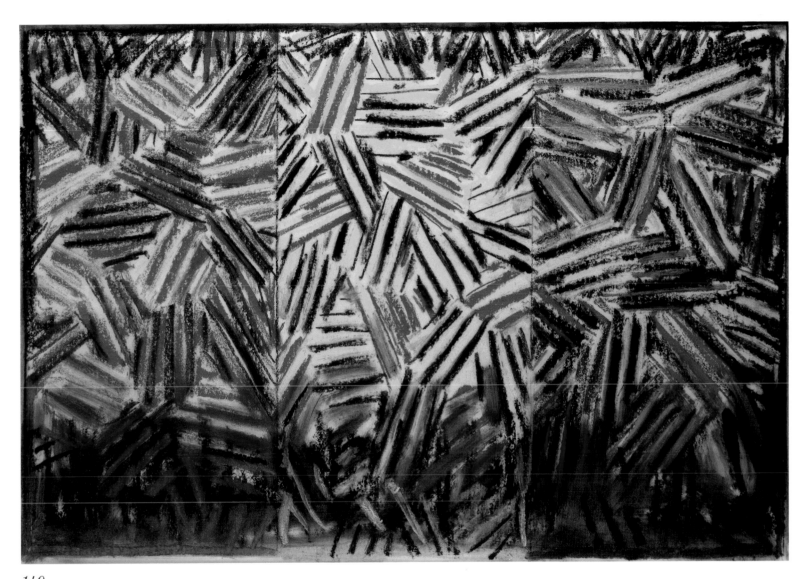

140

Untitled. *1981.*
Paintstik on tracing paper,
21¼ × 31¼".
Collection the artist

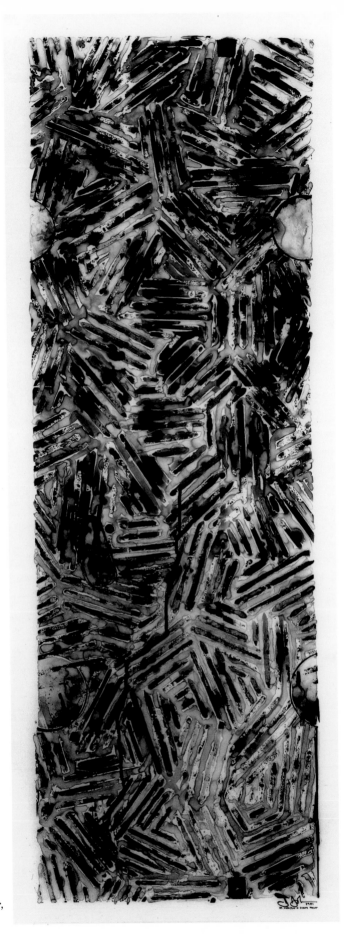

141
Usuyuki. *1981.*
Ink on plastic,
47¼ × 16".
Collection Richard and Peggy Danziger,
New York

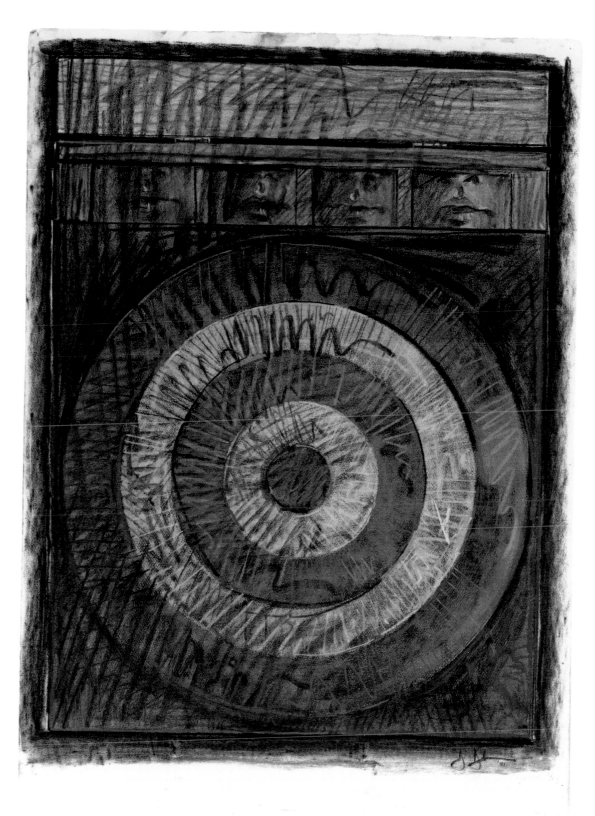

142
Target with Four Faces. *1981.*
Chalk on paper,
41½ × 29½".
Collection the artist

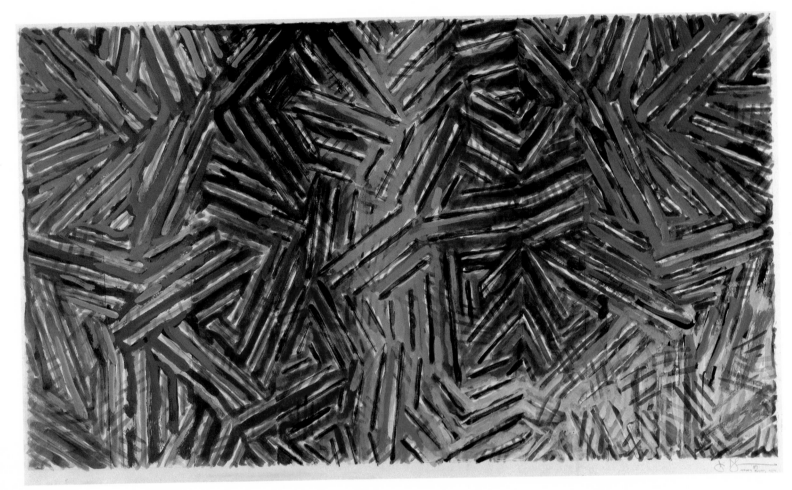

143

Between the Clock and the Bed. *1981.*
Watercolor and pencil on paper,
18 × 30⅝".
Collection the artist

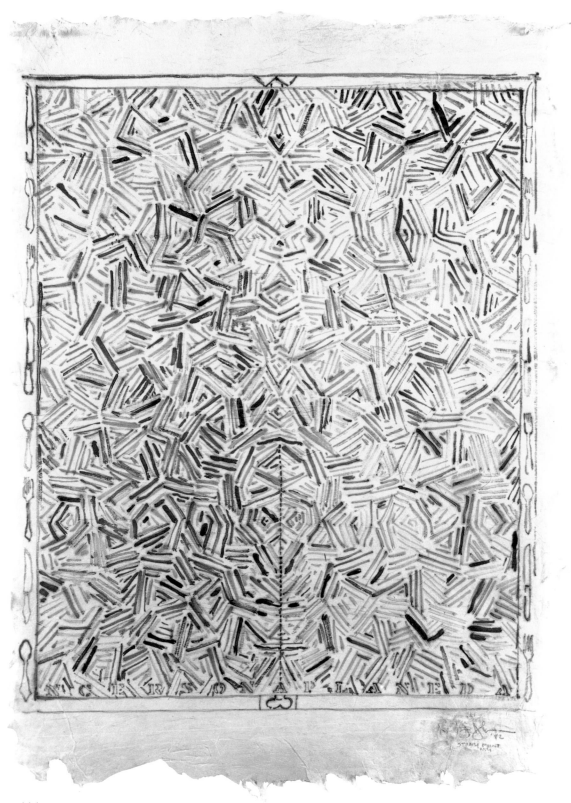

144
Dancers on a Plane. *1982.*
Graphite wash on paper,
35 × 27".
Collection the artist

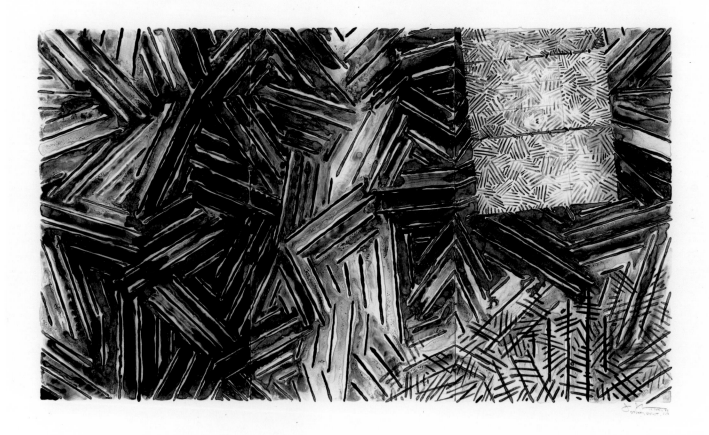

145
Between the Clock and the Bed. *1982.*
Ink on plastic,
18½ × 31".
Collection Aldo Crommelynck

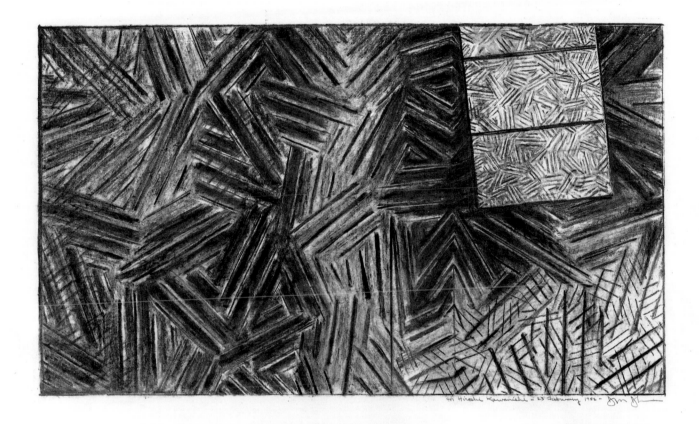

146

Between the Clock and the Bed. *1982.*
Charcoal and chalk on paper,
24 × 36½".
Collection Hiroshi Kawanishi

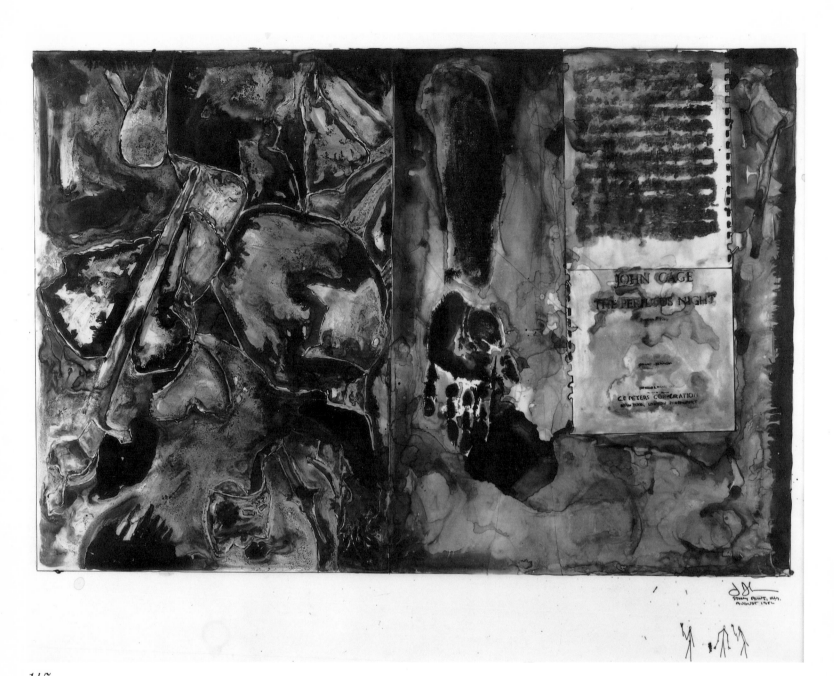

147

Perilous Night. *1982.*
Ink on plastic,
31⅝ × 40⅞″.
Collection the artist

148

Untitled. *1983.*
Charcoal and chalk on paper,
19⅜ × 24¾".
Collection Mr. and Mrs. Asher B. Edelman

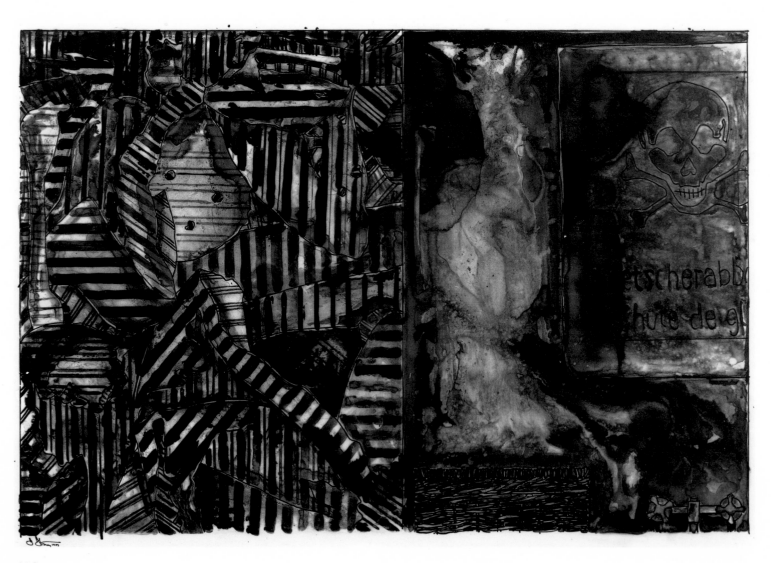

149

Untitled. *1983.*
Ink on plastic,
24 × 35".
Collection The Museum of Modern
Art, New York. Gift of
the Lauder Foundation

150
Untitled. *1983.*
Charcoal and chalk on paper,
33⅛ × 45¼".
Collection the artist

151

Untitled. *1983.*
Ink on plastic, 26¼ × 34½".
Collection the artist

Biography

Jasper Johns was born May 15, 1930, in Augusta, Georgia, and lived in South Carolina during his childhood with his grandparents and other relatives. After studying at the University of South Carolina, Columbia, he came to New York in 1949. He attended art school for a short time before he was drafted into the army and stationed in Japan. From 1952 he lived in downtown New York, supporting himself by working in a bookstore and making display work for stores that included Tiffany & Co.

The first *Flag, Target,* and *Number* paintings were made in the mid-1950s and were shown in his first one-man exhibition at the Leo Castelli Gallery in New York in 1958. He has exhibited there regularly—as well as at numerous museums and galleries in the United States and abroad. In 1959 he participated in the "Sixteen Americans" show at The Museum of Modern Art. During this period Johns made the first of his sculptures, using the images of the flashlight and the light bulb, and in 1960 he made the two *Painted Bronze* pieces of the Ballantine Ale cans and the Savarin coffee can with paintbrushes. In 1960 he made his first lithograph *(Target)* at Tatyana Grosman's Universal Limited Art Editions (ULAE) workshop in Long Island, New York, and has since made prints mainly at ULAE; Simca Print Artists, Inc., New York; Gemini G.E.L., Los Angeles; and Atelier Crommelynck, Paris. Exhibitions of his prints were held in 1970 at the Philadelphia Museum of Art and The Museum of Modern Art and in 1982 at The Whitney Museum of American Art.

During most of the 1960s, Jasper Johns lived and worked on Riverside Drive in upper New York City and later downtown on East Houston Street, as well as at Edisto Beach, South Carolina, where, in 1966, a fire destroyed his house while he was in Japan. Works of this period include the *0 Through 9* series (1961), the *Watchman* and *Souvenir* paintings (made in Japan, 1964), and the large works *Diver* (1962), *According to What* (1964), *Harlem Light* (1967), and *Wallpiece* (1968). Johns' *Map* (1967–71), based on Buckminster Fuller's Dymaxion projection of the world, and originally made for the Montreal Expo '67, was shown at The Museum of Modern Art in 1971.

Jasper Johns has been a Director of the Foundation for Contemporary Performance Arts since 1963. From 1967–75 he was Artistic Advisor to The Merce Cunningham Dance Company. In 1973 Jasper Johns was elected a Member of the American Academy and Institute of Arts and Letters. In 1978 he received the City of New York Mayor's Award of Honor for Arts & Culture. At present Jasper Johns lives in the country outside New York City and in the French Antilles.

List of Exhibitions

Selected One-Man Exhibitions

1958 Leo Castelli Gallery, New York
1959 Galerie Rive Droite, Paris
1960 Columbia Museum of Art, Columbia, South
 Carolina
 Leo Castelli Gallery, New York
1961 Galerie Rive Droite, Paris
 Leo Castelli Gallery, New York
1962 Galerie Ileana Sonnabend, Paris
 Everett Ellin Gallery, Los Angeles
1963 Leo Castelli Gallery, New York
1964 The Jewish Museum, New York
 Whitechapel Gallery, London
1965 The Pasadena Art Museum, Pasadena, California
 Ashmolean Museum, Oxford, England
 The American Embassy, London
 Minami Gallery, Tokyo, Japan
1966 Leo Castelli Gallery, New York
 National Collection of Fine Arts of the
 Smithsonian Institution, Washington, D.C.
1968 Leo Castelli Gallery, New York
1969 Castelli/Whitney Gallery, New York
 Castelli Graphics, New York
 David Whitney Gallery, New York
 Marion Koogler McNay Art Institute, San
 Antonio, Texas
1970 Leo Castelli Gallery, New York
 Philadelphia Museum of Art, Philadelphia
 John Berggruen Gallery, San Francisco
 The Museum of Modern Art, New York
1971 Dayton's Gallery 12, Minneapolis, Minnesota
 Castelli Graphics, New York
 Museum of Contemporary Art, Chicago
 Marion Koogler McNay Art Institute, San
 Antonio, Texas
 The Museum of Modern Art, New York
1972 Galerie Buren, Stockholm
 Fendrick Gallery, Washington, D.C.
 Houston Museum of Fine Arts, Houston, Texas
 Emily Lowe Gallery, Hofstra University, Long
 Island, New York
1973 Gertrude Kasle Gallery, Detroit
1974 Galerie Mikro, Berlin
1974–75 "Drawings," a circulating exhibition organized

by the Arts Council of Great Britain and
shown at the following locations: Museum of
Modern Art, Oxford; Mappin Art Gallery,
Sheffield; Herbert Art Gallery, Coventry;
Walker Art Gallery, Liverpool; City Art
Gallery, Leeds; Serpentine Gallery, London
1976 Leo Castelli Gallery, New York
 Janie C. Lee Gallery, Houston, Texas
 Castelli Graphics, New York
1977 Castelli Graphics, New York
1977–78 "Jasper Johns," a circulating exhibition organized
 by The Whitney Museum of American Art,
 New York, and shown at the following
 locations: The Whitney Museum of American
 Art, New York; Kunsthalle, Cologne; Centre
 National d'Art et de Culture Georges
 Pompidou, Paris; Hayward Gallery, London;
 The Seibu Museum of Art, Tokyo; San Fran-
 cisco Museum of Modern Art, San Francisco
1977 Brooke Alexander Gallery, Inc., New York
1978 Margo Leavin Gallery, Los Angeles
 Galerie Nancy Gillespie, Paris
1978–79 "Jasper Johns: Prints 1970–1977," a circulating
 exhibition organized by the Center for the
 Arts, Wesleyan University, Middletown,
 Connecticut, and shown at the following
 locations: Springfield Museum of Fine Arts,
 Springfield, Massachusetts; Baltimore Museum
 of Art, Baltimore, Maryland; Dartmouth
 College Museum and Galleries, Hopkins
 Center, Hanover, New Hampshire; University
 Art Museum, University of California at
 Berkeley, Berkeley; Cincinnati Art Museum,
 Cincinnati, Ohio; Georgia Museum of Art,
 University of Georgia at Athens, Athens,
 Georgia; St. Louis Art Museum, St. Louis,
 Missouri; Newport Harbor Art Museum,
 Newport Beach, California; Rhode Island
 School of Design, Museum of Art, Providence,
 Rhode Island
1978 John Berggruen Gallery, San Francisco
1979 Janie C. Lee Gallery, Houston, Texas
 Galerie Valeur, Nagoya, Japan
 Tucson Museum of Art, Tucson, Arizona
1979–81 "Jasper Johns: Working Proofs," a circulating

exhibition organized by the Kunstmuseum
Basel, Switzerland, and shown at the following
locations: Staatliche Graphische, Munich;
Stadtische Galerie, Stadelschen Kunstinstitut,
Frankfurt; Kunstmuseum Hannover,
Hannover; Statens Museum fur Kunst,
Copenhagen; Moderna Museet, Stockholm;
The Tate Gallery, London

1980 Castelli Graphics, New York
 The Greenburg Gallery, St. Louis, Missouri

1981 "Jasper Johns Drawings: 1970–1980," Leo
 Castelli Gallery, New York
 Margo Leavin Gallery, Los Angeles
 Thomas Segal Gallery, Boston

1982 Castelli Graphics, New York
 L. A. Louver Gallery, Los Angeles
 "Jasper Johns: Savarin Monotypes," The Whitney
 Museum of American Art, New York

1984 Leo Castelli Gallery, New York

Selected Group Exhibitions of Drawings

1958 "Personal Contacts, A Decade of Contemporary
 Drawings 1948–58," Contemporary Arts
 Museum, Houston, Texas

1959 "100 American Works on Paper I," Institute
 of Contemporary Art, Boston. Exhibition
 traveled to several museums abroad
 "School of New York: Some Younger Artists,"
 Stable Gallery, New York. From 1960 to
 1961 exhibition traveled to several museums
 in the United States under the auspices of
 The American Federation of Arts under the
 title "Some Younger American Artists"

1960 "Annual Exhibition—Contemporary Sculpture
 and Drawings," The Whitney Museum of
 American Art, New York

1961 "Modern American Drawings," organized by
 the International Program of The Museum of
 Modern Art, New York, for circulation to
 eight museums abroad, under the auspices of
 The International Council, from 1961 to 1962

1962 "4 Americans," Moderna Museet, Stockholm.
 Exhibition traveled to the Stedelijk Museum,
 Amsterdam; Kunsthalle, Bern
 "Lettering by Hand," The Museum of Modern
 Art, New York. Exhibition traveled to eight
 American museums in 1963. From 1965 to
 1967 exhibition traveled to seven Latin
 American museums, under the auspices of
 The International Council of The Museum of
 Modern Art, under the title "Lettering by
 Modern Artists"

1962–63 "Abstract Drawings and Watercolors, U.S.A.,"
 organized by The International Program of
 The Museum of Modern Art, New York, for
 circulation to twelve Latin American museums
 under the auspices of The International Council

1964 "American Drawings," The Solomon R.
 Guggenheim Museum, New York
 "Black, White and Grey," Wadsworth
 Atheneum, Hartford, Connecticut
 "Recent American Drawings," The Rose Art
 Museum, Brandeis University, Waltham,
 Massachusetts

1966 "Drawing And," University of Texas, Austin,
 Texas
 "Master Drawings: Pissarro to Lichtenstein,"
 Bianchini Gallery, New York. Traveled to
 the Contemporary Arts Center, Cincinnati,
 Ohio
 "Recent Still Life," Museum of Art, Rhode
 Island School of Design, Providence, Rhode
 Island

1969 "American Drawings of the Sixties: A Selection,"
 New School Art Center, New York
 "Drawings," Fort Worth Art Center Museum,
 Fort Worth, Texas
 "New York Painting and Sculpture: 1940–1970,"
 The Metropolitan Museum of Art, New York

1970 "Highlights of the 1969–70 Art Season," The
 Aldrich Museum of Contemporary Art,

Ridgefield, Connecticut
"L'Art Vivant aux Etats-Unis," Fondation
Maeght, Saint Paul (A.M.), France

1971 "Contemporary American Drawings," French
and Company, New York

1972 "Grids," Institute of Contemporary Art,
University of Pennsylvania, Philadelphia

1973 "American Drawings 1963–1973," The Whitney
Museum of American Art, New York
"3D into 2D: Drawing for Sculpture," The New
York Cultural Center, New York

1974 "America on Paper," Galerie Beyeler, Basel
"American Works on Paper: 1944 to 1974,"
William Zierler Gallery, New York
"Modern Master Drawings," Locksley/Shea
Gallery, Minneapolis, Minnesota
"USA on Paper," The Mayor Gallery, London

1975 "American Works on Paper: 1945–1975," M.
Knoedler and Company, New York
"Formative Years," Visual Arts Museum, New
York

1976 "American Master Drawings and Watercolors,"
organized by The American Federation of
Arts. Exhibition traveled to The Minneapolis
Institute of Arts, Minneapolis, Minnesota;
The Whitney Museum of American Art,
New York; The Fine Arts Museum of San
Francisco, San Francisco (1977)
"Drawing Now," The Museum of Modern Art,
New York. Exhibition traveled abroad under
the auspices of The International Council of
The Museum of Modern Art, New York
"Twentieth-Century American Drawing: Three
Avant-Garde Generations," The Solomon R.
Guggenheim Museum, New York

1977 "American Drawing 1927–77," Minnesota
Museum of Art, St. Paul, Minnesota.
Exhibition traveled to the Henry Art Gallery,
Seattle, Washington (1978); Santa Barbara
Museum of Art, Santa Barbara, California
(1978)

1978 "A Treasury of Modern Drawing: The Joan and
Lester Avnet Collection," The Museum of
Modern Art, New York

1979 "Documents, Drawings and Collages,"

The Williams College Museum of Art,
Williamstown, Massachusetts. Exhibition
traveled to The Toledo Museum of Art,
Toledo, Ohio; The John and Mable Ringling
Museum of Art, Sarasota, Florida; The Fogg
Art Museum, Cambridge, Massachusetts
"Master Drawings and Watercolors of the
Nineteenth and Twentieth Centuries," The
Baltimore Museum of Art, Baltimore,
Maryland. Exhibition traveled to The Solomon
R. Guggenheim Museum, New York; Des
Moines Art Center, Des Moines, Iowa; Art
Museum of South Texas, Corpus Christi,
Texas; The Museum of Fine Arts, Houston,
Texas; The Denver Art Museum, Denver,
Colorado

1980 "American Drawing in Black and White
1970–80," Brooklyn Museum, Brooklyn, New
York
"Drawings," benefit exhibition for The
Foundation for Contemporary Performance
Arts, Inc., Leo Castelli Gallery, New York
"The Object Transformed: Contemporary
American Drawing," Visual Arts Museum,
New York

1981 "New Dimensions in Drawings," The Aldrich
Museum of Contemporary Art, Ridgefield,
Connecticut

1982 "A Century of Modern Drawing from The
Museum of Modern Art, New York." The
exhibition, organized under the auspices of
The International Council of The Museum of
Modern Art, was shown at the Museum and
traveled to The British Museum, London;
Museum of Fine Arts, Boston; The Cleveland
Museum of Art, Cleveland, Ohio
"Drawings from the Collection of Agnes
Saalfield," Contemporary Arts Center,
Cincinnati, Ohio

1983 "Drawing Conclusions—A Survey of American
Drawings: 1958–1983," Daniel Weinberg
Gallery, Los Angeles and San Francisco
"The Modern Drawing: 100 Works on Paper
from The Museum of Modern Art," The
Museum of Modern Art, New York

Bibliography

Alloway, Lawrence. "Jasper Johns and Robert Rauschenberg." *American Pop Art* (exhibition catalogue), Collier Books and The Whitney Museum of American Art, New York, 1974, pp. 52–75.

Ashbery, John. "Brooms and Prisms." *Art News*, vol. 65, no. 1, March 1966, pp. 58–59, 82–84.

Bernstein, Roberta. "'Things the Mind Already Knows': Jasper Johns' Paintings and Sculptures, 1954–1974." Unpublished Ph.D. diss., Columbia University, 1975.

———. "Johns and Beckett: Foirades/Fizzles." *Print Collector's Newsletter*, vol. 7, no. 5, November–December 1976, pp. 141–45.

———. "Jasper Johns and the Figure: Part One: Body Imprints." *Arts Magazine*, vol. 52, no. 2, October 1977, pp. 142–44.

———. (Introduction), and Robert Littman (Notes). *Jasper Johns' Decoy: The Print and the Painting* (exhibition catalogue), The Emily Lowe Gallery, Hofstra University, Hempstead, New York, 1972, unpaginated.

Cage, John. "Jasper Johns: Stories and Ideas." *Jasper Johns* (exhibition catalogue), The Jewish Museum, New York, 1964, pp. 21–26.

Calas, Nicholas, and Elena Calas. "Jasper Johns: And/ Or." *Icons and Images of the Sixties*, E. P. Dutton, New York, 1971.

Contemporary Arts Museum, *A Decade of Contemporary Drawings*, Houston, Texas, 1958.

Coplans, John. "Fragments According to Johns: An Interview with Jasper Johns." *The Print Collector's Newsletter*, vol. 3, no. 2, May–June 1972, pp. 29–32.

Crichton, Michael. *Jasper Johns* (exhibition catalogue), Harry N. Abrams, New York, in association with The Whitney Museum of American Art, New York, 1977.

Feinstein, Roni. "Jasper Johns' *Untitled* (1972) and Marcel Duchamp's Bride." *Arts*, vol. 57, no. 1, September 1982, pp. 86–93.

Field, Richard S. *Jasper Johns: Prints 1960–1970*, The Philadelphia Museum of Art, 1970.

———. "Jasper Johns' Flags." *Print Collector's Newsletter*, vol. 7, no. 3, July–August 1976, pp. 69–77.

———. *Jasper Johns: Prints 1970–1977*, Petersburg Press, Ltd., London, in association with Wesleyan University, Middletown, Connecticut, 1978.

Fried, Michael. "New York Letter." *Art International*, vol. 7, no. 2, February 25, 1963, pp. 60–62.

Gablik, Suzi. "Johns' Pictures of the World." *Art in America*, vol. 66, January 1978, pp. 62–69.

Geelhaar, Christian. *Jasper Johns Working Proofs*, Petersburg Press, Ltd., London, 1980.

Goldman, Judith. *Foirades/Fizzles* (exhibition catalogue), The Whitney Museum of American Art, New York, 1977.

———. "Proof is in the Process: Painters as Printmakers." *Art News*, vol. 80, September 1981, p. 149.

———. "Echoes—To What Purpose?" *Jasper Johns Prints 1977–81* (exhibition catalogue), Thomas Segal Gallery, Boston, 1981.

———. *Jasper Johns: 17 Monotypes*, Universal Limited Art Editions, West Islip, New York, 1982.

Greenberg, Clement. "After Abstract Expressionism." *Art International*, vol. 6, no. 8, October 25, 1962, pp. 24–32.

Herrera, Hayden. "Drawings by Gallery Artists." *Art News*, vol. 73, no. 4, April 1974, p. 98.

Herrmann, Rolf-Dieter. "Drawings by Gallery Artists." *Art News*, vol. 16, no. 2, October 1977, pp. 26–33.

———. "Jasper Johns' Ambiguity: Exploring the Hermeneutical Implications." *Arts*, vol. 52, November 1977, pp. 124–29.

Hess, Thomas B. "Polypolyptychality." *New York Magazine*, vol. 6, no. 8, February 19, 1973, p. 73.

———. "On the Scent of Jasper Johns." *New York Magazine*, vol. 9, no. 6, February 9, 1976, pp. 65–67.

Holmstrand, James, and Jay Nash. "Zeroing in on Jasper Johns." *Literary Times*, vol. 3, no. 7, September 1964.

Hopps, Walter. "An Interview with Jasper Johns." *Artforum*, vol. 3, no. 6, March 1965, pp. 32–36.

———. "Jasper Johns: Fragments—According to What" (brochure), Gemini G.E.L., Los Angeles, 1971.

Johns, Jasper (statement). *Sixteen Americans* (exhibition catalogue), ed. Dorothy C. Miller, The Museum of Modern Art, New York, 1959, pp. 22–27.

———. "Duchamp." *Scrap*, vol. 2, December 23, 1960, p. 4.

———. "Sketchbook Notes." *Art and Literature* (Lausanne), vol. 4, Spring 1965, pp. 185–92.

———. "Marcel Duchamp (1887–1968): An Appreciation." *Artforum*, vol. 7, no. 3, November 1968, p. 6.

———. "Thoughts on Duchamp." *Art in America*, vol. 57, no. 4, July–August 1969, p. 31.

Johnson, Ellen. "Jim Dine and Jasper Johns: Art about

Art." *Art and Literature* (Lausanne), vol. 6, Autumn 1965, pp. 128–40.

———, and David Sylvester. *Jasper Johns Drawings*, The Arts Council of Great Britain, 1974–75.

Kozloff, Max. *Jasper Johns*, Harry N. Abrams, New York, 1969.

———. *Jasper Johns*, Harry N. Abrams/Meridian Modern Artists, New York, 1974.

Krauss, Rosalind. "Jasper Johns: The Functions of Irony." *October*, vol. 2, Summer 1976, pp. 91–99.

Kuspit, Donald. "Personal Signs: Jasper Johns." *Art in America*, vol. 69, Summer 1981, pp. 111–13.

Martin, Katrina. "Starring Jasper Johns: A New 35 Minute Film." *PCN*, vol. 12, January/February 1982, p. 178.

Masheck, Joseph. "Sit-in on Johns." *Studio International*, vol. 178, no. 916, pp. 193–95.

———. "Jasper Johns Returns." *Art in America*, vol. 64, no. 2, March/April 1976, pp. 65–67.

Perrone, Jeff. "Jasper Johns' New Paintings." *Artforum*, vol. 14, no. 8, April 1976, pp. 48–51.

Pincus-Witten, Robert. "On Target: Symbolist Roots of American Abstraction." *Arts*, vol. 50, April 1976, p. 85.

Porter, Fairfield. "The Education of Jasper Johns." *Art News*, vol. 62, no. 10, February 1964, pp. 44, 61–62.

Raynor, Vivian. "Conversation with Jasper Johns." *Art News*, vol. 72, no. 3, March 1973, pp. 20–22.

Rees, R. J. "Jasper Johns Drawings at the Museum of Modern Art, Oxford." *Art International*, vol. 188, no. 972, December 1974, p. 261.

Restany, Pierre. "Jasper Johns and the Metaphysics of the Common Place." *Cimaise*, vol. 8, no. 55, September/October 1961, pp. 90–92.

Rose, Barbara. "The Graphic Work of Jasper Johns: Part I." *Artforum*, vol. 8, no. 7, March 1970, pp. 39–45.

———. "The Graphic Work of Jasper Johns: Part II." *Artforum*, vol. 8, no. 9, September 1970, pp. 65–74.

———. "Decoys and Doubles: Jasper Johns and the Modernist Mind." *Arts Magazine*, vol. 50, no. 9, May 1976, pp. 68–73.

———. "Johns: Pictures and Concepts." *Arts*, vol. 52, November 1977, pp. 148–53.

Rose, Bernice. *Drawing Now*, The Museum of Modern Art, New York, 1976.

Rosenberg, Harold. "Jasper Johns: Things the Mind Already Knows." *Vogue*, vol. 143, no. 3, February 1, 1964, pp. 175–77, 201–3.

Rosenblum, Robert. "Jasper Johns." *Art International*, vol. 4, no. 7, September 1960, pp. 74–77.

———. "Les Oeuvres Récentes de Jasper Johns." *XXe Siècle*, vol. 24, no. 18, February 1962, supplement, unpaginated.

———. Preface to Portfolio *0–9*. Universal Limited Art Editions, West Islip, New York, 1963.

Rubin, William. "Younger American Painters." *Art International*, vol. 4, no. 1, 1960, pp. 24–31.

Russell, John. "Jasper Johns and the Readymade Image." In *The Meanings of Modern Art*, vol. 11, The Museum of Modern Art, New York, 1975, pp. 15–23.

———. "Jasper Johns Sketches Himself—and Us." *The New York Times*, February 1, 1976, Art section, p. 1.

Shapiro, David. "Imago Mundi." *Art News*, vol. 70, no. 6, October 1971, pp. 40–41, 66–68.

Solomon, Alan R. "Jasper Johns." *Jasper Johns* (exhibition catalogue), The Jewish Museum, New York, 1964, pp. 5–19.

———. "Jasper Johns: Lead Reliefs" (brochure), Gemini G.E.L., Los Angeles, 1969.

Steinberg, Leo. "Contemporary Art and the Plight of Its Public." *Harper's Magazine*, vol. 224, no. 1342, March 1962, pp. 31–39.

———. "Jasper Johns." *Metro*, nos. 4/5, May 1962.

Swenson, G. R. "What is Pop Art? Part II (Interview with Jasper Johns)." *Art News*, vol. 62, no. 10, February 1964, pp. 40–43, 62–67.

Sylvester, David. "Interview." *Jasper Johns Drawings* (exhibition catalogue), Arts Council of Great Britain, 1974, pp. 7–19.

Tillim, Sidney. "Ten Years of Jasper Johns." *Arts Magazine*, vol. 38, no. 7, April 1964, pp. 22–26.

Todd, J. "Insight and Ideology in the Visual Arts." *British Journal of Aesthetics*, vol. 21, no. 4, Autumn 1981, pp. 313–15.

Young, Joseph E. "Jasper Johns: An Appraisal." *Art International*, vol. 13, no. 7, September 1969, pp. 50–56.

Zerner, Henri. "Universal Limited Art Editions." *L'Oeil* (French ed.), no. 120, December 1964, pp. 36–43, 82.

Index of Drawings

Photograph Credits

With the exception of photographs supplied by museums or private collectors, unidentified as to photographer, all illustrations were photographed by the following:

Rudolph Burckhardt, New York: plates 18, 20, 25, 28, 29, 31, 32, 34, 36, 37, 39, 44, 46, 48, 52, 55, 57, 58, 66, 68, 71, 73, 79, 80, 87, 88, 93, 94, 95, 96, 97, 98, 99
Geoffrey Clements, New York: plate 19
Bevan Davies: plates 105, 125, 131, 135
Jones/Gessling, New York: plates 5, 70
Margo Leavin Gallery, Los Angeles: plate 134
Mathews: plate 6
Mettee Photography, Maryland: plate 49
Otto E. Nelson, New York: plate 75
Douglas M. Parker: plate 78
Eric Pollitzer, New York: plates 7, 38, 53, 54, 63, 69, 76, 84, 103, 104, 106, 107, 108, 109, 110, 112, 113, 114, 115, 116, 119, 120, 122, 123, 124, 127, 128, 129, 130, 141
Harry Shunk, New York: plates 14, 24, 26, 33, 40, 47, 56, 59, 60, 61, 62, 72, 83, 85, 89, 91, 92
Lee Statsworth, Washington, D.C.: plate 51
Glenn Steigelman, New York: Front jacket, plates 2, 3, 4, 8, 10, 11, 12, 13, 17, 21, 23, 27, 41, 45, 64, 67, 77, 81, 86, 90, 101, 111, 117, 118, 121, 133, 136, 140, 143, 144, 145, 146, 147
Dorothy Zeidman: Frontispiece, plates 9, 16, 35, 43, 137, 138, 148, 149, 150, 151
Zindman/Fremont: plates 139, 142

Baseball's Golden Age

THE PHOTOGRAPHS OF
CHARLES M. CONLON

Baseball's Golden Age

THE PHOTOGRAPHS OF
CHARLES M. CONLON

By Neal McCabe and Constance McCabe
Foreword by Roger Angell

Abrams, New York

Hi Mom

Editor: Sharon AvRutick
Designer: Carol Robson

For more information on Charles M. Conlon or to purchase high-quality prints of his work, please visit TheConlonCollection.com

Cataloging-in-Publication Data has been applied for and may be obtained from the Library of Congress.

ISBN: 978-1-4197-0197-9

In association with *Sporting News* and with the cooperation of Major League Baseball Properties, Inc.

Printed and bound in Hong Kong, China
10 9 8 7 6 5 4 3 2 1

Abrams books are available at special discounts when purchased in quantity for premiums and promotions as well as fundraising or educational use. Special editions can also be created to specification. For details, contact specialsales@abramsbooks.com or the address below.

ABRAMS
THE ART OF BOOKS SINCE 1949
115 West 18th Street
New York, NY 10011
www.abramsbooks.com

The photographs reproduced in this book were printed by Constance McCabe from the original negatives at Photo Preservation Services, Inc., Alexandria, Virginia

Case front: Bob Meusel, New York Yankees, 1927
Case back: Honus Wagner, Pittsburg Pirates, 1912

I ain't a bad looking guy in the White Sox uniform Al. I will have my picture taken and send you boys some.

Jack Keefe
from Ring Lardner's *You Know Me Al*

Page 2:

Cleveland Naps vs.
New York Highlanders
Hilltop Park, New York City
May 18, 1912

New York base runner Bert Daniels has just been thrown out at the plate by Cleveland center fielder Shoeless Joe Jackson. Catcher Ted Easterly applies the tag as umpire Billy Evans makes the call. Cleveland third baseman Ivy Olson looks on.

Charles M. Conlon: "From his vantage point twenty feet from the plate, with slide drawn and accurate focus, the photographer watched. About a dozen feet from the goal the runner dropped for his slide, and almost at the same instant, as he slid forward, the spikes on his shoes glistening in the bright sun, the ball reached the catcher. One quick sweep of the arm, and the runner was touched. Through the cloud of dust that arose as the runner's feet tore up the earth, the umpire looked and waved his decision. It was a lightning play and so close that no mortal man could say definitely or decisively which had reached the plate first, the runner or the ball. The umpire called the man out, as he saw the play, and instantly there was an uproar."

A Day at the Park

by Roger Angell

Here's a welcome new edition of the best book of baseball photographs ever published. I have a copy of the original at home, another in my office, and another in a summer cottage in Maine, and all three are shiny with repeated takings-down and long perusals. I am not a sentimentalist about the early game and its players, which sometimes shine too sweetly in our glum, post-steroids thoughts, and these portraits, with their quotient of celebrated racists, worn-down alcoholics, cheerful fisticuffers, embattled umpires, and semi-literate cheaters, are a tonic remedy for goo. What's best about *Baseball's Golden Age: The Photographs of Charles M. Conlon*, however, is its powerful sense of the everyday: afternoons and games and seasons and eras, spelled out by a sideline photographer employed by the *New York Telegram* (and later *The Sporting News* and the *Spalding Baseball Guides*), who invited local and visiting stars and regulars and benchwarmers and managers to stop for a moment in front of his heavy, glass-plate negative camera, and then looked for a good spot near a foul line to grab a close play at third or home. Neal McCabe, the author and presiding historian of this collection, calls one of these shots—a clenched-jaw Ty Cobb sliding into third in a spray of dirt (page 26)—the greatest baseball action picture ever taken, and who would argue with him?

What surprised me about this book when it first appeared in 1993 was the shared anonymity of its subject, Charles M. Conlon, and its creators, McCabe and his sister, Constance McCabe, the preserver and conservator of these photographs. I recognized the Cobb photo at once, along with some dozens more, but had not noticed who took them. Conlon, never a great battler for a credit line, took his first big league photograph in 1904 (the backyard shot of baseball's presiding young hero, Christy Mathewson, outside the Polo Grounds, that leads off here) and stayed at the work steadily until 1942. Not quite a journeyman, it turned out. McCabe compares him favorably with Atget and Walker Evans, and before we smile knowingly, we need to think about

a compelling 1911 photograph of Mathewson, by then regarded as a national treasure (page 189), or the facing shot of Matty's manager, John McGraw, crouched by third base in a coil of barely contained intelligence and attention.

McCabe's caption for this picture is an extended Mathewson quote about McGraw, and it typifies the startling research and energy the writer has put into the normally humdrum space of an accompanying text. Again and again, he startles and informs. Why did Lefty Grove forbid pictures of himself with the ball in his hand? Where did Babe Ruth get his nickname? Why was Zeke Bonura called Zeke? How did Shoeless Joe Jackson blacken his bat? Why couldn't Jim Thorpe make it in the majors? Who drove Kid Gleason into a nervous breakdown? Read the captions and find out. McCabe can be brief, as well. Of a sunlit and carefree young Lou Gehrig, caught in 1925 (page 64), he asks only, "Why is this rookie smiling?"

Full disclosure forces me to say that Gehrig and a good many others here were heroes of my New York youth, and that some of the earlier players were similarly adulated by my father in his teens; a Cleveland native, he often saw Cy Young pitch and Nap Lajoie hit. I'll take this as a reward of age, but no more. When I go back to the arresting close-up of Honus Wagner's enormous hands gripping a bat (page 23), it doesn't just supply the easy comparisons with his gloved and gauntleted current successors but more urgently reminds me about back-country ballplayers, so common in my father's time but now entirely gone.

After somebody revived the "Murderers Row" nickname and bestowed it on the devastating 1927 New York Yankees batting order, Conlon picked up on the cue and invited the hitters—Earl Combs, Mark Koenig, Babe Ruth, Lou Gehrig, Bob Meusel, and Tony Lazzeri (pages 108 to 113)—to sit for mug shots: extreme close-ups that would resemble those "Man Wanted" posters in a precinct station. It didn't quite work. Thanks to his art (and his

improved lenses), the series isn't a newspaper feature but an essay on intimacy. Up close, we are pierced by their gaze and lean a fraction toward the page, awaiting their conversation.

Conlon, who lived in Englewood and commuted to the convenient Polo Grounds and Yankee Stadium, appreciated the local celebrities, which accounts for the ten Babe Ruths here, including a swath of five different shots of the Babe, always seen in the latter stages of his swing (pages 52–54)—first as a lithe, visiting left-handed star pitcher with the Red Sox in 1918, and the last as a stiff and upright fading slugger in 1934, his final year in the Bronx. Other notables—Honus Wagner, Dizzy Dean, Tris Speaker—also age before our eyes, so to speak, confirming the foreshortened view of life that even beginner fans sense about baseball after a season or two. There's a young 1924 Al Simmons facing his 1939 self (pages 42 and 43), but the latter portrait of the onetime Athletics batting champion and World Series hero—"by now," as McCabe writes, "an ancient and embittered castoff playing for his fifth team in five years"—suffices alone in its sadness.

Conlon preferred youth and promise, and his first portraits of Gehrig, Hank Greenberg, Jimmie Foxx, and Ted Williams, all caught in the dawning moments of their extraordinary careers, flood us with hope. (He encounters the Splendid Splinter at the Stadium [page 38] on his first afternoon in the majors.) More boyish than their modern counterparts, these handsome rookies can't hide their joy over their own capabilities and their immense good fortune in finding such a complex and pleasurable and unendingly difficult line of work.

Acknowledgments

The authors wish to thank a number of friends and colleagues for their support, trust, encouragement, and advice.

Without the dedication and scholarship of Steve Gietschier, Director of Historical Records of *The Sporting News* and custodian of the Conlon Collection, this book could never have been written. His superbly detailed catalogue of Conlon's negatives gave order to a daunting, sprawling collection. His generosity was simply overwhelming: He allowed us unlimited access to the archives of *The Sporting News*. We have attempted to produce a book worthy of his faith in us.

Many highly skilled professionals helped in the preparation of the photographs and text: Mary Lynn Ritzenthaler introduced us to Mr. Gietschier; Karen Garlick was particularly supportive, and we have benefited from her literary and computer expertise; and Sarah Wagner worked on the conservation treatment of an original photographic plate and spent considerable time preparing the prints for reproduction. Others who gave their time and exceptional talents in preparation of the prints include: Nancy Reinhold, Judy Walsh, Steve Puglia, Barbara Lemmen, Vicki Toye, and Pamela Kirschner. Thanks also to Jan Clubb, David Leaf, Terry Wallis, Tom and Carol McCarthy, Tom Keith, Nina Masonson, Shelley Fletcher, Nina Graybill, and Bill Topaz for their professional and personal support during the book's production.

Stephen Small, Director of Photo Preservation Services, Inc., deserves our special thanks. He was always there as a photographic troubleshooter, as a provider of technical information and expertise, and as a friend and supporter. For all his help, we are truly indebted.

Several people provided invaluable assistance in tracking down the elusive Charles M. Conlon: Patricia Kelly, photo collection manager of the National Baseball Library, Cooperstown, New York; Michael Salmon and the library staff of the Amateur Athletic Foundation, Los Angeles, California; Neil Victor and Debra Powell of Sportsbooks, West Hollywood, California; Ralph L. Horton of the Horton Publishing Company, St. Louis, Missouri; and Richard Kraus of the Los Angeles Public Library.

Charles M. Conlon was entirely dependent on the people who consented to pose for him, and we would especially like to thank those ball players and their families who graciously responded to our inquiries about the photographer: Ethan Allen, Dick Bartell, Boze Berger, Stanley and Vicki Bordagaray, Lou Boudreau, Mace Brown, Dolph Camilli, Harry Craft, Frank Crosetti, Tony Cuccinello, Dom DiMaggio, Bobby Doerr, Bob Feller, Rick Ferrell, Mrs. Hal Finney, Charlie Gehringer, Mel Harder, Buddy Hassett, Alex Kampouris, Mark Koenig, Max Lanier, Mary Lavagetto, Al Lopez, Pinky May, Johnny Mize, Hugh Mulcahy, Hal Newhouser, Bill Nicholson, Claude Passeau, Billy Rogell, Hal Schumacher, Birdie Tebbetts, Gail Terry, Cecil Travis, and Bill Werber.

Our special gratitude goes to Frances Smythe of the National Gallery of Art for taking the time to review our book proposal. She encouraged Paul Gottlieb to look at it, and he, in turn, made the publication of this book possible. It has been a pleasure to work with our editor, Sharon AvRutick, and our book designer, Carol Robson, both of whom have been infinitely patient with a pair of rookie authors.

"The Base Ball Photographer"

The game which seems to breathe the restless spirit of American life, that calls for quick action and quicker thinking, that seems characteristic of a great nation itself, is baseball.

<div align="right">

CHARLES M. CONLON

1913

</div>

When the World Series ended, he folded up his camera and waited for Opening Day. He had photographed everyone at the ballpark: players, managers, coaches, umpires, owners, visiting celebrities, wives, and children. Scores of fragile glass negatives, all meticulously identified in his neat hand, had been printed by the photographer in his home darkroom in preparation for their publication in the *Spalding Base Ball Guide*, the "Official Chronicle of America's National Game." In the winter, the editors combined his photographs in montages of ball players batting and throwing, leaping and catching. Row upon row of celebrated faces grinned and glared. On every page, two inconspicuous words appeared: "CONLON PHOTOS." When the spring came, he was back at the ballpark, ready to begin again.

He was not a professional photographer. He was not even a sports photographer. Yet Charles Martin Conlon was the greatest baseball photographer who ever lived, a newspaper proofreader who documented the golden age of baseball in his spare time. Today, his thousands of photographs form the basis of the unmatched collections of *The Sporting News* and the Baseball Hall of Fame. His images have become American icons, but their creator has vanished with barely a trace, his life's work submerged in the vast, anonymous pictorial heritage of baseball.

He was born in Albany, New York, in November 1868, at the same time that players were being recruited in Cincinnati, Ohio, for the first all-professional baseball team, the Red Stockings. During his childhood, there was a short-lived National League franchise in nearby Troy, New York, but the sport played no part in the young Conlon's life: "Baseball interested me," he recalled, "but it did not bother me to the extent that I would take a day off to see a game. You see, it was Albany. Perhaps if it had been New York, or some other city in the National League, it would have been different. I went into the printing business."

Conlon was employed by a local newspaper, the *Troy Press*, in the 1890s, but at the turn of the century he headed for the big city, where he found work at the *New York Evening Telegram*. The editor of the *Telegram*'s sports page was John B. Foster, who also served as the assistant editor of the annual *Spalding Base Ball Guide*. The *Spalding Guide* and its junior counterpart, the *Reach Guide*, were basically promotional tools for their respective sporting-goods companies, but they were indispensable to any true fan. These pocket-size baseball compendiums contained the most up-to-date rules of the game, complete statistics and detailed summaries of the previous season, schedules for the upcoming season, essays, editorials, and hundreds of photographs. Since 1881, the *Spalding Guide* had been edited by the venerable Henry Chadwick, a baseball authority who had seen his first game in 1856 while working as the cricket reporter for the *The New York Times*. His dedication to baseball during the next five decades had helped make the sport America's national pastime, but by 1904, the "Father of Base Ball" was seventy-nine years old, and he was grooming John B. Foster to take his place as editor of the *Guide*. "I came to know Foster very well," said Conlon. "He came to know about my hobby—taking pictures. He said to me one day, 'Charley, they need pictures of ball players for the *Guide*, and there is no reason why you can't take pictures of the players, as well as landscapes. It will be a good pickup for you, and it will be something for a day off.'"

In the spring of 1904, the thirty-five-year-old hobbyist brought his camera to the Polo Grounds, the ballpark of the New York Giants. This was not as ordinary an event as it seems to us today, when spectators take their cameras to baseball stadiums every day, when every team holds an annual promotional event called Camera Day, which allows fans to take close-up pictures of their favorite players on the field. Before the turn of the century, few photographers were interested in dragging their heavy camera equipment to anything as insignificant as a baseball game. Furthermore, their thick glass negatives were incapable of capturing the speed and excitement of the sport. The photographic record of that time consequently consists almost entirely of ball

Marge and Charles Conlon, c. 1907

Charles M. Conlon, 1935

"Of course I remember Charles Conlon," says Ethan Allen, a major-league outfielder and frequent Conlon subject. "The only problem I have is seeing his picture without a camera in his hands."

players in lifeless poses: young men in uniform with hair neatly combed and arms folded sitting together in frozen tableaux. There were primitive attempts to simulate the excitement of the game. One player would stand against a cheap studio backdrop, holding his hands together beneath a ball suspended on a wire; another would lie down on the floor with arms outstretched, pretending to slide. Charles M. Conlon saw other possibilities.

He had the field to himself. He stopped the star pitcher of the Giants outside the ballpark and persuaded him to pose. He assembled the Giants for a casual team portrait while laughing fans looked on. He took his camera out on the diamond to capture the players at their positions, and the players apparently enjoyed it as much as he did. He approached visiting players after the game and they, too, posed for the amateur photographer. He then paid a visit to the upstart New York Highlanders at their new American League ballpark.

Conlon's first baseball photographs were simple snapshots, often poorly framed and out of focus, in which a player's eyes were usually lost in the shadow cast by the bill of his cap. In some pictures, even the player's cap was barely visible against the sky, and the darkroom novice "improved" such photographs by crudely scratching the contours of the cap directly into the negative. (Fortunately, only a few of these early negatives were mutilated by the photographer; see page 180 for his least disastrous attempt at retouching.) Despite Conlon's shaky, nearly nonexistent technique, his first efforts were impressive. Today they seem almost miraculous: Ball players from another era are standing in the sunshine of the twentieth century. Some of these men are plainly amused by the photographer's attentions, and some are posing grudgingly, but in all of these portraits we can glimpse an evanescent moment in history, the dawning of baseball's golden age.

By the summer of 1904, Conlon's first uncredited photographs were appearing occasionally in the *New York Telegram*. His uncredited team photo of the Giants was printed in *The Sporting News* that fall. His portrait of pitcher Christy Mathewson was published in the 1905 *Spalding Guide* the next spring, but it was severely cropped, buried amid a sea of stilted studio poses, and, worse yet, credited to another photographer. Over the next few years, while talented photographers such as Francis P. Burke, Paul Thompson, W. M. Van der Weyde, and Louis Van Oeyen were beginning to produce their own remarkable player portraits, Conlon's pictures continued to appear haphazardly and anonymously.

In April 1908, however, the "Father of Base Ball" breathed his last, and John B. Foster succeeded him as editor of the *Spalding Guide*.

Foster's industrious protégé was the primary beneficiary of this change. By 1909, Conlon's credited photographs were dominating the *Spalding Base Ball Guide*; by 1911, they filled the *Reach Base Ball Guide*. For the next thirty years, he would be the principal photographer for both publications.

Photography was changing rapidly in the first decade of the twentieth century. It was now easier for a photographer to stop motion with the faster glass plates becoming available, and Conlon soon became fascinated with the possibilities of action photography. Around 1906, he began to take his camera onto the field during games: "The favorite position was about fifteen or twenty feet back of first or third," he recalled in 1913, "though occasionally the photographer would be seen hovering around home plate when the conditions of the game pointed to a possible play there. Through familiarity with the game he could usually tell where a slide was likely to occur."

There was a complicating factor: "The camera man was in constant danger from hard-hit drives. Camera in hand, he was not always in position to move rapidly, and the rifle-shot speed with which the ball frequently was driven toward him gave little opportunity to get out of range. Aside from countless narrow escapes, I was seriously injured twice. On one occasion, less than half an hour after I had assisted in caring for a brother photographer who was hit in the head by a batted ball, a vicious drive down the first base line caught me just above the ankle, and I was unable to walk for a couple of weeks." In 1937, Conlon revealed the culprit's identity: "Years ago, while I was off first, John Titus of the Phillies cut one down my way and struck me in the right ankle. It still hurts."

There were other risks in this war zone: "Larry Doyle was the biggest problem. The second baseman of the Giants had a habit of throwing his bat. It endangered players and picture men. [Giant manager John] McGraw saw me get a close shave one day from a Doyle bat, and ordered Larry to tie the stick to his wrist with a thong."

Besides being hazardous to a photographer's health, the action photo was the controversial forerunner of today's instant replay: "One day the Giants were playing the Cubs," Conlon recalled. "Oh, those were the games, and that was the *rivalry*! The Giants lost on a decision at the plate. The umpire called the man out, and I thought he was safe. I snapped the play. McGraw came out raving and called the umpire plenty. Tom Lynch, president of the National League, suspended Mac for three days and fined him. We reproduced the picture in the *Telegram* and it showed that the player had been safe by a stride. The umpire had his attention directed toward it in no kind or courteous

manner the following day. The howl went up plenty. Lynch was in a very tough spot, but he settled the whole thing with an order barring cameramen from the field."

This 1910 ruling was immediately protested by *The Sporting News*: "Base ball photos, hot off the griddle, illustrating plays you have seen yourself, or which you revile yourself for missing, are becoming one of the most valuable and remunerative methods of keeping alive the interest in the real fans, and arousing a spirit of restless inquisitiveness among the backsliders which nothing but a fresh peep at a hot series on the home grounds will satisfy. At from twenty-five to seventy-five cents per peep to the financial improvement of the club, this free and unsolicited advertising is not to be despised. Professional base ball is not a necessity, it is an amusement enterprise essentially, based on sporting principles. Public—and newspaper—support and interest are absolutely necessary to the preservation of the enterprise. Whereof is the foolishness of T. Lynch? The action photo in base ball has come to stay, and will be long in the land after T. Lynch has been gathered to his fathers."

When he wasn't fending off vicious line drives or irate umpires, the exacting Conlon was waiting for just the right photograph. Even in the late innings of this action-packed ballgame, he had still not achieved a satisfactory shot: "One afternoon at the Polo Grounds, inning after inning passed, but without a picture. It was 10–2, in favor of the Giants. In the seventh inning, I was standing off third, and McGraw smiled, 'Charley, no picture today, what?' I complained bitterly and said I'd have to go back to the office without even a single shot to show for a whole day's work. 'I'll give you a picture,' he said. 'Be ready.' [Giant shortstop Al] Bridwell doubled to start the Giant half. Remember, it was 10–2. McGraw suddenly gave Brid the steal sign. Down came the shortstop, after a preliminary look of inquiry and amazement. He was nipped, and the picture was a corker. 'It was the best slide you ever made in your life—for the picture man,' McGraw grinned. Brid understood. The baseball writers discussed the play at some length in their stories and wondered if Brid had gone down on his own, and whether he or McGraw had had a brainstorm. What the writers did not know was the plight of the cameraman—me—without a picture. Managers have been swell to me, but John McGraw was in a class by himself."

Although Conlon took hundreds of action photos, only a handful of these negatives survive. One of them is his 1910 photograph of a sliding Ty Cobb (page 26): "It was not printed the next day," recalled Conlon in 1937. "It did not appear until the *Spalding Guide* came out the following spring." In fact, this astonishing photograph was not published in the *Spalding Guide* until the spring of 1912, one and a half years after it was taken. When it finally did appear—misdated in the *Guide*—it was immediately recognized as something out of the ordinary: "A number of scenes of plays taken during the progress of the past season are given," said the reviewer for *Sporting Life*, "one of Ty Cobb making one of his characteristic slides being especially noteworthy as a remarkable example of snapshot photography." A black blob purporting to be a baseball was later added to the picture, and this egregious disfigurement of Conlon's most famous photograph has since been reproduced thousands of times. Fortunately, the negative was left untouched: The entire original image is offered here for the first time.

Action photography was the most exciting part of Conlon's work, but the pictures he took before the game constitute his true legacy, a profusion of breathtaking images as remarkable for their beauty as for the very fact that they exist at all. In his exquisite player portraits, his distinctive batting practice photos, and his innumerable photographs of players throwing a baseball and swinging a bat, Conlon systematically documented a strange and elegant world that was disappearing even as he took each picture, a world we can see today only because the photographer was awake to the dreams that surrounded him. Conlon had no artistic pretensions—he would remain a full-time proofreader at the *Telegram*—yet he steadily amassed a staggering body of work, at once delicate and powerful, by simply honoring John B. Foster's original request: "Charley, they need pictures of ball players for the *Guide*."

Pregame photography was not nearly as dangerous as taking action photos during a game, but Conlon was still dodging foul balls and errant throws as he wandered through the relaxed anarchy of batting and fielding practice. While ball players jogged, stretched, chatted, and scanned the stands for pretty faces, he carried his large Graflex camera, along with his cumbersome supply of glass negatives. (From 1904 until 1915, Conlon used a 5 × 7–inch format, and from 1916 until 1934 he used a 4 × 5–inch format. In the last years of his career, he was able to dispense with glass negatives, switching to 4 × 5–inch sheet film.) Burying his head in the hood of his camera, the part-time photographer worked quickly, and in a matter of minutes he could take a year's worth of photos of an entire team: As one player after another poses for the camera, we can often see the same fan, or fans, shifting in the grandstand. Conlon further expedited his work in 1913, when he settled on the background that became a constant element in his portraits for the next thirty years, the dugout roof. Haste is evident in many of his photographs: Conlon never fully mastered the mysteries of focus, and he often guessed at exposure times because of the tricky and undependable natural light at the ballpark. But at his

best, Conlon created photographs of such perfection that it is difficult to believe that they were taken under such unlikely conditions.

By 1920, Charles M. Conlon had become, de facto, the official photographer of baseball. He was the staff photographer for *Baseball Magazine*. He had his own logo in the *Spalding* and *Reach Base Ball Guides*. His pictures were sold on baseball cards and posters, they advertised soda pop and shotguns, they appeared in the *New York Telegram* and *The Sporting News*, and they illustrated baseball manuals and textbooks. When the autobiography of his old friend John McGraw was published in 1923, it naturally featured Conlon photographs. And whenever the Yankees or Giants won the pennant in the 1920s and '30s, virtually an annual event in those years, Conlon provided the player portraits for the World Series souvenir programs.

Strangely, even as his photographs inundated the baseball world, his name rarely appeared with his work in print. His pictures had long been accumulating in the files of photo agencies such as Underwood and Underwood, where individual photographers inevitably remained nameless, and, except for the *Guides*, where his artless logo evolved by the late thirties into a twisted Deco grotesque, the photographer was at the mercy of layout artists who rarely chose to acknowledge his contributions. The posters sold by *Baseball Magazine* bore his name, but his pictures were seldom credited in the *New York Telegram* or *The Sporting News*, and they were never credited in the World Series programs, on baseball cards, or in advertisements. Conlon seems to have been indifferent to his relative obscurity, perhaps because he knew that in the world of journalism it had long been self-evident that a baseball photo was a Conlon photo.

It is interesting to note that Conlon, who had unlimited access to every sporting event in New York, never chose to document any sport but baseball. He did take a few snapshots at the 1922 Davis Cup tennis tournament, but these perfunctory photographs pale even in comparison to the pictures he took of his birds, Tottie and Monkey, and his cats, Buddy and Kiddo. He seems never to have been an avid sports fan, yet he was drawn to the world of baseball: From his first day at the ballpark, Conlon felt at home, and his best portraits of ball players are as warm and intimate, as direct and revealing, as a man's pictures of his family and friends. Conlon looked back on his decades of baseball photography with satisfaction and gratitude: "No man ever did a bigger favor than John B. Foster did for me that morning in 1904. It wasn't the money—that's negligible. But the fun I have had, the days in the open, the associations, the confidences I have enjoyed—well, you can't buy those things."

By 1938, Conlon was sixty-nine years old, and he finally began to slow down. He made fewer trips from his home in Englewood, New Jersey, to the ballparks across the Hudson River. He no longer took every player's portrait, and in 1939, he actually shared photo credits in the *Guides* for the first time in decades. By this time, hundreds of energetic young baseball photographers were crowding the old man out of *Baseball Magazine* and *The Sporting News*. In 1940, the *Reach Guide* merged with the *Spalding Guide*, and after John B. Foster's death in 1941, the *Guide* ceased publication entirely. In 1942, by now retired from his newspaper job and deprived of the main outlets for his work, the seventy-three-year-old photographer nevertheless took his camera out to the ballpark for a few last pictures.

His valedictory photographs were taken at the end of the golden age of baseball: Ball players were now leaving to fight in World War II, and the sport would enter the modern era upon their return. Conlon would never photograph Jackie Robinson, just as he had never photographed Satchel Paige, Josh Gibson, Cool Papa Bell, or any of the other Negro League players denied a chance to play in the big leagues because of the institutionalized racism of baseball. Had the major leagues been integrated during his lifetime, Conlon would certainly have made portraits of black players, just as he photographed Native Americans Jim Thorpe and Chief Meyers, members of a minority magnanimously deemed "acceptable" by the bigoted club owners. Conlon's work was a product of his life and times, and the fact of this incalculable loss remains: There are no black faces in Conlon's baseball gallery.

When his wife, Marge, passed away, Conlon gave up photography and went back to Troy, New York, where he died in 1945 at the age of seventy-six. His original negatives had already been acquired by *The Sporting News*, but most of his original photographs remained in the files of his old newspaper, which had become the *New York World-Telegram* in 1931. When it ceased publication in 1967, Conlon's photographs were acquired by the Baseball Hall of Fame.

Many of Conlon's subjects are still alive and well, but few have any memories of him. Bill Werber, a major-league third baseman who Conlon photographed many times, explains: "I have no recollection of Charles Conlon. Lest you deem me to be on the stupid side, a word in defense of my position. These photographers were very zealous at their profession and several of them would be in and around the diamond areas of these parks every day. When asked to pose for a picture, we were happy to accommodate, but it was never necessary to ask: 'What is your name?' 'Whom are you taking pictures for?' Consequently, folks were taking pictures in Boston, Washington, and St. Louis, and I never

bothered to ask for identity." First baseman Buddy Hassett points out another problem: "It's tough trying to remember fifty years ago."

Today, Conlon is remembered fondly, if a little vaguely, by the few ball players who can remember him at all. Hall of Fame catcher Al Lopez and Detroit Tiger shortstop Billy Rogell are among those who can recall Conlon, and they both use the same word to describe him: "gentleman." Perhaps this helps to explain the disparity between Conlon's monumental achievement and his posthumous anonymity. He blended into a crowd of cameramen, content to let his work speak for itself.

Conlon's name has never appeared in any history of American photography, and he is scarcely noted even in the vast literature of baseball, but it is difficult to overstate the significance of his work. His most famous photographs are, quite simply, the most famous baseball photographs ever taken. Turn over any historic photo in the files of the Baseball Hall of Fame, and, more likely than not, it will be stamped "Charles M. Conlon—*Evening Telegram*, New York." His photographs have appeared in hundreds of baseball books, including such classic works as *Eight Men Out* and *The Glory of Their Times*, but even the most ordinary Conlon photos are valuable documents, offering fascinating data on everything from uniforms, bats, and gloves to the advertisements on the outfield fence. In 1937, Conlon had some idea of his work's importance: "I could do quite a book around those hundreds of fine pictures I still possess, but," he wondered, "how many of the present generation would know anything about the men depicted? They tell me that there are players in the big leagues who don't know a thing about the heroes of the past." No effort was made to publish such a collection during Conlon's lifetime.

Among Conlon's historic photographs was the first picture of Giant catcher Roger Bresnahan wearing his new invention, shin guards: "When he put them on that day I thought he was joking," recalled Conlon. "He looked as if he were made up for a masquerade, and I remember that the fans jeered him. They waved handkerchiefs, whistled, and called him 'Percy.'" The photograph appeared the next year in the 1908 *Spalding Guide*, but the negative is nowhere to be found. Hundreds of other important negatives, such as the studies of Three-Finger Brown's pitching hand, Babe Ruth's rookie photo, and dozens of World Series action shots, are similarly missing. The photographer solved this mystery in 1937 with an explanation that will chill any fan's blood: "Some years ago, I found that my plates were running me out of the house, so I destroyed hundreds of them. Perhaps it was a mistake, but where would I have kept them? It is possible that had we had a Cooperstown museum at the time, they would have found a

haven there." In fact, the photographer destroyed thousands and thousands of negatives, apparently at random. Had it not been for the farsighted editors of *The Sporting News*, who were no doubt horrified by Conlon's tale, all of his negatives might have been lost.

The Conlon Collection of *The Sporting News* consists of the photographer's 8000 remaining original negatives. To be in the presence of these negatives is as close as we will come to experiencing the presence of Christy Mathewson, Wee Willie Keeler, or any of the other early ball players photographed by Conlon. There are motion pictures of some of these players, but they are fragmentary and fleeting: A jerky film clip of Christy Mathewson playing catch for the newsreel camera in 1906 has become ridiculous, while Conlon's 1904 negative of Mathewson will forever evoke the pitcher's hauteur and grace. It is remarkable that it is possible to hold in one's hand an object that is, in essence, a piece of the past, magically capturing the memory of an otherwise lost or forgotten moment: Cy Young warming up at Hilltop Park, Shoeless Joe Jackson throwing out a runner at the plate, Ginger Beaumont squinting in the sun.

No one considered Conlon's photographs works of art in his lifetime. Large and obtrusive identifying marks were routinely scribbled on his negatives, apparently by photo editors at the *Spalding Guide* and *Baseball Magazine*. His early 5×7-inch plates usually contained far more picture information than could be squeezed onto the already overcrowded pages of the *Spalding Guide*, and the prints the photographer made from these negatives were often heavily cropped. Today, these original prints are an invaluable resource, but many were retouched and irreparably damaged in newspaper offices decades ago, and most are now severely worn and creased. The Conlon photos we are used to seeing in books are poorly reproduced copies of these scratched and overused prints, and they look like they were taken sixty, seventy, or eighty years ago. The photographs reproduced in the present volume were all newly printed from the original negatives, and most of them look like they were taken one afternoon during a recent home stand.

Conlon deserves to be ranked with the acknowledged masters of twentieth-century documentary photography, Eugène Atget and Walker Evans. All of these men were intuitive, self-taught photographers who collected the world around them, who found unexpected beauty in ordinary places, and who then preserved that beauty in straight, unadorned images. Topsy Hartsel (page 192), his baseball bat poised on a distant coffee cup, is as stately, dignified—and absurd—as Atget's Parisian baker proudly holding an enormous loaf of bread. Conlon's portrait of Bill Dickey (page 193) is as stark and haunting as

Walker Evans' portrait of an Alabama sharecropper's wife. But while Evans was aware of Atget and learned from his work, Conlon was an American original, even closer to Atget in time, in spirit, and in practice. Like Atget, Conlon spent decades in a narrowly circumscribed environment, working outside the photographic establishment, oblivious to and unaffected by artistic trends. And, like Atget, he left us the definitive visual record of the place he loved.

The ballpark was Conlon's universe, an inexhaustible source of unforgettable images: a catcher's mangled hand, a madman kicking up his heels, an umpire lost in thought. He documented baseball obsessively at a time when critics of photography—had they known of his existence—would have questioned his sanity for taking thousands of photographs of so trivial and ephemeral a subject. In recent years, writers have wondered why serious photographers have never been attracted to baseball. After all, they point out, baseball has never had a photographer capable of capturing the magic of the game with an artist's eye. They need to be reminded that there was indeed such a photographer at the field of dreams. His name was Charles M. Conlon.

Christy Mathewson
1904 New York Giants

He was sometimes accused of arrogance and aloofness, yet here the greatest pitcher in baseball obligingly poses for an amateur photographer in the Polo Grounds carriage park (the turn-of-the-century equivalent of the parking lot). The white posts in the distance marked the end of the playing field and were used to rope off overflow crowds. The elevation behind the ballpark is Coogan's Bluff, where fans could go to view the game without a ticket.

This is the first baseball photograph Conlon ever took. It illustrated Mathewson's "body swing" (windup) in *How to Pitch* (1905), an instructional booklet for boys edited by Conlon's mentor, John B. Foster.

Jimmy Gralich Imitating Matty
c. 1913

Mathewson was the idol of every young baseball fan, in many ways the very first sports role model. Here Conlon's young nephew faithfully reproduces Matty's familiar windup. Conlon arranged a meeting between Jimmy and Matty at the Polo Grounds, where the awestruck boy was able to shake his hero's hand.

Billy Sullivan
1911 Chicago White Sox

On August 24, 1910, this man caught a ball dropped by Ed Walsh from the top of the Washington Monument—on the twenty-fourth try. Here, wearing his customary extra-heavy mitt, he re-creates one of those twenty-three earli-er attempts for Conlon.

Billy Sullivan was Ed Walsh's catcher during the spitballer's greatest years, and no less a critic than Cy Young gave Sullivan the credit for turning Walsh into a real pitcher. In 1909, dissatisfied with the cumber-some inflated chest protectors worn by catchers at the turn of the century, Billy designed and patented the Sul-livan Body Protector, the flexible chest protector that, with minor modifica-tions, is still in use today.

Ed Walsh
c. 1913 Chicago White Sox

Walsh was one of the greatest pitchers of the dead-ball era, the man who once won forty games in a season and who still holds the major-league record for career earned run average. While he did not invent the spitball, Walsh was certainly its most brilliant exponent. Here he demonstrates his trademark grip for Conlon.

Despite Walsh's phenomenal success with the spitter, White Sox manager Fielder Jones recommended that the pitch be outlawed: "In my opinion, the spitball is doing a great injury to the game. In the first place, it is not natural. In the second place, it is not cleanly. Lots of people do not like to go out to the park and watch a pitcher slobbering all over the ball. Thirdly, the use of the spitball lengthens the games, as pitchers who depend upon the spitball consume so much time applying the moisture."

Big Ed offered this expert rebuttal: "You don't use a big gob of saliva. Most people have the impression that the ball is soggy when you throw the spitter. It isn't. Two wet fingers are all that is necessary to throw the spitter. You don't have to use your mouth to load it. Perspiration will serve the same purpose." Case closed.

Mike Donlin
1912 Pittsburgh Pirates

In 1906, *The Sporting News* condemned Mike Donlin as a "degenerate" whose "batting ability has kept him in a manly profession in spite of his record as a rowdy and a woman-beater." He had already served a prison term for his drunken assault on an actress in 1902 and was now charged with terrorizing passengers on a train, but Turkey Mike (nicknamed for his flamboyant strut) had also led the Giants to the 1905 world championship, and the New York fans loved Donlin as they would one day love Babe Ruth, forgiving him all his sins.

Mike married vaudeville actress Mabel Hite in 1906 and joined her on stage, becoming such a success that he retired from baseball in 1907, at the very peak of his brilliant playing career. He returned to the Giants in 1908 but left baseball for show business again in 1909 and 1910. The peripatetic Donlin became a Pirate in 1912, exclaiming: "Gee, but it's great to be with a real live team again!"

When his playing career ended, Mike became a movie actor: "I'm here to knock Hollywood right into the Pacific Ocean. Watch Mike Donlin burn up them films." But aside from a small role in his pal Buster Keaton's classic *The General* and a few lines of dialogue in Mae West's *She Done Him Wrong,* Donlin's film career consisted mainly of bit parts in B gangster movies with titles like *Born Reckless* and *Hot Curves.*

Garry Herrmann and Ban Johnson
Fenway Park, Boston, 1914

The all-powerful dictators of baseball survey their domain at the 1914 World Series. Johnson (right), the "Czar of Baseball," was the founder and president of the American League. Herrmann (left), his servile courtier and drinking buddy, was the owner of the Cincinnati Reds and chairman of the National Commission, the governing body of baseball until the Black Sox scandal put it out of business.

John McGraw
1912 New York Giants

In this study of the pensive Giant manager, Conlon may have taken the very first action shot of a player spitting in the dugout (extreme left).

Christy Mathewson: "Ball-players are very superstitious about the bats. Did you ever notice how the clubs are all laid out in a neat, even row before the bench and are scrupulously kept that way by the bat boy? If one of the sticks by any chance gets crossed, all the players will shout: 'Uncross the bats! Uncross the bats!' "

Honus Wagner
1912 Pittsburgh Pirates

Conlon took close-up shots of all the great players demonstrating their batting grips, but only Honus Wagner flexed his muscles for the camera. In 1912, Mike Donlin made this observation to a New York sportswriter: "Do you know why Hans Wagner is playing better ball than ever this year? The answer is easy. The big Dutchman's hands are growing bigger and his arms are getting longer all the time." Contemporaries always remarked on the size of Wagner's extremities, some even comparing him to a gorilla.

Wagner was the first batter ever to have his signature branded on a Louisville Slugger. In 1912, John McGraw told a Pittsburgh sportswriter: "You can have your Cobbs, your Lajoies, your Chases, your Bakers, and all the rest, but I'll take Wagner. He does *every thing* better than the ordinary star can do any *one* thing. He is the most wonderful ball player who ever lived." Even the arrival of Babe Ruth a few years later could not change McGraw's appraisal of Wagner.

← Hack Wilson
1924 New York Giants

Wilson was never more than a part-time outfielder when he played for the Giants, and in 1925 he was demoted to their Toledo farm club. During this routine transaction the Giants' front office made the worst clerical error in the history of baseball: Wilson was left unprotected in the minor-league draft, and the Chicago Cubs were able to steal a future Hall of Famer. The blunder never ceased to plague John McGraw, especially when Hack led the Cubs to the 1929 National League pennant.

This startling photograph appeared on the cover of the 1928 edition of *Who's Who in Baseball*.

Dizzy Dean
1934 St. Louis Cardinals

In the midst of his greatest season, Dizzy has just thrown his blazing fastball for Conlon's benefit. He would go on to win thirty games and lead the Gas House Gang to victory in the World Series.

Ty Cobb
1910 Detroit Tigers

This, Conlon's most famous image, is the greatest baseball action picture ever taken. Miraculously, the priceless glass negative still exists, having somehow survived the careless treatment the photographer gave it. Curious visitors were asked: "Would you like to see the original plate of that picture?" And the fragile negative would be passed from hand to hand.

Charles M. Conlon: "The strange thing about that picture was that I did not know I had snapped it. I was off third, chatting with Jimmy Austin, third baseman for the New York club. Cobb was on second, with one out, and the hitter was trying to bunt him to third. Austin moved in for the sacrifice. As Jimmy stood there, Cobb started. The fans shouted. Jimmy turned, backed into the base, and was greeted by a storm of dirt, spikes, shoes, uniforms—and Ty Cobb. My first thought was that my friend, Austin, had been injured. When Cobb stole, he *stole*. Spikes flew and he did not worry where. I saw Ty's clenched teeth, his determined look. The catcher's peg went right by Jimmy, as he was thrown on his face.

"But in a moment I realized he wasn't hurt, and I was relieved because Jimmy and I were very close friends. Then I began to wonder if by any chance I had snapped the play. I couldn't remember that I had, but I decided to play [it] safe and change plates anyway. I went home kicking myself. I said, 'Now there was a great picture and you missed it.' I took out my plates and developed them. There was Cobb stealing third. In my excitement, I had snapped it, by instinct."

Silk O'Loughlin
American League Umpire, 1908

In 1908, Conlon took a series of photographs documenting the evolution of a recent innovation in baseball: the umpire's signal. Here is the definitive safe sign, demonstrated for Conlon by the man who made it standard. O'Loughlin, the first umpire to eject Ty Cobb from a game, demonstrated his trademark strike sign in a 1907 Coca-Cola advertisement.

Christy Mathewson: "The autocrat of the umpire world is Silk O'Loughlin. 'There are no close plays,' says Silk. 'A man is always out or safe, or it is a ball or a strike, and the umpire, if he is a good man and knows his business, is always right. For instance, I am always right.' He refuses to let the players discuss a decision with him, maintaining that there is never any room for argument. If a man makes any talk with him, it is quick to the shower bath.

"Silk is the inventor of the creased trousers for umpires. I have heard players declare that they are afraid to slide when Silk is close down over a play for fear they will bump up against his trousers and cut themselves. Always he wears on his right hand, or salary wing, a large diamond that sparkles in the sunlight every time he calls a man out. Many American League players assert that he would rather call a man out than safe, so that he can shimmer his 'cracked ice.'"

Jimmy Austin
1912 St. Louis Browns

The Original Pepper Kid earned his nickname because he never stopped hustling, in spite of his modest talents: "He may not hit and he may not field and he may not throw, but by jimminy he will liven 'em up," said Lee Fohl, one of Austin's managers with the Browns. When Branch Rickey was named manager of the Browns in 1913, a slight problem arose: "When I was a boy in college," explained Rickey, "I promised my mother that I would never play ball on Sunday, or go near a ballgame. I regard that promise as sacred and I intend to keep it as long as I live." His solution was to name Jimmy Austin as the team's Sunday manager. One major problem remained, however: The Browns were terrible regardless of who their manager was.

Jimmy Austin
1929 St. Louis Browns

"They say I won't quit until the uniform falls off me. Well, that's right, I won't, and before they get me down and cut it off they'll have to club me to death or gas me unconscious." Jimmy appears alert and fully clothed in this portrait, taken when he was a forty-nine-year-old coach. And indeed, although he had been retired for several years, there was life in the Pepper Kid yet: He played in one last game in 1929, striking out in his last major-league at bat.

Spud Chandler
1938 New York Yankees

Chandler's career winning percentage is the best of any pitcher in baseball history. He was the American League Most Valuable Player in 1943, when he led the league in wins, earned run average, shutouts, complete games, and, of course, winning percentage. Chandler's ferocity on the mound was so renowned that his father-in-law actually became concerned for his daughter's safety. Here Conlon captures a mild version of Spud's "game face."

Frances Willard Chandler
and Frank Willard Chandler
Yankee Stadium, 1942

The 1938 meeting between Spud Chandler and his future bride might have been scripted in Hollywood: He was a sore-armed Yankee pitcher and she was a beautiful blonde with appendicitis. They met in the hospital and fell in love while recuperating from their respective operations. The stork brought the Chandlers a little Spud in the summer of '41.

Wee Willie Keeler
1909 New York Highlanders

"Keeler is as superstitious as a crap-shooter," reported *The Sporting News* in 1906. "He swears by the teeth of the mask-carved horse chestnut that he always carries with him as a talisman that he invariably dreams of it the night before when he is going to boot one—muff an easy fly ball, that is to say—in the meadow on the morrow. 'All of us fellows in the outworks have got just so many of them a season to drop and there's no use trying to buck against fate.' " Here, in one of Conlon's most famous photographs, Keeler poses solemnly in the mead-ow at Hilltop Park, his sad eyes gazing skyward with a look of fore-boding and resignation.

In his prime, 5′4¹/₂″ Wee Willie was the most consistent hitter in baseball and his forty-four-game hit-ting streak is unsurpassed in the National League to this day. His bat-ting philosophy was elegant in its simplicity: "I hit 'em where they ain't."

Joe Martina
1924 Washington Senators

Oyster Joe, a 349-game winner in the minor leagues, made it to the majors for one mediocre season and actually pitched a scoreless inning in the 1924 World Series. Conlon caught him in his one brief shining moment of big-league glory, but, alas, Martina's teammates are teasing him as he takes an unaccustomed bow in the spotlight.

Martina is named as "The Ugliest Player of the 1920s" in *The Bill James Historical Baseball Abstract* (1986), with this photograph offered as incontrovertible evidence.

Bob Rhoads
1909 Cleveland Naps

Over the objections of his Amish parents, sixteen-year-old Barton Emery Rhoads became a professional baseball pitcher in 1896. When he came up to the big leagues with the Chicago Cubs in 1902, he changed his name to Bob in order to spare his family further humiliation, but his punning teammates dubbed him Dusty. Rhoads was a flop with the Cubs but became a successful starter for Cleveland, winning twenty-two games in 1906 and pitching a no-hitter in 1908. Unfortunately, after a poor year in 1909, he was traded back to the Cubs, whereupon he fled to Canada rather than play for his old team again.

 Conlon's beautiful photograph appeared in the *New York Evening Telegram* in 1909 and served as the basis for two classic baseball cards, but Rhoads's defection from baseball rendered publication of this photograph in the 1910 *Spalding Guide* pointless. The negative was then filed away and forgotten for more than eight decades.

Lou Gehrig
1930 New York Yankees

Conlon customarily photo-
graphed a batter at the end of
his swing, but he preferred to
pose Gehrig in his batting
stance, the better to display
Lou's massive leg muscles, the
product of his favorite winter
pastime, speed skating. 1930
was one of Gehrig's greatest
years: 41 home runs, 174 runs
batted in, and a career-high
.379 batting average.

Rogers Hornsby
1925 St. Louis Cardinals

In 1925, Rogers Hornsby won his sixth straight National League batting title and his second Triple Crown. His batting average plummeted twenty-one points from the previous year—and he still hit .403. Hornsby is, without question, the best right-handed hitter in the history of baseball, a man who never watched a movie during the season lest he adversely affect his preternaturally acute batting eye.

Bill Bergen
1911 Brooklyn Superbas

This man is, without question, the worst hitter in the history of baseball. His lifetime batting average was a truly pathetic .170, yet he was a valuable player throughout his eleven-year major-league career because of his extraordinary skill as a catcher. In 1906, a Pittsburgh sportswriter hinted at the source of Bill's unsteady batting eye and his bleary expression in this photograph: "Bergen is a fine catcher, and would be finer still but for his desire to live well. Out this way we have rumors that now and then Bergen is late reporting for duty, all because he met some friends who will invite him to have a bite to eat, etc. Not caring about being churlish, he accepts, and will look on life as a round of pleasure. Time will come when the Brooklyn man will get down to solid base ball playing and forget good things in the pleasure line." But that time never came. In 1911, Bill batted an abysmal .132, unacceptable even by his undemanding standards, and his big-league round of pleasure was over.

Ted Williams
1939 Boston Red Sox

The Kid made his big-league debut at Yankee Stadium on Opening Day in 1939, and the inevitable Charles M. Conlon was there to greet him, camera in hand. Williams knocked in 145 runs in 1939, leading the major leagues and setting the all-time rookie RBI mark.

Joe DiMaggio
1937 New York Yankees

In 1937, his second season with the Yankees, DiMaggio played in his second All-Star Game. He also appeared in his first movie, *Manhattan Merry-Go-Round*, but wisely kept his day job. He was completely unaffected by the dreaded sophomore jinx in 1937, hitting forty-six home runs and knocking in 167 runs, the highest totals of his career. Joe had the audacity to hold out for a hefty pay raise after this marvelous season, and in 1938 he was rewarded with boos from the fans. It took his epochal fifty-six-game hitting streak in 1941 to finally win them back.

Cy Young
1911 Cleveland Naps

This is the most famous picture ever taken of the winningest pitcher in baseball history. Young was forced to retire in the spring of 1912 because of a problem already apparent in Conlon's photograph: "My arm is as good as the day I came into the majors, but I'm too portly to get about. The boys know this and bunt on me. When the third baseman has to start doing my work it's time for me to quit."

Bob Feller
1938 Cleveland Indians

In 1932, Bill Feller built a ballpark on his Iowa farm because he knew that they would come. And they did, but it cost them twenty-five cents apiece for the privilege of watching his thirteen-year-old son pitch. In 1938, this pitching prodigy was in his third year in the majors, leading the league in strikeouts. By 1940, he was the best pitcher in baseball.

Al Simmons
1924 Philadelphia Athletics

In 1921, nineteen-year-old Al Simmons took pen in hand: "Dear Mr. Mack," he wrote, "I am an amateur ball player in Milwaukee and have played for the Right Laundry, Juneau, Stevens Point, and Iola teams. I would like to have a try-out with the Philadelphia Athletics, because I have heard and read so much about them and you. If you take me down South with you, I am sure I can make good."

"Dear Mr. Simmons," replied manager Connie Mack, "I appreciate your interest in my team and me but it is impossible for me to give you a try-out this season. I receive about 1000 similar requests every year." Thus, one of the greatest players in baseball history offered his services to the A's free of charge—and received a perfunctory rebuff. In 1924, Mack finally did acquire Simmons, but this time it cost him $50,000 in cash and players.

Al Simmons
1939 Cincinnati Reds

At thirty-seven, every ball player has the face he deserves. It is the 1939 World Series, and Al Simmons is watching his baseball life slip away. Once an MVP, a batting champion, a World Series hero, a superstar, he is now an ancient and embittered castoff playing for his fifth team in five years. Al's obsessive quest for his 3000th career hit proved futile—too many late nights took their toll.

Charlie Gehringer
1925 Detroit Tigers

When this kid from Fowlerville, Michigan, tried out for the Tigers in 1923, Ty Cobb was so impressed that he signed him up on the spot. Gehringer had just arrived in the majors to stay when Conlon took his photograph at the end of the 1925 season; the rookie's pained and wary expression would remain fixed throughout his brilliant career.

The folks from Fowlerville honored their self-effacing hometown hero with a Charlie Gehringer Day, during which he graciously accepted their gift of a beautiful set of right-handed golf clubs. Rather than embarrass his friends by pointing out that he was a lefty, Charlie quietly became an excellent right-handed golfer.

Charlie Gehringer
1934 Detroit Tigers

Nine years have passed, and the Mechanical Man is now the best second baseman in the major leagues, leading the Tigers to their first World Series appearance in twenty-five years. "He is a manager's dream," said Detroit manager Mickey Cochrane. "Gehringer arrives at the first of the season and says, 'Hello.' He goes along and hits something like .350, and at the end of the season, he says, 'Goodbye, see you next season.'"

Gehringer chose to remain a bachelor during his playing career so that he could care for his ailing mother. When he was elected to the Hall of Fame a few years after his mother's death, he strangely failed to attend his own induction ceremony. The mystery was solved with the announcement that Charlie had just eloped with his sweetheart.

Tim "Big City" Jordan
1910 Brooklyn Superbas

One winter day in 1908, Big City surveyed the Brooklyn ballpark, its frozen playing field converted into an enormous ice-skating rink, and mused: "Say, if I hit a home run now, wouldn't it travel?"

This slugging New York City native was enormously popular with the hometown fans and twice led the major leagues in home runs, yet he is forgotten today except for this famous Conlon image, one of the most graceful batting photographs ever taken. It is April 1910 at the Polo Grounds, the time and place of Jordan's one and only hit of the season, the last of his big-league career: a pinch-hit home run. The next month he would be exiled to the minors forever, the victim of a knee injury. Big City's replacement at first base was Jake Daubert, a rookie who made the Brooklyn fans forget about Jordan in a hurry.

Tim eventually found employment as a house detective at the Hotel Astor.

Jim Bottomley
1929 St. Louis Cardinals

Here is a pitcher's nightmare and a photographer's dream. Bottomley was the National League MVP in 1928, when he led the league in homers, triples, and RBIs. In 1924, he knocked in twelve runs in a single game, setting a major-league record that still stands today. Sunny Jim is immortalized in this classic Conlon portrait of a kindly man beaming under a crooked cap.

Jack Dunn
1904 New York Giants

This man discovered George Herman Ruth and signed him to his first professional contract on Valentine's Day, 1914. When the nineteen-year-old Ruth showed up for spring training, the other players began calling the childlike pitcher Dunnie's Babe, and the nickname stuck. Conlon snapped this picture when Dunn was a utility man playing out his career for his former Baltimore Oriole teammate John McGraw. When Dunn sold Ruth to the Red Sox in 1914, without offering him to the Giants, McGraw was so hurt by his old friend's betrayal that he never forgave him.

Joseph Lannin
Boston Red Sox Owner, c. 1914

On July 18, 1914, this man bought Babe Ruth for the grand total of $2900. The Canadian-born Lannin began his life in America at fifteen as a Boston bellhop, but by the time he bought the Red Sox in 1913 he owned hotels, apartments, and golf courses up and down the East Coast. The Red Sox won the World Series in both 1915 and 1916, but Lannin grew so weary of the business of baseball that he decided to quit while he was ahead, selling the team to theatrical producer Harry Frazee in December 1916. When Lannin threatened to foreclose on Fenway Park because of money still owed him in 1919, the irresponsible Frazee made the most momentous and short-sighted transaction in the history of baseball: He sold Babe Ruth to the New York Yankees, and "The Curse of the Bambino" was born. Since 1918 the Red Sox have never won a World Series, and Boston fans swear that the Babe is still having his revenge.

← Bill Carrigan
1915 Boston Red Sox

Nicknamed Rough as a young catcher, Carrigan was Babe Ruth's first and favorite major-league manager. He led the Red Sox to world championships in 1915 and 1916, before abruptly retiring to a banking career in Lewiston, Maine.

Carrigan occasionally played first base, and even then he wore his catcher's mitt.

Lefty Gomez →
1937 New York Yankees

This man coined the expression "gopher ball" and provided its etymology: "This is a very special delivery of mine. I throw the ball, and then the batter swings—and then it will go for three or four bases." Gomez is remembered today mainly for his self-deprecating wit, but he was the Yankees' pitching ace throughout the 1930s, with a 6–0 lifetime World Series record to prove it. This is an unusual photograph for Conlon in that he rarely photographed a pitcher in mid-windup and even more rarely tilted his camera for artistic effect.

<div style="display:flex">

Babe Ruth
1918 Boston Red Sox

In 1917, Babe Ruth won twenty-four games as a pitcher, but he was such a great hitter that the Red Sox decided to convert him into an outfielder. In 1918, he still pitched in twenty games, compiling a 13-7 record. Thus, when Ruth led the league in homers this year, he became the first and only pitcher to do so. Conlon was there to document the beginning of the Babe's batting ascendancy.

Babe Ruth
1922 New York Yankees

Ruth had two of his greatest seasons in 1920 and 1921, but 1922 was a catastrophe. He was suspended five times before the season ended, and batted an execrable .118 in the 1922 World Series. *The Sporting News* dubbed Ruth the "Exploded Phenomenon" and declared: "The baseball public is onto his real worth as a batsman and in future, let us hope, he will attract just ordinary attention."

</div>

Babe Ruth
1924 New York Yankees

Ruth bounced back in 1923 with a career-high batting average of .393. In 1924, he led the league in batting average and home runs, finishing second in RBIs. This was the closest Babe Ruth ever came to winning the Triple Crown.

Babe Ruth
1926 New York Yankees

In 1925, Babe Ruth had a miserable year, enduring "the bellyache heard round the world." Skeptics wondered if the thirty-one-year-old slugger was starting to slip. In 1926, however, he tore up the league, leading the Yankees to their first pennant since 1923. Here Conlon captures the Babe near the very peak of his career.

Babe Ruth
1934 New York Yankees

Ruth in his last and worst year with the Yankees. His skills had severely eroded, as Conlon's photograph makes disturbingly clear.

Helen Ruth with Daughter Dorothy Ruth and Nick Altrock
1925 Washington Senators

Helen Woodford was a sixteen-year-old waitress when she married a rookie pitcher named Babe Ruth. Little did she know that her husband would eventually become the nation's most notorious carouser and womanizer. By the time Conlon took this photograph, the Ruths' marriage was in ruins, although it would not end legally until Helen's death in a fire in 1929. Dorothy had been adopted by the couple in 1922.

Nick Altrock was a pitching star for the Chicago White Sox in the 1906 World Series. In later years, wearing his trademark crooked cap, Altrock performed a popular slapstick routine in ballparks throughout the country with Al Schacht, the Clown Prince of Baseball.

Jim Thorpe
1917 Cincinnati Reds

He was the greatest athlete of the first half of the twentieth century, but Jim Thorpe could not hit a curveball. He was a sensational college football player and the winner of the pentathlon and decathlon at the 1912 Olympics, but he was stripped of his gold medals when it was discovered that he had played two summers of professional baseball. Because the National Football League did not yet exist, Thorpe was forced to put his athletic skills to work as a baseball player. His major-league career was little more than a publicity stunt, except for one game in 1917: He knocked in the winning run in the tenth inning of a classic pitching duel in which the Reds' Fred Toney and the Cubs' Hippo Vaughn both pitched no-hitters for the first nine innings.

Zeke Bonura
1939 New York Giants

Bonura was a gifted amateur athlete who won the javelin throw at the National AAU Track and Field Championships in 1925. "One day I was suiting up for a football game. I was a newcomer, so naturally the other fellows looked me over. One exclaimed, 'Look at that huge physique,' and ever since then I have been known as Zeke." He was also known as Bananas (because his father was a wealthy fruit wholesaler) and Banana Nose (see photo).

Zeke was oddly superstitious about his bats. They were always red on one side and white on the other because he insisted that they be cut from the center, or heart, of the tree. Conlon caught him as he performed a delicate procedure recommended by the makers of the Louisville Slugger: "Honing, preferably with a dry meat bone, closes the pores of the wood, hardens the bat's surface, prevents slivering and adds punch to hits." This well-groomed, albeit peculiar, bat helped Bonura to a lifetime batting average of .307.

Dazzy Vance
1933 St. Louis Cardinals

"Where did I get the nickname Dazzy? Well it has nothing to do with 'dazzling speed' as most fans believe. Back in Nebraska I knew a cowboy who, when he saw a horse, a gun or a dog that he liked would say, 'Ain't that a daisy,' only he would pronounce 'daisy' as 'dazzy.' I got to saying, 'Ain't that a dazzy,' and before I was eleven years old the nickname had been tacked on me."

Pitching for the Brooklyn Dodgers in the 1920s, Vance twice led the major leagues in victories; by the end of the decade he was the highest-paid pitcher in baseball. He drove batters to distraction by wearing an outrageously torn and flapping undershirt, until pressure from umpires and irate Chicago Cubs manager Joe McCarthy finally forced Dazzy to adopt the more subdued fashion statement we see in this photograph.

Beans Reardon
National League Umpire, 1926

This man's trademark polka-dot bow tie is in the Baseball Hall of Fame. Here he is in his rookie year, experimenting with a striped prototype. On August 15, 1926, at Ebbets Field in Brooklyn, Beans was faced with the first big test of his career: After some daffily indecisive baserunning by Dazzy Vance, there were suddenly three Dodgers on third base. Despite Vance's culpability in the matter, the umpires had no choice but to declare him the sole rightful possessor of third base.

Reardon, who played bit parts in movies during the off-season, enjoyed gambling at the race-track with showbiz pals like Al Jolson until the Commissioner of Baseball ordered him to cease his unsavory associations. But Beans refused to give up his favorite pastime, beer drinking. Using his baseball connections, he even managed to acquire a Budweiser distributorship, which he eventually sold to Frank Sinatra for $1 million.

59

Walter Johnson
1914 Washington Senators

In 1913, the Big Train had his greatest season, winning thirty-six games and pitching eleven shutouts, including a phenomenal fifty-six consecutive scoreless innings. The next year was a letdown for Walter, since he won only twenty-eight games and pitched a measly nine shutouts, but this shy Kansas farm boy had an excellent alibi: He was in love. On June 24, 1914, Walter married Hazel Lee Roberts, the daughter of Nevada Congressman Edward Roberts. The wedding ceremony was performed by the chaplain of the United States Senate.

Patsy Gharrity, Walter Johnson, and Steve O'Neill
1935 Cleveland Indians

The Indians are having a disappointing year, and a gloomy Walter Johnson (center) knows that his days as a major-league manager are numbered. He is flanked by his gloomy coaches, both former big-league catchers. Gharrity (left) was a longtime teammate of Johnson's on the Washington Senators, and O'Neill (right) had spent most of his seventeen-year career with the Indians. The ax finally fell in August, and Johnson's baseball career was over. He was replaced by O'Neill, the man who became rookie pitcher Bob Feller's mentor in 1936.

Conlon carefully composed this shot to include the wonderfully picturesque baseball debris in the foreground.

Paul Waner
1927 Pittsburgh Pirates

In 1927, Big Poison had his greatest
season when he led the National
League in hits, RBIs, and batting
average and was named the
league's Most Valuable Player. He
led the Pirates into the World
Series where it was their misfor-
tune to be swept by the 1927 New
York Yankees. Waner posed for
Conlon at Yankee Stadium during
this Series.

Paul Waner
1942 Boston Braves

Paul Waner enjoyed a drink now and then. "He had to be a graceful player," said Casey Stengel, "because he could slide without breaking the bottle on his hip." Indeed, in this photograph his eyes are so bloodshot that there is almost an illusion of color. Nevertheless, Waner got his 3000th hit this season and immediately arranged an elaborate blowout for his teammates, family, and friends.

In 1931, Waner swore off alcohol and his batting average fell precipitously: "Jewel Ens was our manager, and he kept inquiring about my off-field activity. He thought I was really burning the candle at both ends when I wasn't burning it at all. Finally he was convinced, and he came to me and told me to have a little fun. Might relax me. Well, I took his advice and started hitting again. Finished the year with something like .321." Actually, he hit .322.

Lou Gehrig
1925 New York Yankees

Why is this rookie smiling?

Wally Pipp
1925 New York Yankees

Because this veteran has just taken the day off. Wally Pipp had been the Yankees' regular first baseman for ten years, twice leading the league in home runs, when manager Miller Huggins decided to shake up the lineup of his struggling team. Baseball legend tells us that Wally Pipp had a terrible headache and asked for the day off, but it is more probable that he was benched because he wasn't hitting. In any case, he never played first base for the Yankees again, since Lou Gehrig held down that job for the next fourteen years. Wally Pipp has become a tragicomic actor in a cautionary tale, the victim of cruel fate and a false sense of security, the first person ever to be Wally Pipped.

1913 New York Giants

Conlon never took formal team portraits, but when he came across a rival newspaper photographer setting up a shot, he couldn't pass up the chance. Here is a picture of the National League champions waiting to have their picture taken.

1915 New York Giants

Here is a picture of a last-place team having its picture taken.

↑ Jake Daubert
1913 Brooklyn Superbas

Here is the Superba team captain and fan favorite posing for Conlon in the lovely 1913 Brooklyn road uniform. This was the year Daubert won a Chalmers automobile after being named the outstanding player in the National League. He later played first base for the victorious Cincinnati Reds in the infamous 1919 World Series.

← Rogers Hornsby
1924 St. Louis Cardinals

Hornsby was a pretty good second baseman, but he had trouble going back on pop flies. His defensive shortcomings were generally overlooked, as in 1924, when he had the highest batting average of the twentieth century, .424.

Babe Adams
1924 Pittsburgh Pirates

Sitting in the Pittsburgh dugout before the first game of the 1909 World Series, rookie pitcher Babe Adams joked: "Gee, I wish [Pirate manager Fred] Clarke would pitch me. I'd stand those fellows on their heads. Cobb looks like a sucker to me. And Crawford don't look so hot." Ty Cobb had just won the Triple Crown as he and Wahoo Sam Crawford led the mighty Detroit Tigers to their third straight pennant. Everyone was amused by Adams's absurd boast—everyone, that is, except manager Clarke, who had a hunch. He flipped a shiny new ball to the rookie and said: "You're in, Babe." The stunned Adams proceeded to win three games in the Series, humiliating the Tigers 8–0 in Game Seven to clinch the Pirates' first world championship.

The rest of Babe's long career was solid if unspectacular. He was one of the greatest control pitchers in baseball history, but a sore arm forced him back to the minors in 1917 and 1918. Adams finally appeared in the World Series again when he was a baby-faced forty-three-year-old, pitching one scoreless inning as the Pirates won their second world championship in 1925.

John Bunny
Motion Picture Actor
Shibe Park, Philadelphia, 1913 World Series

In 1913, this man insured his bulbous face for $50,000. Today he is forgotten, but when Conlon took his photograph at the ballpark, John Bunny was routinely mobbed by his admirers, who numbered in the millions. America's first great screen comic, Bunny was far more famous and beloved than any baseball player alive, and he was earning three times the salary of the great Ty Cobb. When he died in 1915, the 300-pound actor was eulogized around the world, but his fame was instantly eclipsed by a promising young newcomer named Charlie Chaplin.

Lloyd Waner
1929 Pittsburgh Pirates

The Waner brothers were generally ill at ease in front of the camera, but when Conlon asked Lloyd to display the signature on his personalized Louisville Slugger, he shyly, but proudly, complied.

Lon Warneke
1939 St. Louis Cardinals

The proud possessor of the most perfect pompadour in baseball, the Arkansas Hummingbird was a Western Union messenger when he rode his bicycle to the ballpark and announced that he played first base. The Houston Buffaloes didn't need a first baseman, so Lon Warneke became a pitcher. Warneke went on to win 193 games in the National League, and then spent six years as a National League umpire. When his baseball career ended, he became a county judge in Arkansas.

Hans Lobert
1913 Philadelphia Phillies

On his first day in the big leagues, John Bernard Lobert was introduced to John Peter Wagner. The latter, better known as Honus, or Hans, noted the strong resemblance between their noses, and decreed that henceforth Lobert would be known as Hans Number Two.

After the 1913 season, Lobert went on a world tour with John McGraw's New York Giants as they played exhibition games against Charles Comiskey's Chicago White Sox. On this tour McGraw matched Lobert, one of the fastest base runners alive, against a racehorse. Hans and the horse ran a close race around the bases, but umpire Bill Klem declared the horse the winner by a nose. "No horse could beat me by a nose!" protested Lobert. Conlon's photograph suggests that an inquiry was indeed in order.

Hans Lobert
1942 Philadelphia Phillies

When Lobert's playing days were over, John McGraw's recommendation won him a prestigious military assignment as the baseball coach at West Point from 1918 until 1925, serving under Douglas MacArthur. By 1942, he was back with the cellar-dwelling Phillies, but even managing the worst team in baseball could not dim Lobert's radiant smile.

Johnny Evers
1904 Chicago Cubs

Evers had a nasty disposition and a high-strung temperament, which caused him to miss most of the 1911 season when he suffered a nervous breakdown. He was generally regarded as the "brainiest man in baseball," yet one thing always puzzled him: "I cannot understand why the umpires don't like me." Perhaps it was because he was the most relentless and obnoxious umpire-baiter in baseball, a man who would protest a rotten call by ostentatiously holding a handkerchief to his nose.

Johnny Evers
1929 Boston Braves

A quarter of a century has elapsed, but the Human Crab has not mellowed. He is now a coach, watching helplessly as the owner and manager of the Boston Braves, Judge Emil Fuchs, guides the team into last place. When Evers managed the Chicago White Sox in 1924, Ed Walsh was one of his coaches: "Whenever we lost, Evers was like a crazy man. He raved and ranted and kicked over chairs and everything else in the clubhouse. I used to listen and say, 'Yeah, Johnny, that's right.' You'd be crazy to disagree with him. And he was rough on umpires too. He had a long chin and when he got in a tiff with an umpire, his chin seemed to be about two feet long."

Fred Merkle
1916 Brooklyn Robins

On September 23, 1908, this man's life was ruined. During a crucial game with the Cubs, Johnny Evers alerted the umpires that Giant rookie Fred Merkle had failed to touch second base as the winning run scored. Merkle was called out, the game was declared a tie, and baseball fans had a scapegoat when the Giants eventually lost the pennant. Fred had committed Merkle's Boner, and he was forever haunted by this tragic oversight: "I suppose that when I die, the epitaph on my tombstone will read 'Here lies Bonehead Merkle.' The tough part of it is that I can't do things other fellows do without attracting any attention. Little slips that would be excused in any other players are burned into me by crowds. Of course, I make my mistakes with the rest, but I have to do double duty. If any play I'm concerned in goes wrong, I'm the fellow that gets the blame, no matter where the thing went off the line. I wish folks would forget. But they never will." And they never did.

Bill Wambsganss
1921 Cleveland Indians

On October 10, 1920, this second baseman's life was transformed. With runners on first and second and nobody out, Wambsganss caught a line drive, stepped on second, and tagged the oncoming runner, instantly becoming a hero: He had completed the first and only unassisted triple play in World Series history, and the Indians' 1921 uniforms would read "WORLDS [sic] CHAMPIONS." In later years, Wambsganss complained that this play was the only thing for which he was remembered. He failed to realize that were it not for that one play, he would not be remembered at all.

Enos Slaughter
1938 St. Louis Cardinals

His mad dash around the basepaths, which won the final game of the 1946 World Series for the Cardinals, typified Slaughter's aggressive, supercharged style of play. Conlon photographed this North Carolina country boy during a rare moment of repose in his rookie year.

Smokey Joe Wood
1914 Boston Red Sox

In 1912, Smokey Joe (nicknamed for his "smoking" fastball) had one of the greatest years a pitcher ever had: His record was 34–5 during the regular season, and he won three more games in the World Series. But he hurt his arm in the spring of 1913, and by 1914 Wood was pitching in constant pain. He eventually became an outfielder, rejoining his old Red Sox roommate Tris Speaker on the Cleveland Indians.

Home Run Baker
1910 Philadelphia Athletics

Frank Baker's nickname seems more than a little ridiculous today, but Conlon's famous photograph captures a classic slugger's swing. Baker's league-leading home run totals (9, 10, 11) are absurdly low when compared with the later totals of Ruth, Foxx, and Greenberg (58, 59, 60), but this photograph demonstrates how dead the ball must have been in the dead-ball era. In 1911, when most batters didn't hit two home runs in a year, Baker hit dramatic home runs in two consecutive World Series games off Rube Marquard and Christy Mathewson, two of the greatest pitchers in baseball history. Home Run Baker's feat was truly phenomenal, and his nickname, well-earned.

John McGraw →
1911 New York Giants

In 1905, John McGraw's Giants showed up for their first World Series in striking black uniforms. Led by Christy Mathewson, who pitched an astonishing three shutouts in the Series, the smartly attired Giants proceeded to demolish the Philadelphia Athletics, four games to one. In 1906, McGraw was not humble about this accomplishment: His team's uniforms now read "WORLD'S CHAMPIONS."

In 1911, the Giants were in their second World Series, and their opponents were once again the Athletics. McGraw was a gambling man who did not wish to tempt fate; therefore black was back. But fate, in the person of Home Run Baker, was not kind to the Giants. This time they lost to the Athletics, four games to two, and black uniforms were forever banished by McGraw.

Gabby Hartnett and
Charlie Grimm
1937 Chicago Cubs

Jolly Cholly Grimm (right) was an ambidextrous banjo player who doubled as manager of the Cubs, leading them to the World Series in 1932 and 1935, but he became a radio broadcaster for the Cubs in July of 1938 when he was replaced as manager by catcher Gabby Hartnett. On September 28, 1938, Hartnett hit the "homer in the gloamin'," one of the most dramatic home runs in baseball history: "It was the most sensational thing that ever happened to me," said Hartnett. "I got the kind of feeling you get when the blood rushes to your head and you get dizzy." Gabby's homer took the Cubs to an anticlimactic 1938 World Series, where they were swept by the New York Yankees.

Burleigh Grimes
1938 Brooklyn Dodgers

Joe McCarthy
1938 New York Yankees

Burleigh Grimes (left), the last of the legal spitballers, was nicknamed Ol' Stubblebeard because he never shaved on the day he pitched. His fierce contentiousness made him a Hall of Fame pitcher, but it also made him an unpopular and unsuccessful manager. Here, Burleigh is well shaven and uncharacteristically cordial as he pays his respects to the manager with the highest winning percentage in baseball history. The calm and dignified McCarthy never played in the big leagues, but his teams played in the World Series nine times, and he, too, ended up in the Hall of Fame.

The Dodgers beat the Yankees three games to two in their April 1938 exhibition series. This was the highlight of the year for the Dodgers: They finished in seventh place, while the Yankees, as usual, won the World Series.

Leo Durocher
1925 New York Yankees

This angelic, anonymous rookie was barely visible on the Yankee bench at the end of the 1925 season, batting only once. Conlon was probably the only person who noticed he was there.

Leo Durocher
1937 St. Louis Cardinals

Leo the Lip, in his last year with the Gas House Gang, was by this point one of the most notorious and colorful ball players in America, impossible for anyone to ignore.

Casey Stengel
1924 Boston Braves

Casey was the batting hero for the New York Giants in the 1923 World Series. His reward? John McGraw traded him to the dismal Boston Braves. This circumstance may explain Stengel's sour expression. The thirty-four-year-old Casey is as yet unrecognizable as the Old Professor he would eventually become in his years as Yankee manager.

Casey Stengel
1938 Boston Bees

By now we can recognize Casey, but he is not yet a manager destined for the Hall of Fame, particularly since his Boston teams usually finished next to last. The Bees' most notable achievement in 1938 was falling victim to Johnny Vander Meer in the first of his two consecutive no-hitters.

Wahoo Sam Crawford
1917 Detroit Tigers

"Crawford was a tremendous hitter," said Casey Stengel. "Hardly any pitchers which pitched against him is still alive. Half of 'em died of heart attacks." By 1917, his last year in the big leagues, Crawford was no longer lethal at the plate, but he could still put on a good show during batting practice. Americans were going off to fight in World War I, and the Detroit Tigers proclaimed their patriotism by affixing flag patches to their uniforms.

Johnny Vander Meer
1940 Cincinnati Reds

In 1938, Vander Meer pitched back-to-back no-hitters, an astonishing feat that has never been duplicated in major-league history. "Someone may tie the record," said Johnny, "but I don't think anyone will break it. If someone does, it will be unbelievable." The next season Vander Meer suffered an arm injury and was forced to return to the minor leagues for rehabilitation. In this photograph, Vander Meer has just returned to the Reds in order to qualify for the 1940 World Series, where he would pitch three scoreless innings.

Rick Ferrell
1938 Washington Senators

As a boy, Wes Ferrell refused to play baseball if he couldn't pitch, so his big brother had no choice but to become a catcher. Easygoing Rick Ferrell went on to become the American League catcher in the very first All-Star Game in 1933. When his playing career ended in 1947, Rick had appeared in more games than any other catcher in the history of the American League, and in 1984, he was elected to the Hall of Fame. His brother Wes went on to become the only pitcher to win twenty games in each of his first four big-league seasons.

Wes Ferrell
1929 Cleveland Indians

In 1929, this rookie pitcher threw his glove into the stands after he was removed from a game, and the fans, relishing his discomfort, passed his glove back very, very slowly. "These fans burn me up," he complained. In 1932, he was fined and suspended for refusing to leave a game. "He wasn't well mannered," explained his manager. In 1936, he removed *himself* from a game and was again fined and suspended. After a loss, Wes Ferrell would bang his head against the dugout wall, hit himself in the face with his fist, and tear up his glove with his teeth. "It was all part of an act," he explained in later years. But the young man in this picture is not acting. He is smoldering and ready to explode.

Dizzy Dean
1932 St. Louis Cardinals

Conlon first photographed Dizzy in 1930, before he had ever pitched in a big-league game. In 1932, Dean's rookie season, he became a star by leading the National League in strikeouts, shutouts, and innings pitched. But in June, a petulant Dizzy deserted the team in a salary dispute, vowing that he would leap out of a hotel window rather than play for St. Louis again. He eventually rejoined the Cardinals after a public apology, the episode only adding to Dizzy Dean's box-office value and growing legend.

Paul Dean
1934 St. Louis Cardinals

Unlike his brother Jay Hanna Dean, who gloried in his well-deserved nickname, Dizzy, Paul Dean despised the name Daffy, a newspaper invention. He was quiet and reserved, the temperamental opposite of his brother, but Paul did possess the family fastball. He won nineteen games in both 1934 and 1935, but by 1936 he had thrown his arm out. His brother suffered the same fate a year later.

Babe Ruth
1924 New York Yankees

Before posing for his most famous Conlon portrait, the Babe considerately parked his chewing gum on his hat.

Lou Gehrig
1936 New York Yankees

No sooner had the ill-starred Lou Gehrig escaped Babe Ruth's shadow in 1935 than a sensational rookie named Joe DiMaggio joined the Yankees in 1936. An amused Gehrig posed for Conlon during his second MVP season.

Joe Tinker and Frank Chance
1923 Boston Red Sox

Here are two-thirds of the most famous trio in baseball history, the double-play combination of Tinker to Evers to Chance. They set no double-play records, but they sparked the Cubs to four World Series appearances between 1906 and 1910 and inspired an immortal scrap of baseball doggerel. Tinker (left) was an average hitter who, for some reason, "owned" pitcher Christy Mathewson: "The only thing to do is keep them close and try to outguess him," conceded Matty, "but Tinker is a hard man to beat at the game of wits." Chance was the Cubs' manager and Peerless Leader. Conlon captured one of the last meetings between Tinker and Chance, who had not played together in eleven years. Red Sox manager Chance would die the next year.

Johnny Evers
1913 Chicago Cubs

They played side by side on the Cubs, but second baseman Johnny Evers and shortstop Joe Tinker couldn't stand each other: "Sometimes we wouldn't get more than inside the clubhouse after a game when Joe'd bark at me about some play or throw, or I'd yelp at him about something, and we'd drop our gloves and go to it on the floor like a cat and a dog." When they were no longer on speaking terms, the two continued their feud on the field: Tinker would throw to second without even looking, hoping Evers would miss the ball, and Johnny would respond in kind. "Thinking about it now," recalled Evers in his old age, "that sort of thing kept us on our toes—probably kept us in the big leagues."

← Walter Johnson
1910 Washington Senators

In 1910, Johnson won twenty-five games and led the major leagues with a career-high 313 strikeouts. It was the Big Train's first great year, but the editor of the *Spalding Guide* was not impressed: "Johnson, the star pitcher of the Washington club, made a better record than he did in some other years, but there is still room for improvement in his pitching. There is no question that he is one of the most promising pitchers of major-league company, but he lacks that control which is necessary to place him with the leaders in the Base Ball world." Johnson would go on to hit more batters with thrown balls than any other pitcher in major-league history, but somehow he managed to win 417 games.

Moe Berg →
1935 Boston Red Sox

America's greatest philologist–bullpen catcher–atomic spy, Berg left notes warning his roommates not to touch his stacks of unread foreign-language newspapers: "Don't disturb—they're alive!" The most mysterious man in baseball, he befriended scientists, diplomats, and rookie pitchers with equal ease, but no one really knew Moe Berg.

Gabby Hartnett
1925 Chicago Cubs

One day at Wrigley Field in 1931, Gabby signed a baseball for a Cubs fan. Unfortunately, the fan's name was Al Capone, and the horrified Commissioner of Baseball quickly imposed a $5 fine on players caught fraternizing with spectators. Hartnett struck this blithe and beatific pose for Conlon the year he finished second in home runs to Rogers Hornsby. Gabby's little sister, Anna, also a talented ball player, gave exhibitions of her catching prowess at county fairs in New England.

Carl Hubbell
1929 New York Giants

While Hubbell never claimed to have invented the screwball, he was undoubtedly the first pitcher to call it by that name, contributing an invaluable word to the American vocabulary. In 1929, the year of his first and only no-hitter, Hubbell was in his first full season as a Giant starter. He dominated the National League for the next decade, but the American League also fell victim to his screwball: With Gabby Hartnett behind the plate in the 1934 All-Star Game, Hubbell struck out Babe Ruth, Lou Gehrig, Jimmy Foxx, Al Simmons, and Joe Cronin consecutively.

Jimmy Foxx
1929 Philadelphia Athletics

In 1924, Home Run Baker was mightily impressed when he saw sixteen-year-old Jimmy Foxx play baseball: "Baker was so sure that I was going to be a great player that he wrote Connie Mack about me, and Mack bought me for the A's. I reported to Mack in August and when he saw me he said, 'Now I'll be accused of robbing the cradle.'" By 1929, Foxx was the Athletics' regular first baseman. When he retired in 1945, this three-time American League MVP had hit more career home runs than anyone except Babe Ruth.

Babe Ruth
1927 New York Yankees

In the Babe's lifetime, only two batters came close to his 1927 record of sixty home runs: Jimmy Foxx, with fifty-eight in 1932, and Hank Greenberg, with fifty-eight in 1938.

Hack Wilson
1926 Chicago Cubs

"How do I hit 'em? I just go up there with the intention of knocking the ball out of the park and swing!" Hack Wilson's approach to batting was not subtle, but it was undeniably effective: He led the National League in home runs four times, and in 1930 he hit a league-record fifty-six home runs and set the all-time major-league mark with 191 RBIs.

At the top of Wilson's brilliant career, however, everything came crashing down: "I started to drink heavily. I argued with my manager and the rest of the players. I began to spend the winter in taprooms. When spring training rolled around, I was twenty pounds overweight. I couldn't stop drinking. I couldn't hit. That year most experts figured I'd break Ruth's record. But I ended up hitting only thirteen home runs."

Joe Cronin
1932 Washington Senators

How much is your nephew worth? Washington Senators owner Clark Griffith decided that $250,000 sounded about right, so in 1934 he sold Joe Cronin to the Boston Red Sox. Cronin, married to Griffith's niece, was the player-manager of the Senators when they went to the World Series in 1933. He later guided the Red Sox to the 1946 World Series, and in 1959 he became president of the American League.

This picture appeared on Cronin's Big League Chewing Gum baseball card in 1933, but both the cut on his lip and the bandage on his thumb had mysteriously vanished.

Frenchy Bordagaray
1937 St. Louis Cardinals

When he was fined and suspended for spitting on an umpire, Frenchy demurred: "The penalty is a little more than I expectorated." Bordagaray scandalized the baseball world in 1936 by growing a moustache, and he was the percussionist for Pepper Martin's Musical Mudcats in the last days of the Gas House Gang: "I learned how to play the washboard in three easy lessons in the clubhouse at St. Petersburg. We used to drive [Cardinal manager] Frankie Frisch nuts." His exasperated teammate Joe Medwick was driven to inquire: "What the hell are we running, a ball club or a musical comedy?" But seriously, folks, Frenchy could hit: He was the leading pinch hitter in the National League in 1938, when he batted .465.

Cy Rigler
National League Umpire, 1911

During his first month as a major-league umpire in 1906, Rigler declared: "It is a mistake to suppose that I am in the game as a fighter. I am not seeking for trouble and hope that none will ever come in any game in which I am the umpire." Few dared challenge this intimidating ex-football player, but when trouble did come, Rigler was ready to rumble. Buck Herzog and Frankie Frisch were among the disputants he whacked with his mask during his thirty-year career.

The wooden grandstand of the Polo Grounds burned down after the second game of the 1911 season, and the Giants were forced to relocate to tiny Hilltop Park, the home of the New York Highlanders. But as this photograph reveals, the Giants returned to the Polo Grounds while construction of their new steel-and-concrete grandstand was still far from complete. The rush job was finished just in time for the 1911 World Series.

Wally Schang
1917 Philadelphia Athletics

One of the most valuable players of his time, this rifle-armed catcher played in the World Series for the A's in 1913 and 1914, for the Red Sox in 1918, and for the Yankees in 1921, 1922, and 1923. The baseball world took note when the eminent Mr. Schang decided to shave before the 1918 season, and he has gone down in history as the last "mousta-chioed" man of the dead-ball era.

John Henry
1918 Boston Braves

In 1917, catcher John Henry of the Washington Senators urged his teammates to join the Base Ball Players' Fraternity in a strike against the major leagues. American League president Ban Johnson promised to crush the fledgling union: "We propose to lay a strong hand on Henry and others like him." Henry's reply was less than diplomatic: "Johnson has no power to ride me out of the American League. He is trying to make me the goat. Just because I have been a good fellow, friendly with the magnates, and liked by my mates, he is picking on me. Well, let him. Johnson is crazy for power." Needless to say, the revolt quickly fizzled, and Henry was humiliated: The "rattle-brained agitator" and "disturber" was forced to accept a $1200 reduction in his annual salary of $4600. In 1918, Henry ended his career in the National League, and only Charles M. Conlon took note of the shell-shocked pariah's new moustache.

In the spring of 1972, Reggie Jackson brought the moustache back to baseball—and major-league players finally went out on strike.

Luke Sewell
1921 Cleveland Indians

Luke snuck into the big leagues for only three games at the end of the 1921 season, but the observant Conlon spotted the new face. Sewell enrolled at the University of Alabama as a fifteen-year-old and played quarterback for the Crimson Tide in 1920. He later managed the St. Louis Browns to their one and only American League pennant in 1944. As manager of the Cincinnati Reds in the early 1950s, he made a visionary innovation: He ordered the grounds-keepers to drag the infield midway through each game, simultaneously smoothing the playing surface and increasing concession sales during this extended break in the action.

Miller Huggins
1927 New York Yankees

"It wasn't an easy task to handle such monkeys as we had on the Yankees," recalled third baseman Joe Dugan. "And that big Bambino, Ruth—I mean, he was probably enough for three managers." Outfielder Bob Meusel agreed: "Those Yankees of the twenties were pretty rough out-fits. It was Hug's place to tell us when we got out of hand." In this famous Conlon portrait, the Yan-kee manager's face shows the strain of trying—and failing—to tame Babe Ruth and the other members of Mur-derers' Row.

Throughout his decades-long career, Conlon never took extreme close-ups of his subjects' faces—except for the afternoon when he took mug shots of Murderers' Row, the fabled start-ing lineup of the 1927 New York Yankees, featured on the following pages.

Earle Combs
1927 New York Yankees

"I have never gone in much for liquor. Some of the boys on those Huggins clubs could not understand how a Kentuckian did not drink. One of them came to me in 1925 and said, 'Combs, if you expect to stay on this club, you had better learn to drink.'" Despite threats and peer pressure, the Yankees' lead-off hitter remained a lifelong teetotaler, nonsmoker, and devoted Bible reader. A weak-armed center fielder, Combs had the misfortune of playing between Babe Ruth and Bob Meusel, the men with the best throwing arms in baseball, but the Kentucky Colonel made up for his defensive shortcomings with a .325 career batting average.

Mark Koenig
1927 New York Yankees

Koenig was a light-hitting shortstop who led the league in errors in 1927, but he was also the man who batted just before Ruth and Gehrig in the lineup of Murderers' Row. He hit .500 in the 1927 World Series, leading all batters.

In 1932, Koenig helped the Chicago Cubs win the pennant, whereupon he became indirectly responsible for one of the most famous moments in baseball history. The Yankees felt that their ex-teammate had been poorly treated by the Cubs when they voted him only a half share of the World Series money. The two teams' increasingly acrimonious exchanges of insults and hand gestures finally culminated in Babe Ruth's called shot, the home run he definitely did or did not predict in pantomime.

Babe Ruth
1927 New York Yankees

"Here you may meet baseball's greatest slugger face to face. Babe Ruth, the Superman of Swat—most picturesque of ball players, the greatest slugger who ever lived." This caption appeared with Conlon's photograph when it was first published in the September 1927 issue of *Baseball Magazine*.

When this most picturesque of ball players hit sixty home runs in 1927, he easily surpassed the next-highest home run total in the American League, the fifty-six home runs hit collectively by the Philadelphia Athletics.

Tony Lazzeri
1927 New York Yankees

In 1925, Lazzeri hit sixty home runs and batted in a prodigious 222 runs. He was playing for Salt Lake City in the Pacific Coast League at the time, but the discerning Yankees quickly signed him up. Like most young major leaguers in this era, the Yankee second baseman had to get a job in the off season to make ends meet: Lazzeri worked with his father as a boilermaker in San Francisco.

Bob Meusel
1927 New York Yankees

In 1918, his first year as an outfielder, Babe Ruth lost a fly ball in the sun. He vowed then and there never to play the sun field again. Thus, although Bob Meusel was the Yankees' left fielder at Yankee Stadium, on the road he usually traded places with right fielder Ruth in order to keep the most valuable eyes in baseball out of the sun. This meant, of course, that Meusel *always* played the sun field. We can see the effects of his self-sacrifice in Conlon's close-up photograph.

Meusel, who batted fifth behind Ruth and Gehrig in Murderers' Row, had the greatest arm in baseball: "He could hit a dime at 100 yards and flatten it against a wall," said teammate Joe Dugan.

Lou Gehrig
1927 New York Yankees

Babe Ruth may have hit sixty home runs this year, but Lou Gehrig was the Yankee voted the American League Most Valuable Player in 1927. For most of the season Gehrig had battled Ruth for the league lead in home runs, and his final total of forty-seven was more than any batter other than Ruth had ever hit in a season. Gehrig's presence in the Yankee lineup aided Ruth immeasurably in setting his new home run record, since no pitcher would dare pitch around the Babe to get to Lou.

Joe Dugan
1927 New York Yankees

Third baseman Dugan always sat next to Babe Ruth on the Yankees bench. He won his nickname by repeatedly "jumping"
(i.e., deserting) the last-place Philadelphia Athletics as a young player: When pitchers threw at him, or when he got home-
sick, Jumpin' Joe would jump the team. Fans taunted him with cries of "I wanna go home!" and Jumpin' Joe would jump again.
Remarkably, when he joined the first-place Yankees in 1923, his aberrant behavior ceased forever.

Pat Collins
1927 New York Yankees

Babe Ruth called everybody Kid because he had difficulty remembering names, but for teammates he would make exceptions. Here is the man Ruth called Horse Nose. Collins was a substitute catcher throughout his career, but in 1927 he played in more games than any other Yankee catcher and contributed seven home runs to the Yankees' league-leading total of 158.

Ben Paschal
1927 New York Yankees

Babe Ruth suffered a "bilious attack" on Opening Day in 1927. It was something he ate, according to Yankee manager Miller Huggins, so Ben Paschal was sent in to pinch-hit. Paschal was accustomed to substituting for the Babe, since he had replaced Ruth for much of the 1925 season when the slugger had been similarly indisposed.

Paschal had batted .360 then, but when the best player in baseball returned, Ben was back on the bench. A reserve outfielder who played in only 364 major-league games, Paschal was entitled to a mug shot as an auxiliary member of Murderers' Row.

← Jack Graney
1911 Cleveland Naps

Fun-loving Graney had a bull terrier named Larry who traveled with the Naps as their mascot and put on crowd-pleasing acrobatic exhibitions before their games. During a game in Washington in 1914, Larry retrieved a foul ball. Unfortunately, even human fans had to give foul balls back in those days, and when Larry refused to surrender the ball to umpire Big Bill Dinneen, the dog was banished from the Washington ballpark by order of American League president Ban Johnson.

Graney was the first player to wear a number on his uniform, the first ex-athlete to become a professional broadcaster, and the first major leaguer to bat against rookie pitcher Babe Ruth (he singled).

Woodrow Wilson →
Baker Bowl, Philadelphia
October 9, 1915

When Jack Graney and his Cleveland teammates visited the White House, the president of the United States had only one question: "Where's Larry? I've got to meet that extraordinary dog!" The White House doorman was ordered to produce the Naps' mascot, whereupon Larry gave a command performance for Woodrow Wilson.

Conlon photographed the first president ever to attend a World Series when Woodrow Wilson threw out the first ball before Game Two of the 1915 World Series between the Phillies and Red Sox. Wilson was also the first president to arrive late for a World Series game, delaying the start of the contest by several minutes. This was the first public appearance of Wilson and his fiancée, Mrs. Edith Bolling Galt. Their engagement had been announced three days previously.

Lefty Grove
1925 Philadelphia Athletics

When the Martinsburg team of the Blue Ridge League needed a new outfield fence in 1920, they sold Lefty Grove, their most valuable asset, to Jack Dunn and the Baltimore Orioles for $3500. Five years later, Dunn sold him to Connie Mack and the A's for $100,600. The rookie glared at everyone as menacingly as he glared at Conlon: "I was suspicious of everybody. And I guess I was scared of big cities. My attitude was the best defense I could think of. I figured that if I scared people away, they wouldn't steal my money and my watch." Even his own teammates were uneasy around Grove, who was known to tear up the locker room after a loss.

Lefty Grove
1937 Boston Red Sox

In 1937, Charles M. Conlon told *The Sporting News*: "In photographing ball players, you run into a lot of difficulties, mainly because they are so superstitious. Lefty Grove still is one of the most persistent believers in that sort of thing. If you don't believe me, try to get him to pose his pitching hand holding the ball. Nobody has ever got that picture, and I guess nobody ever will. Lefty thinks this picture would reveal the secret of his skill. He always tells you, 'There is nothing good-looking about my hand.'"

In 1941, Grove retired with exactly 300 victories, the secret of his pitching skill intact.

Hank Greenberg
1933 Detroit Tigers

In 1929, eighteen-year-old first baseman Hank Greenberg was offered a contract by his hometown team, the Yankees. He declined, noting that they already had a first baseman named Gehrig, who never missed a game. In 1933, rookie Greenberg returned triumphantly to the Bronx as the regular first baseman of the Detroit Tigers.

Hank Greenberg
1940 Detroit Tigers

Greenberg won his second Most Valuable Player award in 1940, leading the Tigers to the World Series. He missed the next four and a half seasons while serving in World War II, but he returned in mid-1945, again leading the Tigers to the World Series with a pennant-winning grand-slam home run on the final day of the season.

← Chief Meyers
1909 New York Giants

When the 1910 season ended, Chief Meyers and Christy Mathewson appeared together in a vaudeville act entitled "Curves," in which Matty demonstrated his famous "fade-away" pitch and Chief portrayed his catcher. The two then demonstrated their inconsiderable acting talents in a dramatic sketch that made this college-educated Native American cringe: A courageous cowboy, played by Mathewson, rescued a fair maiden from the clutches of a bloodthirsty savage, played by Meyers. Mercifully, the sketch flopped when it was greeted by laughter, much to Matty's consternation.

George Moriarty →
1910 Detroit Tigers

Moriarty was a journalist, inventor, song-writer, and the self-proclaimed "poet laureate of baseball," whose magnum opus was entitled "Don't Die on Third." He became an American League umpire in 1917, quit to succeed his old teammate Ty Cobb as manager of the Tigers in 1927, and then became an umpire again in 1929. Moriarty's most memorable day at the ballpark came on Memorial Day in 1932, when he offered to fight the entire Chicago White Sox team, one man at a time. The White Sox misunderstood, and jumped the pugnacious umpire en masse. He was hospitalized with head injuries and a broken hand, but only briefly.

Bill Terry
1934 New York Giants

Terry became the last .400 hitter in the National League when he batted .401 in 1930. He succeeded John McGraw as Giant manager in 1932 and led the team to a world championship in 1933. In January 1934, after Terry predicted that the Giants would again win the pennant, a sportswriter asked: "Do you fear Brooklyn?" The arrogant and tactless Terry responded with a sarcastic question that would torpedo his team's pennant hopes and resound in baseball history: "Is Brooklyn still in the league?" The sixth-place Dodgers avenged this insult by gleefully defeating the Giants in the last two games of the 1934 season, thus enabling the St. Louis Cardinals to beat out Terry's team for the pennant by exactly two games.

John McGraw
1905 New York Giants

In the 1890s, Muggsy McGraw was a brilliant third baseman for the Baltimore Orioles. He made an art form out of tripping base runners while the umpire wasn't looking, but he also perfected the hit-and-run play with Oriole teammate Wee Willie Keeler. Here the Giant manager poses as a first baseman, although he played only one game at the position during his entire sixteen-year career, and he wears his 1904 uniform with his 1905 hat, typical in an era when uniforms were not necessarily uniform. The 1905 Giants always remained John McGraw's favorites, not only because they were his first world champions, but because he considered them the smartest of all his teams.

1904 New York Giants

Here is the only team that ever refused to play in the World Series. Actually, the players very much wanted to play in the Series, but manager John McGraw and team owner John T. Brush were feuding with Ban Johnson and the four-year-old American League: "There is nothing in the constitution or playing rules of the National League which requires its victorious club to submit its championship honors to a contest with a victorious club in a minor league," declared the arrogant Giant owner. There followed an immediate hail of criticism from the fans and the press, accusing McGraw and Brush of cowardice, and bitter complaints from the Giant players, who had been concerned about being deprived of a large postseason paycheck. The 1905 World Series went on as scheduled.

Jimmy Archer
c. 1913 Chicago Cubs

"Here is a hand with a history. The first and fourth fingers look like the wreck of the Hesperus. The little finger curves like a barrel hoop. Jimmy couldn't straighten it out to save his life but it didn't bother him any as he said 'the ball fitted well into the curve.' The first finger is grown to about two sizes owing to the fact that both joints have been repeatedly broken. That is some finger. The other two fingers might not do over well for a violin player, but they are quite straight and normal for a catcher. Not saying that they have not met with their mishaps. Jimmy broke every finger of this hand. But the fractures didn't result in such odd shoots and angles as were assumed by the other fingers in the healing process."

This description of Archer's hand was illustrated by Conlon's photograph in the October 1917 issue of *Baseball Magazine*. Editor F. C. Lane collaborated with Conlon again the next year on a bizarre article entitled "Inside Dope from a Ball Player's Hands." The illustrations consisted entirely of close-ups of famous players' hands. Sadly, none of these twenty-five negatives now exist.

Wes Ferrell
1938 Washington Senators

In December 1938, Charles M. Conlon made a proposal to *The Sporting News*: "It seems to me that a discussion among your readers on 'Who is the handsomest player in the majors?' might prove interesting. Quite a number of the boys would qualify in Hollywood if good looks were the only requirement." A poll was conducted and the winner was . . . Wes Ferrell. An autographed photo of Wes was awarded to the woman who best explained her choice: "His head is well shaped; his eyes are neither too far apart, nor too close together; his nose is in the middle of his face, where it belongs, not off to one side; and most important of all, his ears are close to his head. No matter how you look at him, he's handsome."

The seventy-year-old Conlon had a simpler explanation: "It's his hair. The girls like his marcel."

Bill Lee
1936 Chicago Cubs

The first runner-up in Conlon's beauty contest was Bill Lee, the Cubs' ace pitcher who led the majors in wins and shutouts in 1938. He was a Plaquemine, Louisiana, native who had imbibed the traditions of the bayou: "You might call it superstitious when I insist upon putting down my glove a certain way and demanding that no one touch it. And I always take four, and only four, warm-up pitches at the start of an inning and I won't pose for a picture on the day I'm going to pitch."

Here Conlon captures an amazing simulation of a warm-up pitch, performed by Bill Lee and his Lucky Glove.

Napoleon Lajoie
1909 Cleveland Naps

In 1909, Lajoie was the highest-paid player in baseball, managing a team named in his honor. "Jumpin' Jehosophat, how he does sock 'em!" raved *The Sporting News*. "Infielders frequently are bowled over like tenpins by his terrific liners, and even the outfielders have difficulty handling them." After a quarter-century of retirement, Lajoie recalled those days wistfully: "If I could make one wish that would come true, I'd wish that the boys I was playing with in 1908 could operate on that jack-rabbit ball they're throwing today, just for one season. My biggest regret is that I never had an opportunity to take a few swipes at it. When I think of how hard we used to hit the dead ball, I begin to wonder why some of these modern-day pitchers haven't been killed."

George Stovall
1914 Kansas City Packers

On August 3, 1907, in a Philadelphia hotel dining room, Cleveland first baseman George Stovall called Napoleon Lajoie a vile name, and the Naps' manager fined him $50. Stovall repeated his insult and suggested that Lajoie double the fine. "All right, I'll make it $100," replied the agreeable Lajoie. "Does that go?" inquired Stovall. "You can bet it does!" said Lajoie, at which point Stovall picked up a heavy oak chair and attempted to crush his manager's skull. Only the quick reflexes of Cleveland pitcher Dusty Rhoads, who deflected the chair, prevented a serious injury. Lajoie suffered a glancing blow to the head, and the chair splintered on the floor. "We did have a little mite of a disagreement," recalled Stovall forty years later, "but it never amounted to as much as they said. Guess we'd be good friends now if we met."

Because of such incendiary behavior, Stovall became known as Firebrand and the Human Torch. Incredibly, he became the Naps' manager in 1911 and then managed the St. Louis Browns in 1912 and 1913. He temporarily relinquished the latter position after drenching an umpire with tobacco juice. In 1914, Stovall became the first major-league player to jump to the outlaw Federal League: "Someone had to be first," he explained, "and it might as well be I." Kansas City manager Stovall posed for Conlon in the first year of the league's two-year existence; this is the only Conlon Federal League portrait that survives as a negative.

Benny Bengough
1932 St. Louis Browns

"A good catcher should be able to tell whether he can catch a foul ball by the crack of the bat and the first flash he gets of the ball as he turns around," said Benny Bengough, the man who actually described foul balls as "the spice of life." Here he rapturously removes his catcher's mask for Conlon's camera, a phantom pop foul illuminating his eyes. In 1917, Benny was a lowly minor-league bullpen catcher when his mother complained that her boy never got a chance to play. The manager got the message and Bengough's baseball career got its start. He eventually became a back-up catcher for the greatest team in baseball history, the 1927 New York Yankees.

In 1933, this picture appeared on card #1 of the first baseball bubble-gum card set ever issued. Today, that Benny Bengough card is an exceedingly rare and costly collectible.

Babe Ruth and Lou Gehrig →
1926 New York Yankees

Conlon took thousands of photographs of players simply warming up on the sidelines, pictures that satisfied the curiosity of baseball fans in the pre-television era who wanted to see what their heroes looked like in their everyday environment. These scenes seem all the more unreal to us today precisely because they were once so commonplace. Here is a representative example: two guys playing catch—one named Ruth, one named Gehrig.

Ex-pitcher Babe Ruth superstitiously insisted on warming up with a Yankee catcher before each game. From 1920 to 1924, his partner was Fred Hofmann. From 1925 to 1930, his partner was Benny Bengough.

Fred Hofmann
1922 New York Yankees

Hofmann was a jovial benchwarmer, always prepared to party. He thus fulfilled all of the qualifications necessary to become Babe Ruth's roommate, a position he occupied for three years. Although Hofmann's accepted nickname was Bootnose, his roomie preferred the more elemental Crooked Nose. Fred was naturally along for the ride when Ruth was in an auto accident and reported killed in 1920. His greatest thrill in baseball came when he drew a base on balls in the 1923 World Series.

Fred Hofmann
1939 St. Louis Browns

Hofmann was a highly knowledge-
able baseball man. In 1922, and
again in 1928, he traveled to Japan
to give baseball exhibitions that
helped popularize the sport in that
country. Fred was a coach for the
St. Louis Browns when they played
in their only World Series in 1944,
and he stayed with the team when
they moved to Baltimore in 1954.
He scouted future Hall of Famer
Brooks Robinson and later discov-
ered and signed future Oriole great
Boog Powell.

Honus Wagner
1914 Pittsburgh Pirates

"Hans is awkward. His best friends admit that. There's no airy, fairy grace about him. When he moves from his favorite position to stop a hot one, it's like a standing army mobilizing for a night march or a naval monitor getting under way. His tread is a cross between that of the elephant and rhinoceros. In reaching for the leather, his arms look like cotton hooks and move about as gracefully as steam cranes. Hans is built along the lines of a threshing machine. But—he gets there just the same. It must be conceded that there are mighty few drives that get by him. And the average fan, watching the speed and certainty with which Hans goes after the grassers and yanks down the soarers, forgets the shortstop's seeming clumsiness and thinks of him rather as the 'Flying Dutchman.'" (*The Sporting News*, March 3, 1906)

Honus Wagner
1936 Pittsburgh Pirates

"Not so long ago, a friend asked me when I was going to give up the game. 'Never,' I told him, and I meant it. I'll never want to quit, and I'll be tagging around with ball players as long as I can walk. I am right where I want to be—as a coach with the Pirates. This is the team I played with for so many years, and I get a real kick out of being on deck in the monkey suit every day, taking my turn at batting them to the boys and going out to the coaching line." Honus finally hung up his spikes after the 1951 season, at the age of seventy-seven. He lived long enough to see an enormous statue of himself dedicated by the city of Pittsburgh in 1955.

Honus Wagner
1910 Pittsburgh Pirates

"I have sometimes wished I could have batted against the lively ball," said Honus in the 1930s. "In my day, the ball was pretty dead and you had to wallop it to make it go. A home run was something to get you a headline all the way across the top of the page in the newspapers, and always brought out an extra 500 fans the next day. Of course, I don't know if I would have hit any better against the lively ball."

In 1927, when asked what he thought Honus Wagner could have done with the lively ball, Ring Lardner replied simply: "He couldn't have hit it much farther than he hit the old one." In this photograph, Wagner displays the slashing power that so impressed his contemporaries. His Pirate teammates are obviously impressed, but then so were his opponents: "When Pittsburgh had infield or batting practice, we just sat on the bench to watch Wagner's every move," said New York Giant catcher Chief Meyers. "He was the best."

Tommy Leach
1910 Pittsburgh Pirates

Conlon took several photographs during batting practice this day at Washington Park in Brooklyn. It is now a few moments later, and a former home-run king has stepped in to take his cuts. True, he hit only six home runs in 1902 (the lowest league-leading total of this century), and all of them were hit inside the park, but this was still quite an accomplishment for Tommy the Wee, a man dismissed from a tryout in 1898 with these words: "We don't play midgets on the Giants."

Washington Park was a terrible place to play baseball. Brooklyn lived in dread of fire in the wooden stands, and the conditions were intolerable for players and spectators alike: "If any breeze did get a notion to stir," wrote John B. Foster, "it was choked to death by the big chimney on the other side of Third Avenue, which belched forth smoke and cinders all of the afternoon. Once the park warmed up well, it so remained. Fans went to the field prepared to swim in perspiration, and usually they did." The opening of modern Ebbets Field in 1913 was truly a breath of fresh air for baseball in Brooklyn.

← Wilbert Robinson, John McGraw,
and Christy Mathewson
1912 New York Giants

Beginning in 1910, Charles M. Conlon covered the World Series as a photojournalist for thirty years. He photographed the crowd outside the ballpark and the paying customers within. He photographed all of the pregame activities: the march of the teams from the clubhouse; the traditional handshakes between managers, starting pitchers, and mascots; the postseason award presentations; the first-ball ceremony. When the game began, he took action shots of every exciting play. Today, virtually all of these negatives are lost.

The men in this photograph are not posing. Pitching coach Robinson (left), manager McGraw (center), and pitcher Mathewson (right) are at brand-new Fenway Park in Boston, anxiously awaiting the start of a game during one of the most nerve-racking World Series ever played. A vendor can be seen hawking souvenir pennants behind the dugout. The Giants would lose the eighth and deciding game to the Red Sox at Fenway Park following an infamous muffed fly ball by Fred Snodgrass and a disastrous mental error by Christy Mathewson, who called for catcher Chief Meyers to take a foul pop-up he could not reach.

Zack Wheat
1912 Brooklyn Superbas

Zack and Daisy Wheat were married in 1912, eight days after they had met at Redland Field in Cincinnati. Wheat was the highest-paid Superba that year, earning the grand sum of $3300, but he was worth it because he put fans in the box seats. Brooklyn florist and baseball enthusiast W. C. Martin became overly excited one day in 1915 when Wheat hit a game-tying home run in the bottom of the ninth. Mr. Martin complained of chest pains but survived into extra innings, long enough to see Wheat knock in the winning run in the eleventh. "Mr. Martin gave a great yell of joy, then sank back quietly in his seat," reported *The Sporting News*. Zack Wheat had killed his first fan.

Wahoo Sam Crawford
1912 Detroit Tigers

Conlon intended to document Crawford's batting grip in this photograph, but he also captured Wahoo Sam's characteristically peevish expression. Crawford played a pivotal role in the bizarre incident that occurred here at Hilltop Park on May 15, 1912. A fan in the stands persisted in taunting Ty Cobb, using highly charged racist language. When Crawford asked Cobb if he was going to tolerate such abuse, Ty jumped into the stands and attacked the fan. It turned out that the heckler was missing one hand entirely and had only two fingers on the other, but Ty Cobb beat him up all the same. American League president Ban Johnson witnessed the incident and suspended Cobb, whereupon the Tigers went on a one-day strike to protest the decision. On May 18, 1912, the Philadelphia Athletics trounced a ragtag collection of college and semipro ball players who were Detroit Tigers for a day. The final score was 24–2.

Hughie Jennings
1909 Detroit Tigers

An overflow crowd lines the outfield fence at Hilltop Park as manager Hughie Jennings exhorts his Tigers to capture their third straight American League pennant. The runner taking his lead off third base on the far right is, not surprisingly, Wahoo Sam Crawford, the man who set the all-time major-league record for triples.

Jennings, a Cornell graduate, was a practicing attorney in the off-season. When he was the captain of the champion Baltimore Orioles in the 1890s, his teammates included Wee Willie Keeler, John McGraw, Wilbert Robinson, and Kid Gleason.

Hughie Jennings
1910 Detroit Tigers

Conlon took a famous series of photographs of Jennings, whose distinctive body language was accompanied by an unforgettable ear-splitting scream. "I used to say, 'That's the way!' Then I found that it was too dull and tiresome. I wanted something with snap and go to it. So I changed it to 'That's the way-ah!' From this I changed it to just 'The way-ah!' Finally I found I was just yelling 'Ee-yaah!'"

Christy Mathewson: "Hughie Jennings emits his famous 'Ee-yaah!' and the third baseman creeps in, expecting Cobb to bunt with a man on first base and no one out. The hitter pushes the ball on a line past the third baseman. The next time Jennings shrieks his famous war-cry, it has a different intonation, and the batter bunts."

Hughie Jennings
1912 Detroit Tigers

On March 9, 1912, this grim news was reported to the baseball world: "Manager Hughie Jennings, of the Detroit team, will not be able to coach after the fashion that has made him famous when the American League season opens next month, unless something akin to a miracle happens. Five months have passed since Jennings was injured in an auto smash-up, and he still is crippled. He can't twist his wrist enough to get his fingers to his lips to whistle, and he will have trouble picking grass. He can't kick and prance, for one leg is so weak he has to nurse it carefully. If Jennings has not been able to recover more than this in five months there is not much chance that he will in four weeks more. There is a fear that his injuries may be permanent."

But sometimes miracles happen. Hughie recovered to kick and prance again that season.

Tris Speaker
1916 Cleveland Indians

Speaker was the greatest center fielder of his generation, yet the Red Sox sold him to Cleveland just before Opening Day in 1916 when he refused to accept a fifty percent pay cut. In a famous portrait, the Gray Eagle peers intently at Conlon's lens, his icy gaze betraying the bitterness he felt at leaving Boston, the city where he had become an institution. Tris responded to this shattering development by having one of his best years for his new team. He batted .386 in 1916 to lead the American League in hitting, thus depriving Ty Cobb of the chance to win a mind-boggling thirteen consecutive batting titles. Between 1907 and 1919, only Speaker was able to surpass Cobb at the plate.

Tris Speaker
1928 Philadelphia Athletics

"Tris Speaker resents being joshed about his age. He says that just so long as he continues to go at top speed it really does not matter how much the fans 'ride' him because his hair is gray, but that it hurts him when he is going bad. Speaker refuses to divulge his exact age, but declares that he has been gray since he was seventeen years of age and that he is not yet thirty. Few fans will believe that Tris is as young as he would like people to believe, but, after all, what does it matter? He is playing the greatest game of his career, and until he starts to slip the fans in Cleveland will not worry about his gray hair."

The justifiably sensitive Speaker was indeed only twenty-eight years old when this item appeared in *The Sporting News* in 1916. By 1928, however, he was in his twenty-second and last major-league season, his playing skills having finally caught up with his hair.

Tony Lazzeri
1929 New York Yankees

On October 10, 1926, in the seventh inning of the seventh game of the World Series, St. Louis Cardinals pitcher Grover Cleveland Alexander struck out Tony Lazzeri with the bases loaded. It was one of the most dramatic moments in World Series history. In 1930, Lazzeri good-naturedly called that strikeout his greatest thrill in baseball, but by 1945, the year before his death, he was tired of hearing about it: "Funny thing, but nobody seems to remember much about my ball playing except that strikeout. There isn't a night goes by but what some guy leans across the bar, or comes up behind me at a table in this joint, and brings up the old question. Never a night. All they want to talk about is that damn time I struck out."

Grover Cleveland Alexander
1917 Philadelphia Phillies

When he fell on hard times after his retirement from baseball, Alexander reenacted his legendary strikeout for the customers of a Times Square freak show. At the heart of the legend was the allegation that Alexander was nursing a brutal hangover when he came in from the bullpen to strike out Lazzeri, but the pitcher always denied that he had been out drinking the night before: "I don't want to spoil anyone's story, but I was cold sober that night. There were plenty of other nights, before and since, that I wasn't, but that night I was as sober as a judge should be." Cardinal manager Rogers Hornsby concurred, adding indignantly: "I would be a hell of a manager if I put a drunken pitcher in to save the last game of a World Series, wouldn't I?"

Babe Ruth
1928 New York Yankees

Ruth could never quite bring himself to say that he had actually called his shot against Charlie Root in the 1932 World Series. Here is his typically evasive 1936 version, surreally fractured by a Detroit sportswriter who rendered the Babe's expletives suitable for public consumption: "Every time I went to bat the Cubs on the bench would yell, 'Oogly googly.' It's all part of the game, but that particular inning when I went to bat, there was a whole chorus of oogly googlies. The first pitch was a pretty good strike and I didn't kick, but the second was outside and I turned around to beef about it. As I did, Gabby Hartnett said, 'Oogly googly.' That kinda burned me and I said, 'All right you bums, I'm going to knock this one a mile.' I guess I pointed, too. The next pitch was a fast one and I got a hold of it. Before I started to first base I turned to Gabby Hartnett and said, right back to him, 'Oogly googly.' It was the first time I ever knew him not to have an answer. He didn't say a word."

Charlie Root
1926 Chicago Cubs

Root always denied that Ruth had called his shot: "Baloney. If he had pointed to the stands, he'd have gone down on his fanny. I'd have loosened him up. Nobody facing me would have gotten away with that." This notorious headhunter wasn't bluffing: A distressed Brooklyn sportswriter once complained that Charlie seemed to be throwing at Dodger hitters "for the sheer fun of it," and Cubs manager Charlie Grimm was so impressed by Root's jaw-thrusting belligerence that he dubbed him Chinski. Offered the chance to play himself in *The Babe Ruth Story* (the worst baseball movie ever made), Root emphatically declined to participate in the perpetuation of the myth of the called shot: "I'm tired of being the goat in that one."

Earl Averill
1929 Cleveland Indians

In 1929, Averill became the first American League to hit a home run in his first major-league at bat. His Cleveland teammates dubbed him Rockhead when he put himself on the disabled list by letting a firecracker explode in his hand, but Earl preferred the more dignified abbreviation Rock. His distinguished career earned him a place in the Hall of Fame, but today he is remembered mainly for one swing of the bat: In the 1937 All-Star Game, Averill hit a line drive that broke the big toe on pitcher Dizzy Dean's left foot.

Dizzy Dean →
1938 Chicago Cubs

Dean had pitched more innings than anyone else in baseball between 1932 and 1936, and he was already suffering arm problems when Averill's line drive broke his toe. But when he returned to the mound before his injury had healed, Dizzy ruined his arm for good, and his fastball was gone forever. In April 1938, Branch Rickey traded Dean to the Cubs for three players and $185,000. Dizzy helped the Cubs win the pennant with his 7–1 record, but he lost Game Two of the 1938 World Series, despite a valiant effort: "I never had nothin'. I couldn't break a pane of glass and I knew it, but I pitched."

This photograph portends the demise of baseball's golden age: The Cubs have adopted the zipper.

Catching for the New York Highlanders on June 28, 1907, Branch Rickey set a major-league record when he allowed the Washington Senators to steal thirteen bases. He soon left baseball to become a law student. Conlon photographed Branch upon his return to New York as manager of the Browns.

The Mahatma mystified players with his scholarly approach to baseball and irked them with his stinginess during salary negotiations. He amused the baseball world with such eccentric notions as the pitching machine, the batting cage, and the batting helmet, all of which have, of course, become universally accepted. He later developed the modern minor-league farm system for the St. Louis Cardinals, and, as general manager of the Brooklyn Dodgers, he broke baseball's racist color line by signing a ball player named Jackie Robinson.

Charles Comiskey
Chicago White Sox Owner, 1917

Before Charley Comiskey revolutionized first-base play in the 1880s, a first baseman planted himself close to the bag and rarely strayed. It occurred to Commy that he could field more ground balls if he stood a few yards away from the base and yet still have time to cover the bag if necessary. There were fears that his unorthodox style of play would confuse his infielders, but the other fellows seem to have caught on.

In 1917, Comiskey was at the Polo Grounds, watching his White Sox win the World Series. Two years later, team members would become fed up with earning the worst wages in baseball from the miserly Comiskey, and the "Black Sox" would take the field for the 1919 World Series.

Heinie Zimmerman
1913 Chicago Cubs

"Heinie Zimmerman is great with the stick this year," reported *The Sporting News* in 1912, "but he has recently brought shame on the national game and the profession of ball playing. At a game in St. Louis, umpire Rigler had occasion to order Zimmerman from the game. The player, instead of leaving the field, is alleged to have gone before the grandstand and so offended decency by his obscene actions that even men were made to blush." Heinie was fined $100, but he went on to win the Triple Crown. Playing third base for the Giants in the 1917 World Series, Zimmerman became the Series goat when he chased a White Sox runner home without throwing the ball, but Heinie pointed out that none of his Giant teammates had covered home plate: "Who the hell was I going to throw the ball to? The umpire?" When Zimmerman and Hal Chase were suspended from baseball in 1919 for fixing games, the editor of *The Sporting News* had to admit that he was sorry to see the colorful Zimmerman go: "He is doubtless uncouth, vulgar, and altogether unreliable, but even so he has some of the qualities that excite a certain sort of admiration."

Hal Chase →
1917 Cincinnati Reds

Prince Hal was one of the greatest-fielding first basemen in baseball history but he ended up a drunken desert drifter. Why? Because Chase was also the biggest crook in baseball history, the man who made the 1919 Black Sox scandal inevitable. Chase was finally banned from baseball in the wake of that scandal, but by that point he had already been throwing games for more than a decade, and, as Chase himself put it: "Once the evil started, there was no stopping it, and club owners were not strong enough to cope with the evil."

Hal Chase summed up his life on his deathbed: "I am an outcast and I haven't a good name. I'm the loser just like all gamblers are. I lived to make great plays. What did I gain? Nothing. Everything was lost because I raised hell after hours. I was a wise guy, a know-it-all, I guess."

Charles M. Conlon: "Too bad about Hal. But when he had it, he *had* it."

153

Shoeless Joe Jackson
1913 Cleveland Naps

Conlon gives us a pitcher's-eye view of one of the most fearsome batters ever to step up to the plate, the man who inspired Babe Ruth's batting style. Shoeless Joe is posing at the Polo Grounds during the season when he became the first man ever to hit a ball over the roof of the right-field grandstand and completely out of the park. He holds Black Betsy, his customized Louisville Slugger darkened not by paint, but by fire. No other man ever used such a bat.

Buck Weaver
1916 Chicago White Sox

Ty Cobb called him the greatest third baseman he ever saw, but Buck Weaver was banned from baseball after the Black Sox conspired to lose the 1919 World Series. Weaver was not a participant in the plot, but he did have "guilty knowledge" of it and chose not to inform on his teammates. For the rest of his life he struggled in vain to clear his name.

In the background is the brilliant Black Sox pitcher Eddie Cicotte, who threw the 1919 World Series for $10,000 in cash.

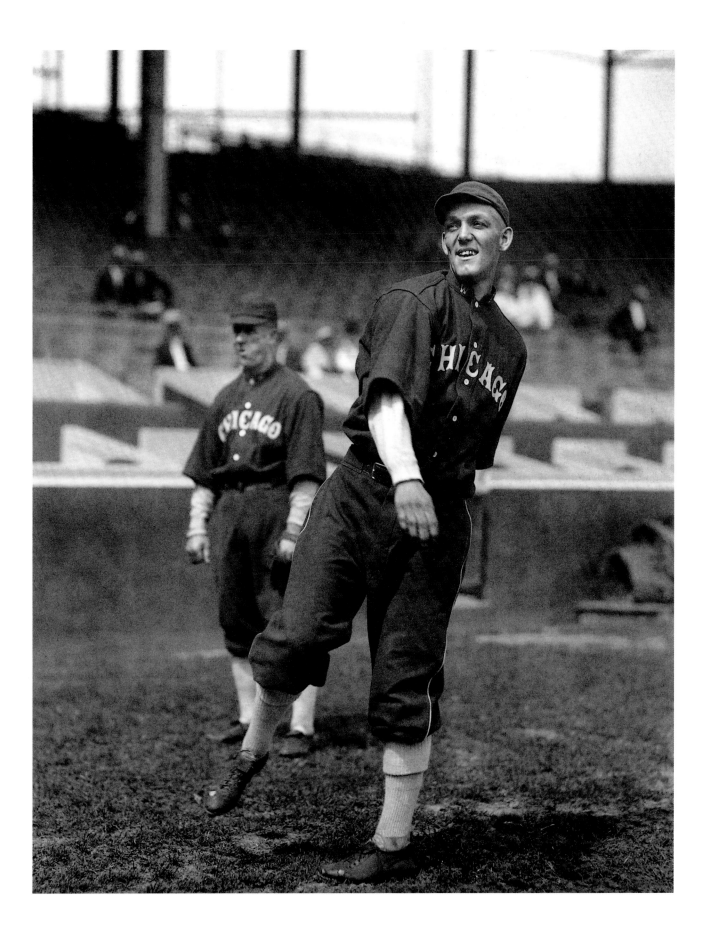

155

Eddie Cicotte
c. 1913 Chicago White Sox

"I was credited with inventing the knuckler, but at least half the credit belongs to Eddie 'Kickapoo' Summers. Detroit had us both farmed to Indianapolis in 1906 and while there we developed the knuckleball. After I joined the Red Sox in 1908, I acquired the nickname 'Knuckles' on account of the pitch." Conlon made many studies of Cicotte demonstrating his new and peculiar pitching grip. Note that Eddie's knuckles did not touch the ball; the pitch's name arose from the fact that the knuckles were prominently raised above the ball.

But Eddie did not stop at the knuckleball: "All the pitching deliveries concocted by the imagination were tabooed in certain quarters after Cicotte made a success of fooling batters last year," said White Sox manager Pants Rowland in 1918. "They talked about the 'mud ball,' the 'paraffin ball,' the 'licorice ball,' the 'talcum ball,' and about every other kind of delivery." A master of gamesmanship, Cicotte continually rubbed the ball against his uniform and brought it to his mouth, baffling batters with an all-purpose mystery pitch that came to be called the "shine ball."

Eddie Cicotte
c. 1913 Chicago White Sox

Cicotte and his Black Sox teammates were banned from baseball after they nearly destroyed the World Series. More than three decades later, Cicotte was still not fully aware of the gravity of his transgressions: "That was all long, long ago. We done wrong and we deserved to get punished. But not a life sentence. That was too rough."

Ray Schalk
1923 Chicago White Sox

Catcher Ray Schalk pauses to take batting practice, his glove and ball perched on home plate. He had looked on helplessly as his Black Sox teammates deliberately lost the 1919 World Series: "Schalk was wise the moment I started pitching," said Eddie Cicotte. The catcher immediately complained to his manager, Kid Gleason, who in turn complained to Charles Comiskey. But when American League president Ban Johnson was informed of Comiskey's suspicions, he drunkenly dismissed them as "the whelp of a beaten cur."

"It was the Kid who made me a real catcher," said Schalk. "There were mornings when he worked me so hard I thought I'd never be able to crawl out and catch in the afternoon. But you know, I always did. If I was a success it was because of Gleason. He sold me on the idea that a little fellow didn't have to give too much ground to the big bruisers in baseball. What a wonderful little man he was."

Kid Gleason
1926 Philadelphia Athletics

In Ring Lardner's classic baseball book, *You Know Me Al,* White Sox coach Kid Gleason is pitcher Jack Keefe's keeper and taskmaster: "I believe Gleason will starve me to death," complains Jack in a typical moment of self-pity. "A little slob like him don't realize that a big man like I needs good food and plenty of it." The rough-and-tumble Kid became manager of the White Sox in 1919: "We never had no fightin' on that club. I used to tell those mugs that if they wanted to fight, they could fight me. I was no juvenile, but I could move in and go to work in a fight. And we didn't have no fightin' either." But those mugs betrayed him in the World Series, and Gleason realized too late the error of his permissive ways: "I oughta grabbed a bat and crashed it down over the empty skulls of every one of those players." The man in this photograph is recovering from a nervous breakdown; Philadelphia manager Connie Mack has taken pity on the Kid and given his old friend a job.

← Walter Johnson
1927 Washington Senators

Lou Gehrig
1927 New York Yankees

Two of baseball's greatest gentle-men shake hands before a game at Yankee Stadium. Johnson (left) is in his last year as a player, and Gehrig (right) is in his first year as a superstar.

Moe Berg →
1935 Boston Red Sox

John Kieran
New York Times Sports Columnist

Kieran was a regular panelist on the popular radio quiz show "Information Please!" When Moe Berg appeared as a guest on the program, the catcher astounded lis-teners coast to coast with the depth of his erudition. Kieran, an expert ornithologist, was often accompanied by Berg on New York nature walks.

Orval Overall
1910 Chicago Cubs

The last time the Cubs won a world championship, Orval was the pitcher who clinched it by shutting down Ty Cobb and the Detroit Tigers in 1908. In that final game, he struck out four men in one inning, the first and only time that feat has been accomplished in World Series play. Overall's baseball career was cut short by arm troubles, but he later became a successful banker.

Johnny Kling
1913 Cincinnati Reds

After the Cubs won the 1908 World Series, catcher Johnny Kling decided to hold out for a big raise in 1909. This was a big mistake. The president of the Cubs reminded Kling that Marshall Field, the founder of Chicago's famous department store, had passed away only a few years earlier: "That store will go on just as if nothing happened," he said, "and so will the Cubs if you stay out." Johnny stayed out and the Cubs went on just as if nothing had happened, with Jimmy Archer behind the plate. Kling gave pocket billiard exhibitions before meekly returning to the Cubs in 1910.

In their retirement years, many Chicago catchers shared the same uncanny fate: Ray Schalk of the White Sox and Johnny Kling, Jimmy Archer, Gabby Hartnett, and Bob O'Farrell of the Cubs all became prosperous owners of bowling alleys.

Lee Meadows
1924 Pittsburgh Pirates

In 1921, pitcher Lee Meadows disagreed with a strike call by umpire Bill Brennan. Removing his glasses, he approached the umpire and offered them to him: "You need these worse than I do, Bill." A former botany instructor, Meadows was the first ball player to wear glasses in the twentieth century. Since he was a pitcher, standing only 60′6″ from home plate, skeptics warned him that he was making a brave but particularly foolhardy career choice for one so "afflicted." In 1920, a batted ball did indeed strike Meadows in the face, shattering his spectacles, but fortunately this batting-practice foul ball left him with no permanent injuries.

When his playing days were over Lee went to work for the IRS.

Fred Luderus
1912 Philadelphia Phillies

Slugging team captain Luderus led all Philadelphia batters with a .438 average in the 1915 World Series, a performance that earned him a Coca-Cola endorsement in 1916. Grover Cleveland Alexander had three consecutive thirty-game-winning seasons for the Phillies with Luderus at first base, and he remembered his old teammate fondly: "Fred'd come up to me before a game and say, 'Well, boy, you get out there and I'll try and get a couple for you.' Maybe he'd hit two up against the fence, maybe he wouldn't. But if he didn't, he didn't. No sense in worrying. Ball players never worried in the old days."

Red Ruffing
1926 Boston Red Sox ➡

By 1929, one apoplectic Boston sportswriter had seen enough: "Ruffing is noth-
ing but a snare and a delusion and a bitter disappointment as a right-handed pitch-
er. He would add to the strength of the team by not going into the box at all. There
is nothing mysterious about this, as Charley loses all his games. It ought not to be
difficult to replace a pitcher who loses all his games." Sadly, this was not much of
an exaggeration: Ruffing lost seven out of every ten of his decisions with the Red
Sox. But what could you expect from a pitcher who was missing four toes on his
left foot after an accident in a coal mine?

⬅ Red Ruffing
1936 New York Yankees

By 1936, Red was a twenty-game winner
destined for the Hall of Fame.

Mel Ott
1928 New York Giants

In 1928, his third year as a Giant, nineteen-year-old Mel Ott finally put his home-run swing on display. He would go on to lead the National League in home runs six times. When he retired in 1947, he had hit more home runs than any other batter in National League history. Conlon was living dangerously when he stood in the range of this pull hitter during batting practice, but the result was one of his most beautiful photographs.

Mel Ott
1933 New York Giants

"The biggest kick I ever got came in the 1933 World Series." In this, his first World Series, Ott hit a home run in his first at bat, went four for four in his first game, and won the Series with a tenth-inning home run in Game Five.

On December 6, 1941, Ott succeeded Bill Terry as manager of the Giants. Brooklyn manager Leo Durocher conceded that there had never been a nicer guy than Mel Ott, but he qualified his praise for the Giant manager with these immortal words: "Nice guys finish last."

Grover Cleveland Alexander
1915 Philadelphia Phillies

In 1915, the twenty-eight-year-old Alexander won thirty-one games, leading the Phillies to the World Series. The next year he won thirty-three games, and thirty more the year after that. His 1916 total of sixteen shutouts is still the all-time major-league record. When he retired with 373 victories in 1930, he had tied Christy Mathewson for third place on the all-time list.

Grover Cleveland Alexander
1928 St. Louis Cardinals

Once the greatest pitcher alive, in his last years Alexander was an unspeakably tragic figure, destitute and ravaged by alcohol: "I'm in the Hall of Fame at Cooperstown, New York, and I'm proud to be there," he said in 1944, "but I can't eat the Hall of Fame. And I can't eat the promises of jobs that I get every day and never materialize. I can drink all the beer I want for nothing—I can get enough in one day to keep me drunk for a week if I wanted to do that—but I can't get a bite to eat."

Babe Ruth
1922 New York Yankees

In 1922, the Babe was fuming. He missed the first five weeks of the season after being suspended for an unauthorized barnstorming trip. Five days after his return, he threw a handful of dirt into an umpire's face, chased a fan into the stands, and was suspended again. Run-ins with umpires Big Bill Dinneen and Tommy Connolly resulted in three more suspensions, rousing Ban Johnson to this blunt warning: "A man of your stamp bodes no good in the profession. The time has arrived when you should allow some intelligence to creep into a mind that has plainly been warped." After the season, Ruth vowed that he would change his ways. The next year he won the American League Most Valuable Player award.

Babe Ruth
1935 Boston Braves

Playing for Boston, the city where it all began for him in 1914, a washed-up ballplayer makes his farewell appearance in New York. The Babe hit his last three home runs in a game against Pittsburgh on May 25, 1935, but his instinct for the dramatic failed him, and he did not bow out of baseball with this electrifying performance. One long week later, he finally retired.

Zack Wheat, Jr., and Zack Wheat
1925 Brooklyn Dodgers

Zack and Daisy Wheat lived near Ebbets Field and took their kids to all the Dodger games. Here Zack poses for Conlon with his son, wearing a black armband in memory of the recently deceased Dodger owner, Charles Ebbets. Mrs. Wheat had an especially memorable day at Ebbets Field in 1925: When Zack broke a scoreless tie with a home run in the bottom of the ninth, the fan seated next to Daisy dropped dead.

Sam Leslie and Sam Leslie, Jr.
1935 Brooklyn Dodgers

Leslie had twenty-two pinch hits in 1932, setting a major-league record that would stand for nearly three decades, and he batted .500 as a pinch hitter for the New York Giants in the 1936 and 1937 World Series. Here the tools of ignorance overwhelm his tiny son.

← Ed Walsh
1912 Chicago White Sox

Big Ed had his last great season in 1912 when he won twenty-seven games for the second year in a row. By 1913 his arm was dead, his career virtually over. He had simply thrown too many pitches: Between 1906 and 1912, Walsh averaged nearly 360 innings a season, the equivalent of forty complete games a year.

He later served briefly and unhappily as an American League umpire and was the pitching coach at the University of Notre Dame when his son Ed, Jr., pitched there in the mid-1920s.

→

Ed Walsh, Jr.
1928 Chicago White Sox

Twenty-three-year-old rookie Ed Walsh, Jr., is breaking into the majors with the White Sox at the same age his father did. Unfortunately, this is where their career parallels end. How did it feel to be the son of the illustrious Ed Walsh? "Terrible. Being the son of a great man is a rotten handicap." Young Ed's major-league career was forgettable at best, and he was dead at the age of thirty-two, the victim of rheumatic fever. But he did accomplish one unforgettable feat: He stopped Joe DiMaggio's longest batting streak. On July 26, 1933, pitching in the Pacific Coast League, Ed Walsh, Jr., held the eighteen-year-old DiMaggio hitless after Joe had batted safely in sixty-one consecutive games.

Paul Dean and Dizzy Dean
1934 St. Louis Cardinals

When Dizzy (right) predicted before the 1934 season that "me 'n' Paul" would win forty-five games between them, it was regarded as just another of his outrageous boasts. But the Deans surpassed this figure with forty-nine wins during the season, and each won two more games in the World Series. It was the greatest year two pitching brothers ever had.

Wes Ferrell and Rick Ferrell
1935 Boston Red Sox

Meet the proprietors and purveyors of the Ferrell Brothers' Big League Dog Food and the best brother battery in the history of baseball. On July 19, 1933, Wes Ferrell (left) was pitching for the Indians when Red Sox catcher Rick Ferrell (right), hit a home run. Wes berated Rick as the latter ran around the bases: How dare he hit a home run off his own flesh and blood? When the umpire gave Wes a new baseball, he immediately drop-kicked it into the stands. Wes was still livid when he came up to bat in the bottom of the inning, and, ignoring a bunt sign, *he* now hit a home run. Wes Ferrell still holds the major-league record for career home runs by a pitcher.

← Paul Waner and Lloyd Waner
1927 Pittsburgh Pirates

At the Polo Grounds in 1927, a sports-writer heard a fan with a Brooklyn accent loudly proclaiming his admiration for the big person, Paul (left), and the little person, Lloyd (right). Here are Big Poison and Little Poison, posing for Conlon at the Polo Grounds during the greatest year two brothers ever had. Playing side by side in the outfield, Paul and Lloyd had 460 hits between them, with a combined batting average of .367. Their efforts got them into the 1927 World Series, but neither ever played in the Fall Classic again.

Pinky Hargrave ➡
1930 Detroit Tigers

Bubbles Hargrave
1930 New York Yankees

Here is a typical Conlon pose with a charming twist: two catchers, two brothers. Bubbles (right) led the National League in batting in 1926, the first time in the 1920s that Rogers Hornsby failed to win the batting crown, and the first time in the twentieth century that a catcher won a batting title. Pinky (left) was a red-haired journeyman who raised beagles in his spare time.

Rube Waddell
1905 Philadelphia Athletics

Conlon was the only photographer able to capture the mad gleam in the eye of this adult child bewitched by windup toys and whiskey, fire trucks and floozies. Waddell was a masterful pitcher who could strike out batters at will, but he was also a demented brat: "Sometimes when a batter bunted in the vicinity of the pitcher's box," recalled a teammate, "the Rube would reach for the ball but instead would grab his own foot, turn it over, and yell that his ankle was broken." In 1904, Waddell struck out 349 batters, a major-league record that would not be approached for decades. But Rube was literally unmanageable, and Connie Mack traded his star pitcher away after the 1907 season. He died at thirty-seven, a victim of alcoholism and tuberculosis.

Connie Mack
1929 Philadelphia Athletics

"Mr. Mack doesn't have to open his mouth," said Al Simmons. "A wave of that scorecard is enough." When Connie Mack celebrated his fiftieth anniversary as a major-league manager in 1944, President Franklin D. Roosevelt sent him a telegram: "Long may your scorecard wave." In 1929, Mack was waving his A's to their first World Series in fifteen years.

← Lou Gehrig
1934 New York Yankees

In 1934, the Iron Horse led the major leagues with a career-high forty-nine home runs and became the first Yankee ever to win the Triple Crown.

Johnny Mize →
1938 St. Louis Cardinals

The Big Cat peers down at Conlon with the look of sleepy self-assurance that earned him his nickname. Mize, whose cousin Claire was Babe Ruth's second wife, led the National League in home runs four times. He spent the last five years of his career as a Yankee first baseman, and in each of those years the Yankees won the World Series.

Fielder Jones
1904 Chicago White Sox

This man's prescient parents chris-
tened him Fielder Allison Jones when
he was born in Shinglehouse, Penn-
sylvania, in 1874. He was the center
fielder and manager of the White Sox,
leading the Hitless Wonders to a
world championship in 1906. But
Jones was a very hard loser, and in
1918, when he had been reduced to
managing the dismal St. Louis Browns,
Fielder finally snapped. After a partic-
ularly tough loss, a club official said
innocently: "Goodbye, see you tomor-
row," to which the seething Jones
replied: "I don't think you will. Not
unless you come out to the Pacific
Ocean. I'm going home." He left the
team and returned to his Oregon lum-
ber business, quitting baseball forever.

Al Schacht
1928 Washington Senators

These twinkling eyes belong to the Clown Prince of Baseball, the slapstick comic who entertained fans in ballparks around the world for decades, wearing a battered top hat and swallowtail coat. Conlon photographed Schacht's alternate persona, the respected third-base coach of the Washington Senators. In 1908, the fifteen-year-old Schacht had sold peanuts and soda pop at the Polo Grounds in order to be near his idols, Turkey Mike Donlin and Christy Mathewson. By 1911, he was the Giants' batting-practice pitcher, learning Matty's fadeaway from the master himself. Schacht pitched briefly for the Senators before an arm injury ended his career.

Carl Mays
1922 New York Yankees

Mays was a brilliant pitcher with a spectacular submarine delivery, but he was despised by teammates and opponents alike because of his foul personality. He did little to improve their opinion of him when, on August 16, 1920, he threw the pitch that killed the popular Cleveland shortstop Ray Chapman.

← Tommy Connolly
American League Umpire, c. 1913

Connolly, born in Manchester, England, began his umpiring career in New England in 1894. He was the very first American League umpire—his was the only game not rained out on Opening Day in 1901—and he umpired the first World Series in 1903. Tommy gave misbehaving players fair warning when the limits of his tolerance had been reached: "You can go so far with Connolly," said Ty Cobb, "but when you see his neck get red, it's time to lay off of him." And he always had the last word in any dispute: "I may be wrong, but I'm right officially. Play ball!"

Connolly was behind home plate when Carl Mays threw the pitch that killed Ray Chapman. Mays accused the umpire of causing the tragedy by failing to remove a scuffed baseball from play. The pitcher, of course, had scuffed the ball in the first place.

Muddy Ruel
1924 Washington Senators

"Muddy made a pitcher out of me when I was all through," said Walter Johnson. "He was the smartest catcher baseball ever had, and certainly the greatest handler of pitchers. When I worked with Muddy, it was like sitting in a rocking chair. I never disputed his choice of pitches." Ruel, a practicing attorney who scored the winning run in the 1924 World Series, was nicknamed Muddy by childhood playmates after he made a spectacular rainy-day slide into a mudhole.

Ruel was the catcher behind the plate when Carl Mays threw the pitch that killed Ray Chapman.

←

Ray Chapman →
1917 Cleveland Indians

In 1917, the world mourned the tragic death of Cleveland's famous canine mascot, Larry. For many years, Larry had shared hotel accommodations on the road with Jack Graney and Graney's human roommate, Ray Chapman.

Today Chapman is a morbid footnote, famous only for the manner of his death. But once upon a time he was "Chappie," a talented all-around ball player and a singer in the ball club barbershop quartet, a happy-go-lucky fellow who would join his Cleveland teammates before a game as they lined up in single file, leaned over and let Larry bound across their backs.

The Sporting News reported in 1910: "Cobb, it seems, is unpopular with the masses in general, and especially with the players, and it is all brought about by his great love for Ty Cobb himself. But withal, you have to acknowledge that he is the greatest ball player in the game today and possibly the greatest of all time. Hate this marvel if you wish—what cares he? The greater your hate for him, the harder he will play ball."

The St. Louis Browns made manifest their hatred for Cobb on October 9, 1910, when they conspired to "lay down" for Napoleon Lajoie, Cobb's opponent for the batting title. With the assistance of the Browns, the well-liked Lajoie went eight for eight, forever clouding the results of the 1910 batting race. It was diplomatically declared a tie, and both players were awarded Chalmers automobiles.

Ty Cobb →
1928 Philadelphia Athletics

Conlon's 1910 photograph of Cobb appeared annually in the baseball guides for the next decade. The perennial American League batting champion took great pride in the fact that his batting stance remained unchanged throughout his twenty-four-year career, and indeed, although separated in time by nearly two decades, these two Conlon images eerily mirror one another.

Clyde Milan
1940 Washington Senators

"Center field was sun field in Washington, and I played there mostly. The old type sun glasses were not satisfactory to me. You had to keep them over your eyes all the time, and that annoyed me. I lost more fly balls with glasses than without them, so I said to heck with them. I would play a ball hit into the glare by shading my eye with my glove." Decades of staring into the sun gave Clyde the most amazing set of wrinkles ever seen at a ballpark. He spent his last morning on earth hitting spring-training fungoes in the Florida sunshine. When he went inside to the Senators' clubhouse, Clyde collapsed and died.

↑
Clyde Milan
1913 Washington Senators

When Ty Cobb stole ninety-six bases in 1915, setting a major-league record that would stand for nearly fifty years, he surpassed Clyde Milan's record 1912 total of eighty-eight. Clyde had great respect for his main competitor on the base-paths: "Ty was tops. He had the nervous foot of the born stealer. He never liked the base he was on. I was geared the same way—the bag ahead always looked more attractive."

In 1907, Clyde Milan and Walter Johnson were discovered by the Senators during the same scouting trip. They joined the team within a month of each other and were roommates for fourteen years.

Earl Whitehill
1924 Detroit Tigers

In 1924, Earl met his future bride, Violet Oliver, the California girl who appears on the Sun-Maid raisin box. Whitehill's stunning good looks were the object of taunts by opposing bench jockeys who hoped to capitalize on his violent temper: He once threw the home plate umpire's whisk broom over the grandstand after a disputed call. Even Tiger manager Ty Cobb was wary of antagonizing the volatile southpaw. Whitehill has the worst lifetime earned run average of any pitcher with 200 or more wins, which may help to explain his extreme irascibility.

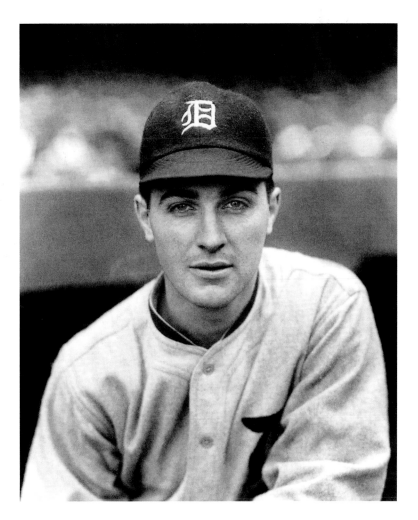

Dutch Leonard
1914 Boston Red Sox

Leonard's 1914 earned run average of 1.01 is still the best in major-league history. In 1915, Dutch made a lifelong enemy of Ty Cobb by intentionally hitting him with a pitch. Cobb retaliated by trying to spike the Red Sox pitcher. Leonard had his revenge in 1926 when he implicated Cobb, Tris Speaker, and Smokey Joe Wood in a game-fixing conspiracy, provoking a scandal that nearly resulted in the players' expulsion from baseball. Leonard refused to level his charges in Cobb's presence, preferring instead to remain in the safety of his California raisin ranch. This was a wise move, since Cobb very likely would have strangled his accuser. The charges were dropped, but the taint remained.

John McGraw
1909 New York Giants

Christy Mathewson: "Did you ever see the little manager crouching, immovable, at third base with a mitt on his hand, when the New York club goes to bat in the seventh inning two runs behind? The first batter gets a base on balls. McGraw leaps into the air, kicks his heels together, claps his mitt, shouts at the umpire, runs in and pats the next batter on the back, and says something to the pitcher. The crowd gets its cue, wakes up and leaps into the air, kicking its heels together. The whole atmosphere inside the park is changed in a minute, and the air is bristling with enthusiasm. The game has found Ponce de Leon's fountain of youth, and the little, silent actor on the third base coaching line is the cause of the change."

Christy Mathewson →
1911 New York Giants

Mathewson was Conlon's first and favorite subject. In 1937, the photographer recalled his old friend: "I treasured Matty's confidence. In 1911, I went to the World Series in Philadelphia. Coming back to New York, I dived into the diner at North Philadelphia. I sat down at a table for four. Soon, in came Matty, [former Giant catcher Roger] Bresnahan, and [Giant pitcher Hooks] Wiltse. They began to discuss the game—what had happened and why, what would have or might have happened. They discussed fellow players in a frank way. Matty did, anyway. Bresnahan gave him an inquiring look. Matty looked at me, with a smile. He said, 'Roger, Charley can be trusted—always.' I got one of the biggest kicks of my life out of that remark."

189

← Willard Hershberger
1939 Cincinnati Reds

Willard Hershberger is the only major-league player to kill himself during the season. He was a substitute catcher called into action during an intense heat wave and an equally intense pennant race. On August 3, 1940, blaming himself for Reds losses, Hershberger leaned over a hotel bathtub and slashed his throat. When the Reds won the 1940 World Series, they voted Hershberger's mother a full share of their earnings, nearly $6000.

Ginger Beaumont →
1910 Chicago Cubs

Ginger was the first man ever to bat in the World Series when he flied out against Cy Young in 1903. He was also the first man to go 0 for 5. In 1902, he led the National League in batting, beating out players like Honus Wagner, Wee Willie Keeler, and Wahoo Sam Crawford. It is fitting that Ginger made his last major-league appearance in the 1910 World Series, when he walked and scored a run to end his career.

Topsy Hartsel
1909 Philadelphia Athletics

Hartsel was the speedy Athletics lead-off man in the first decade of this century whose diminutive stature (5′ 5″) helped him lead the league in walks five times. His team-mates nicknamed him after a black character in *Uncle Tom's Cabin* because they thought he looked like an albino. In turn-of-the-century white America, this was considered a very funny joke.

Bill Dickey
1928 New York Yankees

Here is an unknown rookie catcher who played in only ten games for the Yankees in 1928. Of course, Bill Dickey went on to become one of the greatest Yankees of all time, but this example illustrates Conlon's approach to his subjects: Take every player's picture, no matter how brief his stay in the big leagues. Dickey never got to play in the 1928 World Series, but at least this photograph made it into the 1928 World Series souvenir program.

Chick Hafey
1929 St. Louis Cardinals

In this wistful portrait, a man is finally getting a good look at the world. Hafey was plagued by chronic sinus and eye ailments. Surgery provided little relief, but when he put on glasses for the first time in 1929, Hafey was delighted: He could now watch movies without getting a headache. Chick became the first batting champion to wear glasses and was the first bespectacled Hall of Famer, but bright days never ceased to plague him, even with the flip-up sun glasses he wore under the bill of his cap.

Big Bill Dinneen →
American League Umpire, 1910

Dinneen was the pitching hero of the very first World Series, in 1903, when he won three games and led the Boston Pilgrims to victory over the Pittsburgh Pirates. He retired as a player near the end of the 1909 season and immediately became an umpire, beginning a new career that would last until 1937. Conlon spotted a reflective Dinneen preparing for a game at Hilltop Park during his first full season as an umpire.

Hack Simmons
1910 Detroit Tigers

George Washington Simmons was a baseball nonentity, a mediocre utility man who bounced back and forth between the majors and minors throughout his brief career. But one afternoon he leapt for Charles M. Conlon, and he hasn't come back to earth yet. He is still there with Cobb and Crawford at Hilltop Park, still there floating over the field of dreams.

INDEX TO THE PLATES

198